D0378260

Nikon® Capture NX 2
After the Shoot

Mike Hagen

WILEY

Wiley Publishing, Inc.

Nikon® Capture NX™ 2 After the Shoot

Published by
Wiley Publishing, Inc.
10475 Crosspoint Blvd.
Indianapolis, IN 46256
www.wiley.com

Copyright © 2009 by Wiley Publishing, Inc., Indianapolis, Indiana

Published simultaneously in Canada

ISBN: 978-0-470-40926-8

Manufactured in the United States of America

10 9 8 7 6 5 4 3 2 1

No part of this publication may be reproduced, stored in a retrieval system or transmitted in any form or by any means, electronic, mechanical, photocopying, recording, scanning or otherwise, except as permitted under Sections 107 or 108 of the 1976 United States Copyright Act, without either the prior written permission of the Publisher, or authorization through payment of the appropriate per-copy fee to the Copyright Clearance Center, 222 Rosewood Drive, Danvers, MA 01923, (978) 750-8400, fax (978) 750-4744. Requests to the Publisher for permission should be addressed to the Permissions Department, John Wiley & Sons, Inc., 111 River Street, Hoboken, NJ 07030, (201) 748-6011, fax (201) 748-6008, or online at http://www.wiley.com/go/permissions.

LIMIT OF LIABILITY/DISCLAIMER OF WARRANTY: THE PUBLISHER AND THE AUTHOR MAKE NO REPRESENTATIONS OR WARRANTIES WITH RESPECT TO THE ACCURACY OR COMPLETENESS OF THE CONTENTS OF THIS WORK AND SPECIFICALLY DISCLAIM ALL WARRANTIES, INCLUDING WITHOUT LIMITATION WARRANTIES OF FITNESS FOR A PARTICULAR PURPOSE. NO WARRANTY MAY BE CREATED OR EXTENDED BY SALES OR PROMOTIONAL MATERIALS. THE ADVICE AND STRATEGIES CONTAINED HEREIN MAY NOT BE SUITABLE FOR EVERY SITUATION. THIS WORK IS SOLD WITH THE UNDERSTANDING THAT THE PUBLISHER IS NOT ENGAGED IN RENDERING LEGAL, ACCOUNTING, OR OTHER PROFESSIONAL SERVICES. IF PROFESSIONAL ASSISTANCE IS REQUIRED, THE SERVICES OF A COMPETENT PROFESSIONAL PERSON SHOULD BE SOUGHT. NEITHER THE PUBLISHER NOR THE AUTHOR SHALL BE LIABLE FOR DAMAGES ARISING HEREFROM. THE FACT THAT AN ORGANIZATION OR WEB SITE IS REFERRED TO IN THIS WORK AS A CITATION AND/OR A POTENTIAL SOURCE OF FURTHER INFORMATION DOES NOT MEAN THAT THE AUTHOR OR THE PUBLISHER ENDORSES THE INFORMATION THE ORGANIZATION OF WEB SITE MAY PROVIDE OR RECOMMENDATIONS IT MAY MAKE. FURTHER, READERS SHOULD BE AWARE THAT INTERNET WEB SITES LISTED IN THIS WORK MAY HAVE CHANGED OR DISAPPEARED BETWEEN WHEN THIS WORK WAS WRITTEN AND WHEN IT IS READ.

For general information on our other products and services or to obtain technical support, please contact our Customer Care Department within the U.S. at (877) 762-2974, outside the U.S. at (317) 572-3993 or fax (317) 572-4002.

Wiley also publishes its books in a variety of electronic formats. Some content that appears in print may not be available in electronic books.

Library of Congress Control Number: 2009922968

Trademarks: Wiley and the Wiley Publishing logo are trademarks or registered trademarks of John Wiley and Sons, Inc. and/or its affiliates in the United States and/or other countries and may not be used without permission. Nikon and Capture NX are trademarks or registered trademarks of Nikon, Inc. All other trademarks are the property of their respective owners. Wiley Publishing, Inc. is not associated with any product or vendor mentioned in this book.

WILEY

About the Author

Mike Hagen is a professional photographer and an avid adventurer who combines his enthusiasm for the outdoors with excellence in photography. He is a skilled digital photography expert, location photographer, workshop leader, and editorial writer.

He started his business Out There Images, Inc., in 1998 as a way to share his passion for photography with the rest of the world. Mike is well known for his intensity, energy, and enthusiasm. If you ever participate in a workshop with him, you will be pleasantly surprised by his generosity and infectious enthusiasm for imparting his knowledge to all participants.

Based in Gig Harbor, Washington, USA, Mike has traveled extensively throughout the Americas and the rest of the world to follow his photographic dreams. Travel and adventure are his passion, so you'll frequently find him somewhere far away from civilization, camera in hand, having a ball in the outdoors. Visit his website at www.outthereimages.com.

Credits

Acquisitions Editor
Courtney Allen

Project Editor
Laura Town

Technical Editor
George Maginnis

Copy Editor
Kim Heusel

Editorial Manager
Robyn B. Siesky

Vice President & Group Executive Publisher
Richard Swadley

Vice President & Executive Publisher
Barry Pruett

Business Manager
Amy Knies

Senior Marketing Manager
Sandy Smith

Project Coordinator
Kristie Rees

Graphics and Production Specialists
Carrie A. Cesavice, Andrea Hornberger

Quality Control Technician
Laura Albert

Proofreading
Linda Seifert

Indexing
Sharon Shock

For Stephanie, Matthew and Allison.
Thanks for your patience and your prayers.

Acknowledgments

I'd like to thank Courtney Allen for inviting me to write for Wiley. She has been patient and supportive throughout the entire process and I owe her a debt of gratitude for her generosity.

Also, I'd like to thank my Editor, Laura Town, for her invaluable input on content and style.

Contents

Introduction

Nikon Capture NX 2 represents a new and efficient way of working on your digital images. With Nikon's U-Point Technology, you can literally click on your photograph where you want to fix it, and make the adjustments immediately. U-Point Technology automatically selects the area for you so you can quickly change color, saturation, hue, brightness, and contrast. With many other image editing programs, you have to spend a fair amount of time making selections or masks to adjust areas of the photograph. Now with Capture NX 2, our workflow is much more rewarding since we can literally "click and fix" our images.

This book is designed to help you understand which elements of the program you should use and which elements aren't as important. I give lots of practical, real-world advice on how to get the most out of the program. Also, I try to bring in camera settings as frequently as possible to try to tie together what you do in the field with what you do on your computer. The interaction between camera and software is important, and the earlier you understand these details, the better your photographs will be.

I encourage you to read the book starting from the first chapter, so that you are able to set up the program in a way that helps you become more efficient. There are many default settings in the program that I recommend changing so that Capture NX 2 will run faster and give you better results.

Who should read this book?

Anyone using Nikon Capture NX 2, be they an amateur photographer or a professional, will find this book very useful. I've done my best to explain the software in easy-to-follow text without overwhelming you with too much technical jargon. Simply stated, this book is written to help you learn how to integrate Nikon Capture NX 2 into your workflow.

Written for Nikon Capture NX 2

Nikon Capture has gone through many versions including Nikon Capture 4.4, Nikon Capture NX and now Nikon Capture NX 2. This book is written for Nikon Capture NX 2, the latest version of the software. There is a significant difference between Capture NX and Capture NX 2 and I highly recommend that Capture NX users upgrade to Capture NX 2 because of the added capabilities in the new program.

With that said, many of the explanations in this book are applicable to Nikon Capture NX users. Owners of Capture NX will find this book to be of great help in understanding the software.

What file formats can you use?

Nikon Capture NX 2 is best suited to working on your Nikon raw files, otherwise called NEFs. NEF stands for Nikon Electronic Format and is Nikon's own proprietary image format. Nikon Capture NX 2 will not allow you to open RAW files from other camera manufacturers such as Canon, Pentax or Olympus. However, Capture is a fantastic tool for working on JPGs and TIFFs from any camera system.

I recommend Nikon Capture NX 2 all the time for shooters of other camera systems since it is such a powerful tool. For these shooters, I recommend converting your RAW file to a TIFF, then opening it up in Capture NX 2 so you can have access to all the powerful features of the software package.

Keyboard shortcuts

Capture NX 2's keyboard shortcuts are consistent both in Windows and Mac OS. In almost all cases, you can substitute the Windows Ctrl (control) key with the Mac Cmd (command) key. Also, you can substitute the Windows Alt key with the Mac Option key. When you read a sequence like Ctrl + S, that means you need to press the Ctrl key and the S key simultaneously for the shortcut to activate. When I tell you to right mouse click, you have to Ctrl+Click when you are using a one-button mouse with Mac OS.

I have included most of the keyboard shortcuts in Appendix A.

One more thing

I've done my very best to make sure everything in this book is 100% accurate. I'm a big fan of Capture NX 2 and I want to do everything I can to make your experience with the program as rewarding as possible. If you find any errors or have suggestions for improvement, feel free to email me at mike@outthereimages.com. Also, feel free to check out my personal website:

www.outthereimages.com

Understanding Nikon Capture NX 2

U nderstanding how Nikon Capture NX 2 fits into your digital workflow is essential to having a good experience with the program. It is an amazing piece of software, but it's also limited in its scope. You can complete most important image-editing tasks in Capture NX 2, but you also need to understand when and where to take your images to other software packages.

This chapter is all about understanding how Capture NX 2 works with NEFs, JPEGs, and TIFFs. I'll cover traditional workflow in Capture NX 2, capture formats, output formats, and advantages to working with NEFs in Capture NX 2.

Overview of Workflow in Capture NX 2

Many people want to know where Capture NX 2 fits into their workflow. If you use other software packages such as Adobe Lightroom, Adobe Photoshop, or Apple Aperture, it can be hard to figure out whether you should start working with your images in Capture NX 2 or end with Capture NX 2. In order to figure out where to use the program, it's important to understand what Capture NX 2 does and what it doesn't do.

Capture NX 2 has excellent tools to help you improve color, contrast, and saturation. Figure 1.1 is a great example of how the program can quickly take a lackluster image and produce a winning photo with minimal effort. The photo on the left was the original shot from a Nikon D300. The photo on the right is what the shot looks like after a few quick fixes in Capture NX 2 using a *curve* and a few color control points.

One of the areas where Capture NX 2 doesn't do well is advanced retouching for portraits, skin, and texture because the new Auto Retouch

see also

Color management is discussed in Chapter 3 and control points are discussed in Chapter 8.

Brush isn't as flexible as other tools that you might find in Photoshop. Also, Capture NX 2 doesn't have a way to copy parts of one image and paste them onto another image. For these types of image fixes, you really need to use another program, such as Photoshop. So, I use Capture NX 2 to improve the colors, saturation, and contrast, and then I use a program like Photoshop to finish off the image if there is more work to be done for retouching, cloning, and compositing. If I don't have to do any of this extra work, then I stay in Capture NX 2. If I do have extra work, then I start in Capture NX 2 and use the Open With command to open my photograph in Photoshop.

Figure 1.1

see also

The Open With command is discussed in Chapter 3.

Everyone has his or her own workflow, and trying to show a single workflow that fits everyone's style is an impossible challenge. However, there are some general guidelines that you can use to achieve better images.

In general, fix the big problems first and then work your way down to the small details. After managing their files, most photographers commonly start with the global fixes in order to make the overall image look good. Then, they move to the regional fixes to improve smaller areas independently. Next, they move to the pixel level for repairing dust or small discrepancies and then finally work to prepare the image for output. Table 1.1 breaks down the typical workflow for Capture NX 2.

see also

White Balance, Picture Controls, and Exposure Compensation are discussed in Chapter 4.

Global fixes

Global fixes are fixes that affect the entire image. This includes tools such as White Balance, Picture Controls, and Exposure Compensation, because they impact all areas of the image equally. Global fixes typically can't be applied to specific areas of the image.

Regional fixes

Regional fixes are applied to selected areas of your photograph, like the sky or a grassy field or a person's face. You use regional fixes when one part of the image is underexposed or the wrong color. The great thing about Capture NX 2 is that it excels at regional fixes by using the Color Control Points and the Selection Tools. In fact, the Color Control Points and the Selection Tools are the primary reasons why I use Capture NX 2 in my workflow. It is easy to make quick selections and selectively apply fixes to photographs. In other programs, it can sometimes take hours to successfully mask an area of a photograph. Now, with the new Nikon Capture NX 2 U-Point technology, you can almost simply click on the region you want to fix, and voila! Area fixed.

Table 1.1
General Workflow Approach

Step	Description	Tools
1	Manage Files	Browser, Keywords, Sorting, Filing, Filtering
2	Global Fixes	White Balance, Picture Control, Curves, Exposure Compensation, Highlight Protection, Black/Neutral/White Points, and so on
3	Regional Fixes	Color Control Points, New Steps, Selection Tools
4	Pixel Fixes	Auto Retouch Brush
5	Preparing for Output	Cropping, Sizing, Sharpening, Soft Proofing

Figure 1.2 demonstrates how easy it is to make a selection with a control point and modify the photo. In this case, I converted the image to black and white and then used a Selection Control Point to keep the leaves their original red color. It could take hours to do this using other software packages. In Capture NX 2, it's quick and easy.

note

The U-Point technology has completely changed my workflow. Being able to click a button and then have the software (seemingly magically) select exactly the thing I want to edit is a huge deal for a working photographer. It means that I can spend one minute on a task that used to take ten minutes in other programs. U-Point technology is discussed in Chapter 8.

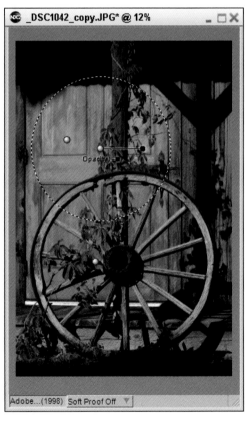

Figure 1.2

Pixel fixes

The next step in your workflow is to fix the small, pixel-level problem areas in your image. *Pixel fixes* are typically used for getting rid of dust in your image. However, there are many other reasons for doing pixel fixes, such as removing acne on a teenager's face, removing a power line from the corner of the image, removing a jet contrail from the sky, or getting rid of trash in your background. Figure 1.3 shows the before and after on an image in which a pixel fix was used to remove the price stickers on some pumpkins at a grocery store. The Auto Retouch Brush did a great job of removing the white stickers and repairing the pumpkin color and texture.

Previous to the release of Capture NX 2, prior versions of Nikon Capture were missing a healing tool or a repair tool. Wisely, Nikon created a new tool called the Auto Retouch Brush that helps solve some of our pixel-level problems.

see also

The Auto Retouch Brush is discussed in Chapter 8.

Preparing for output

Preparing for output is the final step in your workflow, and it requires the use of a number of actions such as cropping, resizing, sharpening, and soft-proofing. Figure 1.4 shows a resizing step in Capture NX 2 that makes the original photograph into a 4-x-6-inch photograph.

Now that Capture NX 2 has the Auto Retouch Brush, you can complete many pixel-level fixes inside NX 2 rather than having to go to Photoshop, which saves significant time. Also, because you're still in NX 2, you can output your document for print right from the program. I would guess that for about half of my images, it is possible to start and end in Capture NX 2. The other half of my photos need to be sent to Photoshop for further work.

see also

Preparing photos for output is discussed in Chapter 9.

Using the right file format can make all the difference with respect to your workflow. Capture NX 2 allows you to work with three file formats:

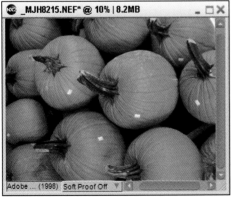

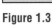
Figure 1.3

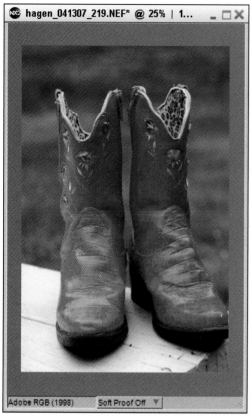
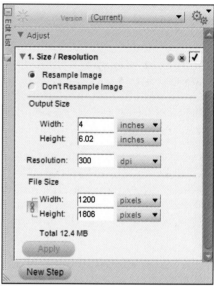

Figure 1.4

- **JPEG.** Joint Photographic Experts Group
- **NEF.** Nikon Electronic Format
- **TIFF.** Tagged Image File Format

There isn't a single file format that is always correct for every job. I lead a large number of workshops every year on digital photography, and at every workshop, I hear people state adamantly that you have to use RAW files in order to be a "real" photographer. I hear just as many other people adamantly defend their use of JPEG files.

The truth is that each file format has its strengths and weaknesses. I use just about all the file formats depending on my current needs for the

project I'm working on. NEF (RAW) files are great for when you need ultimate flexibility to modify, improve, or enlarge your images. JPEGs are great for moving fast and creating quick content like slide shows, 4-x-6 prints, Web galleries, and so on. TIFFs are the preferred output format for magazines, books, and large prints.

I encourage you to fully understand each file format and then use the right format for the job. The next section will help you come to a decision about which formats fit your own workflow.

Capture Formats

The general term for the file format that you use when you take a photograph in your camera is the capture format. Don't confuse the terminology here between Nikon Capture NX 2 and a capture format. Capture in this sense is referencing the format you use when you take the photograph.

All Nikon cameras, including point-and-shoots and dSLRs, have the ability to shoot JPEG images. Most Nikon dSLR cameras have at least two file formats, and some Nikon cameras have three. Nikon entry-level and midrange dSLRs like the D60 and the D200 generally give you the choice to capture your images in JPEG mode or NEF. Nikon professional dSLRs allow you to shoot in JPEG and NEF (RAW) mode, as well as in TIFF mode.

Each type of file format can also be configured in multiple ways. For example, a JPEG can be configured to use high-quality compression along with a high pixel count. A RAW (NEF) file can be 12-bit RAW or 14-bit RAW, and each type can be compressed or uncompressed.

Each file format can be chosen inside your camera; in fact, making this decision is probably one of the more important decisions you'll make in your camera. Figure 1.5 shows the typical file format choices in the Nikon D300 camera menu.

Deciding which file type to use can be just about as difficult as figuring out how to use a new software package. I'll give some good recommendations a little later. In the meantime, Table 1.2 breaks down each of the capture file formats available in Nikon cameras.

Table 1.2
Capture File Formats

File Format	Description
NEF Lossless Compressed	RAW file using a fully reversible compression. Reduces file size by 20% – 40%. Zero quality loss.
NEF Compressed	RAW file using a nonreversible compression. Reduces file size by approximately 50%. Miniscule quality loss.
NEF Uncompressed	RAW file using no compression. Largest size files and can take longer to write to memory card.
NEF 12-bit	RAW file recorded at 12 bits (that is, 4,096 levels per channel).
NEF 14-bit	RAW file recorded at 14 bits (that is, 16,348 levels per channel). Significantly increases the amount of color data recorded.
JPEG Optimal Quality	Compressed JPEG. 8 bits (256 levels per channel). Allows images to vary file size depending on each scene.
JPEG Size Priority Compressed	JPEG. 8 bits (256 levels per channel). Images are compressed so that each photo maintains the same file size.
TIFF	Uncompressed files at 8 bits (256 levels per channel). Download times are dramatically increased.

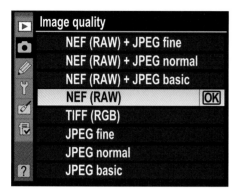

Figure 1.5

NEF files

NEF files are the most flexible of all the image capture formats. Most professional photographers who use Nikon cameras use NEF files because they know that NEF offers the greatest opportunity to create beautiful images after capturing them. The beauty of working with NEFs is that they are a file format that can be infinitely manipulated, but never damaged.

A good way to think of NEFs is to imagine a base image with a bunch of instructions applied to it. The base image would be the photograph (perhaps a mountain scene), and the instructions would be things such as white balance, color mode, tone compensation, and so on. The moment you take the NEF in the camera, the base image is fixed and cannot be altered in any way. However, the instructions can be modified to your pleasing as frequently as you want.

If you are working on an NEF in Capture NX 2, you can change:

- White balance
- Color mode or picture control
- Tone compensation
- Saturation
- Sharpening

- Hue adjustment
- Color moiré reduction
- Auto color aberration
- Active D-Lighting

You can modify these parameters as frequently as you want and never worry about damaging the original file. It is very easy in Capture NX 2 to revert to the original photograph by clicking the Version option and choosing the Original version. Figure 1.6 shows the menu that allows you to move between the currently selected version of the photo (indicated by the check) and the original version. If you save an NEF, then you haven't modified the base photo in any way; rather, you've only modified the instruction set.

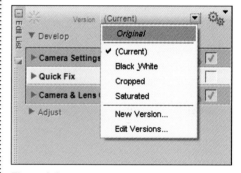

Figure 1.6

Compression

There are three capture parameters to consider with NEFs: compression, bit-depth, and resolution. The first choice you need to make when shooting in NEF (RAW) mode is to decide what compression mode you want to use. As Table 1.2 showed, Nikon provides up to three different compressions:

- **Uncompressed.** The Uncompressed RAW format provides the largest NEF file size while not losing any data due to compression. I know many professional

photographers who use the Uncompressed RAW format because it gives them 100% of the possible information from the camera. The downside of using this format is that the file sizes are much larger, which means they take up substantially more space on your memory cards and storage disks. Additionally, because the files are bigger, the read/write times to your memory card will be longer, which bogs down your camera when taking quick bursts of photographs.

- **Compressed.** Compressed RAW takes your NEF image and runs it through a compression routine that reduces the file size by about half of an Uncompressed RAW. For example, a Nikon D200 image shot as Uncompressed RAW would typically be about 16MB, while the same image shot as Compressed RAW would be approximately 8MB. The obvious advantages to shooting in Compressed RAW are that you can save many more images on your memory cards and that these images download faster. The disadvantage is that you lose a tiny, miniscule amount of quality. Everyone always asks me "how much?" and my answer is that I have never been able to detect any difference between Compressed and Uncompressed NEF files.

- **Lossless Compressed.** This is truly just as the title indicates: a smaller file size with zero quality loss. The compression algorithm is completely reversible, meaning that the file size decreases when you save it to your memory card, and then is fully uncom-pressed when you open it up again in software. The Lossless Compressed NEF option is only available on the newer high-end Nikon cameras, such as the D300, D3, and D700.

Figure 1.7 shows what these choices look like from the Nikon D300 camera menu. The big question is "which compression method should I use?" On my newer camera bodies (D300, D3, D700), I'm using the Lossless Compressed format, because it gives me the highest quality

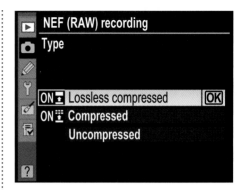

Figure 1.7

images while still reducing the file size. For my other cameras, like the D2X and D200, I'm using Compressed RAW, because I really can't tell the difference between it and Uncompressed RAW. For my entry level and mid-range Nikons, like the D40, D60, D70, D80, and D90, I just select "NEF," because there aren't any further compression options in the menu. The entry level and mid-range cameras are programmed to always record in Compressed RAW mode whenever you shoot in RAW.

note

I don't use Uncompressed NEF files as a capture format because I can't detect any noticeable difference in the quality between Compressed and Uncompressed NEF files. Compressed files are substantially smaller and easier to work with.

Bit-depth

The next choice you have to make when you shoot RAW is what bit-depth to use. Figure 1.8 shows the Bit Depth menu from a Nikon D700 camera.

- **12-bit images.** These record 4,096 levels per color channel. All Nikon cameras have three basic color channels; Red, Green, and Blue. We call the images we get from our

cameras RGB images. A 12-bit image means that there are 4,096 levels to define the red data, 4,096 levels to define the green data, and 4,096 levels to define the blue data. Multiply that out and you get 69 million different possibilities of color available to you. Three channels with 12-bits per channel give us a 36-bit image.

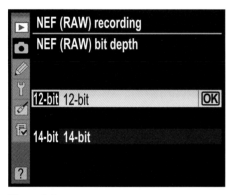

Figure 1.8

- **14-bit images.** These files, on the other hand, record 16,384 levels per channel. Because we have three color channels in

our cameras (Red, Green, Blue), we call an image in this format a 42-bit image. Using the same math as above, a 14-bit image will give you billions and billions of different color possibilities. Yikes! Even though you can capture 42 bits of color, the truth is that there aren't many devices out there that can actually show you all this data. Fourteen bits of data is simply overkill for just about everything we do in this day and age. In fact, most printers out there can't use the higher bit-depth data and actually send data to the printer in 12-bit or 8-bit modes. The advantage right now for 14-bit is during the editing process when you need to pull more detail out of the shadow regions of your image. Table 1.3 shows a quick breakdown of Nikon cameras and what bit-depth they support.

note

It won't be long before we have the ability to use all 14 bits of data in our prints. Therefore, I choose to shoot in 14-bit mode if my camera supports it in the hopes that one day we'll be able to use all the information.

Table 1.3
Nikon Cameras and Bit Depth

Nikon Camera Model	Supported Bit Depth for NEFs
D40/D40x	12-bit
D60	12-bit
D70	12-bit
D80	12-bit
D2X/D2H	12-bit
D200	12-bit
D300	12-bit, 14-bit
D700	12-bit, 14-bit
D3	12-bit, 14-bit

Another piece in the bit-depth puzzle is understanding how Capture NX 2 handles the higher bit-depth files. Capture NX 2 works in a 16-bit operating environment, which means that it converts your 12-bit or 14-bit RAW file to 16-bit mode while you are working on it. This is the same as other high-end image-editing programs like Photoshop CS3 or Apple Aperture. On the other hand, if you open a JPEG in Capture NX 2, then it only works in an 8-bit editing environment.

In the real world, working in a higher bit-depth environment means that you have a little extra room to tweak your images without having the image fall apart. For example, if you are making a Levels change to your image and move your control sliders to the extremes, you will notice that an 8-bit image might start to appear grainy or noisy. If you do the same thing with a 14-bit image, then you can go to greater extremes before the image begins to degrade.

Figure 1.9 shows the advantages of working in higher bit modes. Look at the difference in the shadows. The top photograph is the as-shot image taken at Montana de Oro State Park in California at sunset. The bottom photograph shows the same photo brightened up in Capture NX 2 with a Levels adjustment painted in with the Selection Brush. Look at all the detail that exists in the shadows that you might otherwise consider to be gone if you had shot in JPEG mode. Because you have 12 bits or 14 bits of data to start with, the gaps between levels are much smaller, and it is much easier to brighten up a dark image without severe degradation.

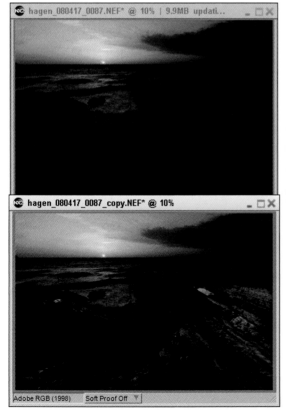

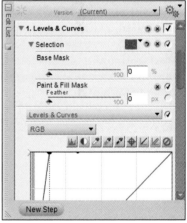

Figure 1.9

Resolution

The last item I'll mention about NEF images here is that they are always captured at the camera's native resolution. So, if you have a Nikon D300, then all the NEF images will have a resolution of 12 megapixels. Unlike a JPEG, there isn't any way to directly modify how many pixels you use in your NEF files.

JPEGs

All JPEGs are created as 8-bit files in the camera, and you don't have any option to change that. Additionally, JPEGs are opened in Capture NX 2 in an 8-bit working environment. An 8-bit image has 256 levels per channel, which means that it can produce a total of 16.7 million colors. I've made many side by side comparisons between JPEGs and NEFs, and it is sometimes difficult to distinguish a difference between the final prints. This assumes, of course, that you have done an excellent job of exposing for the JPEG.

The upside to using JPEGs is that they are very small files and therefore are quick to open, save, and send over the Internet. The downside is that they are far more limited for what you can do in post-processing. Because there is substantially less data in a JPEG, the image starts to break down if you want to perform big changes to brightness or saturation. However, if you nailed your exposure in the camera, then a JPEG can be one of the best and fastest file formats to use.

With a well exposed JPEG, you can snap the photograph, download to your computer, and then print. Workflow with JPEGs can be exceedingly fast and refreshing. In fact, I use JPEGs all the time in my professional portrait work and I get fantastic prints from them. The key is that you have to be close to perfect with your exposure and your white balance. If you make any major mistakes, you'll quickly be wishing that you had taken the photographs in NEF format!

Compression

There are two types of JPEG compression methods that you can use:

- **Optimal quality**
- **Size priority**

Figure 1.10 shows what this selection looks like on a Nikon D700. Size priority makes all your JPEGs the same size. It naturally follows that the Size priority setting will use a more aggressive compression (that is, lower quality) for more complicated photographs and less aggressive (higher quality) compression for simple photographs. For example, say you are taking two photos: one of a sandy beach and another of a city skyline. The sandy beach photograph is fairly simple without much detail, while the city skyline is complicated with many colors, shapes, and textures. Size priority forces both photographs to be the same size and applies more compression to the city skyline. The city skyline photograph would be slightly lower quality than the sandy beach photograph.

Figure 1.10

The Optimal quality setting allows each of your photographs to be as big or as small as necessary, regardless of how much detail is in the photograph. In the sandy beach and city

skyline examples, both images use the same high-quality compression. I use Optimal quality JPEG compression because it allows the files to be as big or small as necessary to achieve the highest quality.

The next choice you need to make in your camera when you shoot JPEGs is the Compression Ratio. This is different from the compression method just described. There are typically three compression ratios—fine, normal, and basic—and they all have to do with how small the camera makes the final image files.

Table 1.4 shows each of the JPEG compression modes and the subsequent compression levels. The compression ratios are based on an uncompressed NEF file. If your uncompressed NEF is 10MB, then a JPEG fine reduces the size to approximately 2.5MB. This is a 1:4 (1-to-4) compression ratio. A 1:8 compression ratio

(JPEG normal) gives you a 1.25MB image. The highest quality JPEG image results from the fine compression setting. This also results in the largest JPEG file size.

Image file sizes

The final part of JPEG setup is determining how many pixels you want to use. If you have a camera like a Nikon D60, then that camera will shoot a maximum of 10MP (*megapixels*). Your Nikon camera gives you the option of shooting 10MP, 5MP, or 2.5MP images. Nikon calls these Large, Medium, and Small image sizes. Table 1.5 summarizes image size.

The best combination for JPEG shooters is to use JPEG+Fine+Large with Optimal quality compression. This gives you the highest quality JPEG and shoots with the most pixels.

Table 1.4
JPEG Compressions

Compression Level	Ratio
JPEG fine	1:4 compression
JPEG normal	1:8 compression
JPEG basic	1:16 compression

Table 1.5
JPEG Image File Sizes

Name	Description
Large	Uses all your camera's pixels (10MP for a Nikon D60)
Medium	Uses half your camera's pixels (5MP for a Nikon D60)
Small	Uses one quarter of your camera's pixels (2.5MP for a Nikon D60)

NEF + JPEG

Most Nikon dSLRs allow you to capture RAW and JPEG files together (Figure 1.11). This option is useful when you want quick access to JPEGs for making prints at the drug store or when you want to send them via e-mail to your grandmother. This also allows you to access the RAW files when you want to work up a masterpiece print for wall art.

Figure 1.11

The downside to shooting images in NEF + JPEG simultaneously is that you now have to manage two files for every photograph you own. Also, this method takes up a lot of space on your memory card.

see also

The Nikon Capture NX2 browser has a method for managing two files, which is covered in Chapter 2.

TIFF

The last capture format you can select in your camera is TIFF (Figure 1.12). There are just a few high-end Nikon cameras (such as the D2X, D3,

and D700) that allow you to choose TIFF as an Image quality option. Lower-end Nikon cameras such as the D60 or D90 don't offer this option. TIFF images are very hard to work with as a capture format because of their large size and slow transfer rates.

Figure 1.12

Depending on your memory card speed, TIFFs can take an inordinate amount of time to download from your camera to your CF card. In fact, if you take a burst of images in TIFF mode and your camera's internal memory buffer fills up, then it can sometimes take up to 10 minutes for the buffer to completely empty.

For these reasons, I don't recommend shooting in TIFF mode in your camera. Stick with NEF or JPEG depending on your needs. In the Output Formats section, I talk about TIFFs as a great output format, but I encourage you to stay away from them as a camera capture format. Table 1.6 summarizes my recommendations for file formats.

caution

TIFFs captured in your camera are only 8-bit files. This means that they don't capture all the bit depth that your camera is capable of capturing.

..

Table 1.6
Capture File Format Recommendations

Photographic Subject	File Format Suggestion	Why?
Family vacation	JPEG+Fine+Large	Simple to use; quick to print.
Stock photography	NEF	Highest quality for customers and clients.
Nature/landscape	NEF	Highest quality for prints and artwork.
Sports (youth, college)	JPEG+Fine+Large	Simple to use; quick to print; easy to sell to parents and newspapers.
Portraiture	NEF or JPEG	JPEG if you are doing high-volume portraits; NEF if you have time available to work on each image.
Weddings	JPEG+Fine+Large	Allows you to do your post-processing very quickly. Shoot NEF if you aren't very consistent with exposures and white balance.
Fine art	NEF	Highest quality for artwork.

..

Output Formats

One of the neat features of Capture NX 2 is that you can start with your photo in any one of the three supported formats (JPEG, NEF, TIFF) and then resave it into any other of those three formats. For example, you can start with a JPEG and then save the file to a TIFF or an NEF. The big advantage here is that if you make a bunch of improvements to a JPEG in Capture NX 2 and want to come back to modify them in the future, you can save that JPEG as an NEF and come back to it at any time while still having access to all the new steps you created.

The general workflow for saving images in Capture NX 2 is to choose File→Save As.

The following sections will help you understand what happens in the background of each of the output formats.

tip

An alternative to using the menus to select the Save As command is to use the keyboard shortcut Ctrl+Shift+S (⌘+Shift+S).

JPEG

Saving any file to a JPEG will automatically down sample it to 8-bit mode. Thus, if you start with a 16-bit NEF/TIFF and save it to a JPEG, you will lose a significant amount of color information. As mentioned in the previous sections, JPEGs are lossy files in the sense that you lose information when they are compressed to a smaller size. However, I don't want to scare you away from using the JPEG file format. It is very common to work on an image as an NEF and then save it to a JPEG for printing at the pro lab or the corner drug store.

Saving

Note that if you make a number of adjustments and edits to an NEF and then save it as a JPEG, you will then lose the ability to come back and modify those edits in the future. Saving your image to a JPEG flattens all your adjustments onto the image. Saving as a JPEG should be done at the very end of your process and should only be done once in that image's life. In other words, you don't want to keep resaving a JPEG on top of itself because each time you do so, the JPEG is recompressed and you lose image data. My workflow is to make all my adjustments on a JPEG in one session, and then save it once as a new JPEG file at the end of the process.

After you choose File ➡ Save As, you need to type a new name for your file. The next step is to set your options for the Save Options Dialog shown in Figure 1.13. The goal here is to set the quality of your JPEG based on the intended use for your photograph. If you are going to print your photograph, then click the Quality drop-down list and choose Excellent Quality. If you are posting the image to the Internet, you can use a lower quality setting, such as Good Balance.

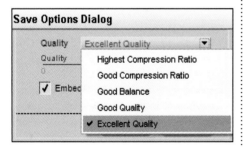

Figure 1.13

Quality settings

There are three ways to adjust your JPEG quality settings:

- **Click the drop-down menu in the Save Options Dialog box.**

- **Click and drag the Quality slider to your desired value**. Zero percent is the lowest quality setting, and 100 percent is the highest. Unfortunately, there isn't any way to determine how big your file will be when you set the Quality slider, as in other programs.

- **Type the quality percentage in the text box**.

Here's a list of the JPEG quality settings and when to use them:

- **Highest Compression Ratio.** Use when sending low-quality images as e-mail attachments

- **Good Compression Ratio.** Use when posting your images to the Web

- **Good Balance.** Use when posting images to the Web

- **Good Quality.** Use when printing images around 4 inches x 6 inches or 5 inches x 7 inches

- **Excellent Quality.** Use when printing large images for reproduction in other print media (magazines)

The last JPEG Save As option is Embed ICC profile. Select this option if you have a color-managed workflow. Selecting this option embeds your current color space into the metadata of the photograph. If you are working in Adobe RGB (1998) and select this option, then the Adobe RGB (1998) color profile will be embedded into the image.

see also

Color profiles and setting up system preferences are discussed in Chapters 9 and 10.

It is important that you understand what will happen if you choose the wrong profile. For example, if you are printing your photographs at the laboratory, then you want to make sure that your image is imbedded with the sRGB profile. Imbedding it with Adobe RGB or Pro Photo RGB will mean significant color shifts from the lab.

note

I've made some very big prints from JPEG files and can personally vouch for their capability as an effective output format. Don't let all the naysayers scare you away from JPEG. It is a great file format.

I convert all my files to JPEGs when I send my prints to a commercial laboratory like MPix (www.mpix.com) or Costco (www.costco.com) for printing. A typical JPEG is 5MB to 7MB and is much easier to send over the Internet than a 60MB TIFF.

NEF

As mentioned earlier, starting with an NEF is generally considered the best way to begin your digital workflow. Using Capture NX 2, you can start with an NEF created from your Nikon dSLR camera and then save it as an NEF after you finish working on it. This has the advantage of preserving all your steps and adjustments so that you can return to the original image at a future date.

Printing

If you do all your printing from Capture NX 2 (rather than sending your files to another program like Photoshop), there really isn't any reason to save your images as anything else. In other words, start with your photo as an NEF from the camera, edit it in Capture NX 2 as an NEF, print it from Capture NX 2 as an NEF, and then save it when you are finished as an NEF. This workflow preserves the quality of the photo, as well as all your editing steps.

If you print from another program, such as Photoshop, or if you output at a commercial printing lab, then you'll want to save your images as TIFFs or JPEGs.

Editing

A neat feature of Capture NX 2 is that if you open a TIFF or a JPEG in the program, you can save it as an NEF. It is important to note, however, that this new NEF can't be edited in other software such as Adobe Camera RAW, Lightroom, or Apple Aperture. The reason is that this new NEF is a Capture NX 2 NEF and is different from an NEF you created in your camera. The NEF you create from a JPEG is written in a format that only Capture NX 2 can translate.

This may seem like an oversight by Nikon, but this approach to image editing is the same if you start with other programs like Lightroom. For example, if you make changes to your image in Lightroom, such as curves, black-and-white conversion, and so on, then those changes are only visible in Lightroom—not in Capture NX 2.

The way to get around this limitation is to save your image as a TIFF or a JPEG after you finish the editing steps. Then you can open that JPEG/TIFF file in Photoshop, Lightroom, or Aperture to work on it some more.

Saving

One final thing about NEFs: When you start with an NEF from your camera, then make some changes in Capture NX 2 and save it as an NEF, there are no options available to you from the Save dialog box. This is because all the changes you make to an NEF are always reversible. By its very nature, NEFs are designed in such a way that all your edits are nondestructive, so don't be afraid of saving your work over the top of the existing file. You can always get back to the original image.

TIFF

Earlier in the chapter I stated that you shouldn't use TIFFs as a capture format because they are slow and hard to use in the camera. That recommendation doesn't apply to using TIFFs as an output format. In fact, TIFFs are a great output format because they are completely lossless when you save them.

I use TIFFs in my workflow when I am finished working on an image in Capture NX 2 and I want to bring it into Photoshop to do some additional work. In this scenario, I export the image as a 16-bit TIFF to retain all the color and contrast data so that Photoshop has the most information to work with.

Saving

To save an image as a TIFF, follow these steps:

1 **Choose File ➜ Save As. The Save Options Dialog box appears.**

2 **Choose TIFF from the Save as type drop-down menu.**

3 **Name the file and click OK.**

4 **Now you can make your other selections for the Save Options dialog box.**

The first choice you make in the Save Options Dialog box is whether to save the document as an RGB or CMYK file. Almost everything photographers do revolves around RGB files, so you should generally select the RGB option. Choose CMYK if you are printing your images on a commercial printing press.

The next choice is to select either 8 bit or 16 bit. If you are exporting to another program to do more work on the image, then I highly recommend saving the file as a 16-bit image. If you are sending the TIFF to a lab to print, then an 8-bit image may be required in order to keep the file size smaller. Be sure to check with the lab before you send the file so that you know what format they require.

Compressing

Next, choose what compression to apply to your TIFF. Selecting None means that you will save an uncompressed TIFF that will be very big. It could be up to 60MB or more! Most of the time, I recommend selecting LZW compression in order to reduce the file size. LZW is a lossless compression scheme that is supported by most software packages on the market today. You can feel secure in knowing that if you save your TIFF in LZW compression, you'll be able to open it in most other professional image editors. Finally, choose whether to embed the ICC profile, and then save your changes.

Advantages of Working with NEFs in Capture NX 2

If you haven't figured it out by now, working with NEFs is probably the best way to maximize your workflow options. All changes you make to an NEF are reversible in the sense that you can always get back to the original image. Additionally, you can save different versions of the image and can quickly get back to them with a click of the mouse. Editing NEFs is nondestructive and is truly the professional way to work on your files.

Nondestructive editing simply means that all your edits do not change the basic properties of the original image. For instance, if you perform a black-and-white conversion on an image and then save it as a JPEG or a TIFF, you actually lose the color data for the photograph. If you do the same thing on an NEF, the black-and-white image is only a version of the original NEF file. You can easily get back to the color image by reverting to the original file.

Another advantage to working with NEFs is that you can save multiple versions of the same image and not substantially increase the file size. For example, you can save the original version of a photo, a version with enhanced color saturation, a black-and-white version, and a sepia-toned version to a single NEF file. All these versions can be toggled on or off with the click of your mouse. The size increase to the NEF is very small in comparison to saving four additional JPEGs or TIFFs as independent photographs.

see also

Curves and saturation are discussed in Chapter 5.

tip

Another neat thing about Capture NX 2 is that you can start with a JPEG, make some changes to the image in the form of New Steps, and then save the image as an NEF. The changes you make to these NEFs are only visible in Capture NX 2, but the advantage is that now all your JPEG files can be edited in a non-destructive workflow. That's a major shift from a traditional JPEG workflow. New Steps are discussed in Chapter 6.

For all the advantages of working with NEFs, there are also some disadvantages. The biggest is the lack of cross-compatibility with other programs. If you make changes to your image in Capture NX 2 and resave the file as an NEF, those changes are typically only visible in Capture NX 2.

For example, if you convert an NEF to black and white and then save the image, you cannot see the black-and-white conversion in a program like

Adobe Lightroom or Apple Aperture. Figure 1.14 shows this discrepancy. The left side of the figure shows the black-and-white version in Capture NX 2, while the right side of the figure shows the image as it looks in Adobe Lightroom.

The reason for this discrepancy is that the changes you make in Capture NX 2 are stored inside the NEF as instructions. Adobe Lightroom can only see the RAW data that was captured in the camera, such as white balance and exposure information. Also, if you make a bunch of changes to your NEF in Adobe Lightroom, then those

changes are not visible in Capture NX 2. Lightroom uses its own protocols for nondestructive editing that other programs cannot access.

So the big question is: How do you make your changes visible between programs? The answer is that you have to output a JPEG or a TIFF from Capture NX 2 so that the changes are applied to the image. The Photoshop term for this process is flattening. In other words, you flatten all your layers so that all the enhancements are applied to the image. In Capture NX 2, you either choose File → Open With or you simply save your photograph as a JPEG or a TIFF.

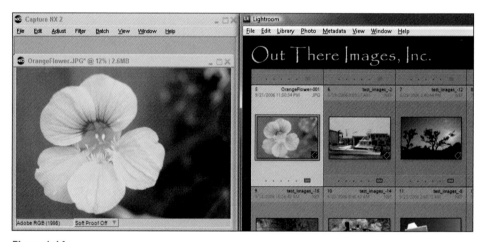

Figure 1.14

2

Working With the Interface

A lot of thought went into improving the new Capture NX 2 user interface. The most important aspect of the new program is the ability to use multiple monitors in your workflow. Add to that the ability to use keywords and labels that are compatible with other photo programs and you have a winning software combination!

This chapter discusses how to set up the interface to effectively process images and to help make your workflow more efficient. I go through each of the main elements of the software, including the folders pane, Browser, metadata pane, and Bird's Eye pane. I finish up the chapter by showing how to configure Capture NX 2 for multiple monitors.

Work Environment

The Capture NX 2 work environment is organized from left to right to provide a logical workflow (Figure 2.1). The left side of the window includes three sections, called the folders pane, Browser and metadata pane. These three areas are where you will find, organize, keyword, and open your images.

The very top of the window is where your menu lists are located. These include menus such as File, Edit, Adjust, Filter, Batch, View, Window, and Help. As with other software packages, most functions in the program can be found in the menus.

Just below the menu lists are two toolbars with a variety of buttons. The toolbar on the left side is called the Activity toolbar, and it includes the Workspace button, Nikon Transfer button, and Print button. The toolbar on the right is called, simply, the Toolbar. This has 17 buttons that let you access tools such as zoom, rotate, crop, Control Points, the Auto Retouch Brush, and the Selection tools.

On the right side of the screen are the Bird's Eye, Edit List, and Photo Info palettes. You'll use the Bird's Eye to assist you in zooming in and out in your image. The Edit List is where your image adjustments will be made. The Photo Info palette is used for viewing histogram and tonality data for your image.

Folders Pane

The tasks of organizing, finding, and categorizing your photos can be huge. In fact, these tasks are often the most daunting part of shooting in digital. This process is called Digital Asset Management (DAM). Nikon knows that DAM is a big issue for photographers, so it has endeavored to make the Capture NX 2 interface much more friendly for finding and organizing your files.

Opening the folders pane and folders

The first step in using Capture NX 2 is understanding how to use the folders pane. To open the folders pane, click the little plus (+) symbol next to the word "Folders" (see Figure 2.1) in the top-left corner of your computer monitor. This opens a pane that displays a file structure that mirrors the files on your hard drive. At any time, you can also close the folders

pane (dock it) by clicking on the minus (−) symbol. Note that when you open a photograph, the folders pane automatically closes back to its smaller docked size.

You can also open folders by choosing File → Open Folder in Browser. When you use this method, a new dialog box appears that allows you to choose the folder you want to open. Once you select the folder you want to open, click OK, and the appropriate folder opens in the folders and Browser panes.

Your folders pane also shows any hard drive or additional storage that is currently attached to your computer system. For example, you can see a thumb drive, CD-ROM, or USB drive in addition to your computer's hard drive. If you have storage that isn't connected and turned on, then you won't be able to see the photos on that drive. The folders and Browser panes can display

Folders pane,
Browser, and
metadata pane Menus Toolbar Bird's Eye

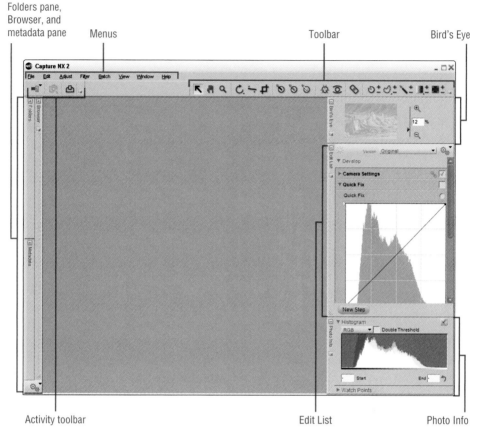

Activity toolbar Edit List Photo Info

Figure 2.1

photos only when they are pointed at a storage device that is attached and running on your system. This is in contrast with a cataloging program like Adobe Lightroom, which creates a database for your images and allows you to see them even if your hard drive isn't attached.

The folders pane is separated into two discreet sections. The main lower part is the Folders section, and the smaller top part is the Favorite Folders window. I will explain the lower folders window first.

Folders window

The Folders window shows the same file structure that you currently have on your computer (Figure 2.2). If you store your photographs on an external hard drive, then they display as a separate drive.

There are two ways to open folders. The first is by single clicking on the plus (+) symbol next to the folder or drive name (Figure 2.3). On the Mac, you'll click on triangle symbols to open the

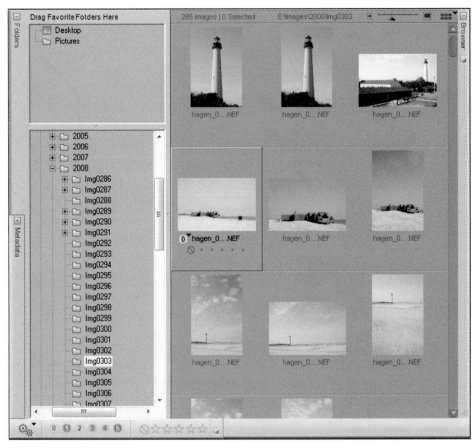

Figure 2.2

folder. The second is to double-click on the name of the folder itself. These actions open the folder tree so you can see all the nested subfolders below.

To see the photographs in a folder, click the folder name. The Browser pane displays the photographs that are stored in the folder you just clicked. Figure 2.4 shows the photographs that are stored in folder Img0296. To look at photos in a different folder, click another folder name.

see also

For additional information on file types, see Chapter 3.

Figure 2.3

If you have a folder that contains images that Nikon Capture NX 2 can't display, then that folder might appear empty. For example, I frequently shoot with a Canon camera that produces Canon RAW files called CR2 files. I can't see those images in the Capture NX 2 folder, even though they are present on the external hard drive.

Favorite Folders window

The second part of the folders pane is the Favorite Folders window (Figure 2.5). The purpose of this area is to give you a place to put your most frequently used folders so you don't have to keep searching for them in your directory tree. To add a folder to this area, simply drag it from the folder tree below and drop it into the Favorites area. This doesn't actually move your folder from the hard drive; rather, it creates a shortcut you can quickly access.

You can delete these shortcuts at any time by clicking the folder in the Favorites area and then pressing Delete on your computer keyboard. Or, you can right-click (Option-click) on the folder and choose the Delete option from the menu that appears. Again, deleting the folder from this window doesn't actually remove it from your disk drive. It only removes the shortcut.

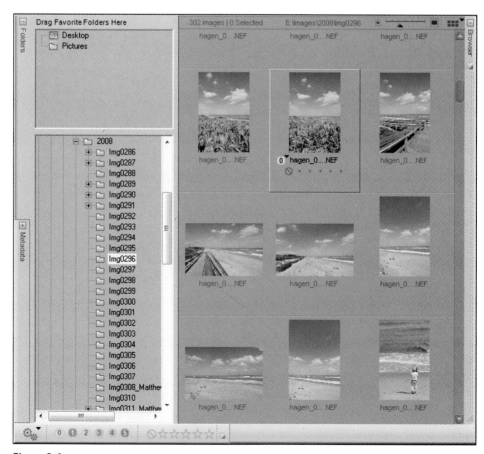

Figure 2.4

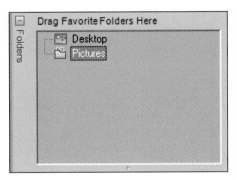

Figure 2.5

I like to use the Favorite Folders window as a temporary holding area for the current project I'm working on. For example, if I have just completed a wedding and I'm processing the images, then I place the folder into my Favorite Folders window. When I finish with my editing and processing from the event, I remove the folder from the Favorites area. This saves me the time of having to navigate through the entire file tree whenever I want to access those photos.

You can place as many folders as you want in the Favorite Folders window. I encourage you to keep the window lightly populated so that you can quickly find your most important images. If you put too many favorites into the window, then it quickly becomes cluttered and you won't be able to find what you are looking for.

Navigating your work space

One of the neat things about Capture NX 2 is that you can customize your working environment and then save it. For instance, try moving the separation bar between the Favorite Folders window and the Folders window. You can create more working space if you need it in either window. Neat!

Above the folders pane are three buttons that can help you navigate through your folder structure (Figure 2.6). These buttons are a left arrow (Previous Folder), a right arrow (Next Folder), and a folder button with an up arrow (Up Folder). Here are the descriptions of each button:

- **Previous Folder button.** Use this to navigate to the last folder that you opened.

- **Next Folder button.** Use this to go back to the original folder you were using.

- **Up Folder button.** Use this to go up one level in your folder directory.

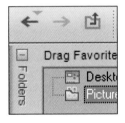

Figure 2.6

Browser Pane

Nikon has greatly improved the browser functions of Capture NX 2 over previous versions of the software. One of the best things about the new browser is that *star ratings* and *tags* are compatible with other professional software programs like Adobe Bridge and Expression Media. Star ratings enable you to provide ratings for your images. Generally speaking, you would apply more stars to higher quality photos. The word "tags" is a generic term that we use to define things like keywords or text assigned to a photograph.

In past versions of Nikon Capture, the star ratings and tags you added to your images were visible only in Capture. Now, with Capture NX 2, you

have great compatibility between programs. Capture NX 2 also sees the star ratings and tags that are generated from other programs. I discuss the details of the ratings later in the chapter.

Figure 2.7

Opening the Browser and photos

To open the Browser, simply click on the + symbol above the word "Browser." To change the size of the Browser, click on the crosshatched (or textured) area on the lower right of the pane.

There are several ways to open photographs in the Browser. The first is to double-click on the photograph. The second is to click and drag your photograph from the Browser into the editing window of Capture NX 2. Note that this method only works on a PC, not on a Mac. I like to open my photographs this way because sometimes I double-click too slowly. I wait for something to happen, and after a few seconds, I double-click again and wonder whether the first double-click worked. I find it easier to just drag the photo from the Browser into the editing area. It's the little things that count, right?

A third way to open your photo is to right-click on the image and then choose Open Image in Editor. The final way to open photos is by choosing File ➙ Open Image.

Moving the Browser

You might want to move the Browser if you like it in a different area of your screen or if you want to move it to a second monitor hooked up to your computer. To detach the Browser pane from the side of the window, click on the triangle below the word "Browser" (Figure 2.7). Then you can move the Browser around by clicking your mouse on the vertical portion of the right-hand bar.

Managing thumbnails

With all the new improvements to Capture NX 2, I can honestly say that working with thumbnails is now a strong point of the program and not a sore point. One of the first skills to learn when using the Browser is how to change the thumbnail size. Look at Figure 2.8 to see that you can make your thumbnails very small or very large. You'll generally use the smaller thumbnails when you want to quickly find an image in a folder. After you locate the image, you can increase the size of the thumbnails to get a larger preview of the image.

There are a number of ways to change the thumbnail size. The first is to simply use the thumbnail slider control shown in Figure 2.9. Drag the little triangle to the right to increase the thumbnail size, and drag the triangle to the left to decrease the size.

The second way to change thumbnail size is to click on the thumbnail buttons to the left and right of the slider. Click on the big button (Figure 2.9) to increase the thumbnail size. Click on the small button to decrease the thumbnail size.

The third method for changing thumbnail size is to use the keyboard. Press Ctrl + + (⌘ + +) with your keyboard to increase the size or Ctrl + − (⌘ + −)

Figure 2.8

Figure 2.9

to decrease the size. The nice thing about Capture NX 2 is that it shares many shortcuts with other popular imaging programs such as Photoshop. If you already have keyboard shortcuts memorized from other software, try them out in Capture and you'll be pleasantly surprised!

see also

All the keyboard shortcuts used in Nikon Capture NX 2 are listed in Appendix A at the end of the book.

Renaming images

Now that you're an expert at resizing thumbnails, it's time to learn how to rename your images in the Browser. Renaming images should be done

very early in your workflow, because the name that your camera creates for your images doesn't really mean anything in particular. Many photographers like to keep the original file name as their final name. The problem with this approach is that after a while, your file names start to repeat themselves.

The name your camera assigns your images is generally similar to DSC_1234.NEF. After you get to DSC_9999.NEF, your camera's counter rolls over to DSC_0001.NEF. It doesn't take long for most photographers to start duplicating file names, and that means organizational trouble for your photo archives. Therefore, each of your photographs should have its own unique file name.

Naming your image files is always a personal decision. There are just as many ways to name your files as there are photographers, so I'll explain my method and leave it at that. The file name I use for all my images looks like this:

hagen_081117_0001.JPG

The first part is my last name. The second part is the download date, starting with the year, then month and then day. The third part is the sequential number, beginning with 0001 for the first photo of the day.

Renaming your photos can be done one at a time or through a batch process. The slowest way to rename your photographs is to click on each file and type the text for the new name. This approach is fine for one or two images, but it is a terrible way to rename hundreds of photos at once because it takes so long.

The best way to rename your images is to use the Batch Rename process. To start the process, select all the images you want to rename. The fastest way to select an entire folder of images is to use the Select All keyboard shortcut, Ctrl+A (⌘+A).

There are two methods you can use to activate the batch renaming feature in Capture NX 2. The first is by choosing Edit→ Rename. The second is to press F2 on your keyboard. Both methods open the File Naming dialog box.

see also

Batch processing is discussed in detail in Chapter 10.

The left side of the dialog box is the Prefix section. This is where you type a new name that overwrites your old file name. In this example (Figure 2.10), I type hagen_081013 as my new name. The Sample area at the top of the window displays the new name to make sure that you aren't making any mistakes. If you choose Original name, that will keep the original file name as the prefix of the renaming sequence. If you choose None, then the prefix portion of the file name will be left out.

The next section of the File Naming dialog box is the Underscore drop-down menu. You should generally place underscores or dashes between elements of your new name, because spaces in your name can sometimes cause truncation or parts of your file name to be lost when uploading your images to the Internet. If you want, you can also choose Hyphen, Space, or None from this menu (Figure 2.10).

The third section is the Sequential Number drop-down menu. I like to add a sequential number as a unique identifier for my photographs. Other people like to use the Date Shot or the Date/Time Shot as their identifier. All options are fine. Choose the method that works best for you (Figure 2.11).

The fourth section of the File Naming dialog box is another drop-down menu for another underscore or hyphen selection.

You also have the option for a suffix. I typically don't use this area because my naming convention requires the use of only the first three areas (Prefix,

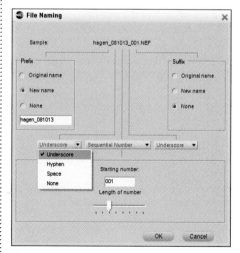

Figure 2.10

RENAME -
DOWN LOAD DATE - 001

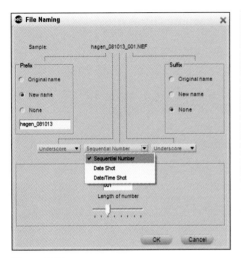

Figure 2.11

Browser views

There are other views available in the Browser pane. Just to the right of the thumbnail size slider is the browser view selector drop-down menu (Figure 2.12). This lets you pick between the two available browser views in Capture NX 2: the Thumbnail Grid and the Thumbnail List.

Figure 2.12

The Thumbnail Grid view is the default view for the program. You'll probably use this view for most of your work in Capture NX 2 because it's the easiest way to visually find your images.

Underscore, Sequential Number). Therefore, I keep the None option selected. However, feel free to add a suffix if you need it. Some people choose to add another name or number code that fits their own naming convention.

At the bottom of the File Naming dialog box is a section for your sequential number. Most of the time you'll start the numbering from 1, but you can start with any number you need by simply typing the value in the Starting number box. You can also choose how many digits you need for placeholders by moving the Length of number slider. For example, if you have 245 images to rename, then you need at least three placeholders for a naming convention.

After the new naming convention is entered, click OK and let Capture NX 2 rename all your photographs. It's important to note that this process is permanent. If you mistakenly rename an entire folder with the incorrect name, there is no way to undo your work. Thus, be careful and deliberate when you use the batch renaming utility.

The Thumbnail List view (Figure 2.13) shows how this list is organized by name, rating, date, size, type, and so on. I like to use this view to quickly sort my images by the critical data. For example, if I want to find the oldest photo in a folder, I simply click on the Date Shot column header to sort all the photos in chronological order. If you click the column header a second time, it sorts all your photos in reverse order.

Notice also that you can change the width of the columns to your own liking. For example, you might do this when you need to read the entire name of your photo or when you want to make the columns fit your screen. Place your mouse between the two column headers until you see a vertical bar displayed. Click and drag to make the column smaller or bigger.

The last thing I want to say about the Thumbnail List view is that there is a column on the end called Extras (Figure 2.14). This column can't be

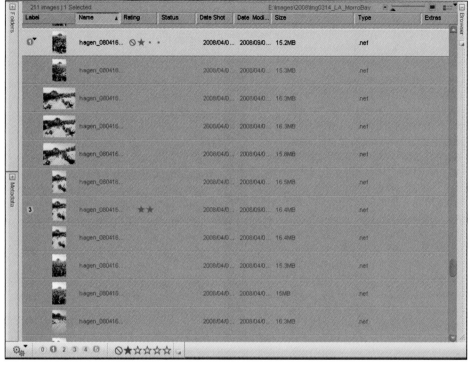

Figure 2.13

Figure 2.14

used to sort your images. Rather, it is there to show you more information about your images. For example, a small "i" symbol appears if your image has XMP data, and the High Speed Crop icon is displayed if you took that image in your camera's Hi-Speed crop mode.

Okay, switch back to the Thumbnail Grid view and set the thumbnail size to medium so you can see the small buttons underneath each thumbnail. If you hover your mouse over a thumbnail, you'll notice that a variety of symbols appear to help you better organize, find, and sort your images. Figure 2.15 shows each of the possible buttons and what they are called.

Label icon

The Label icon is used for applying a color label or a numerical label to each photograph. Many times photographers use a color label to help with the sorting of images. For example, you might use green to indicate a "customer select" and red to indicate a "keeper." Everyone has his or her own method and approach, so it is nice that Capture NX 2 gives you the option to use just about any combination of colors and numbers you want. In the next section, I cover all the details associated with using color labels in your workflow and creating different label lists. To change the label value that you apply to the photograph, simply click on the Label button and choose a different value, as shown in Figure 2.16.

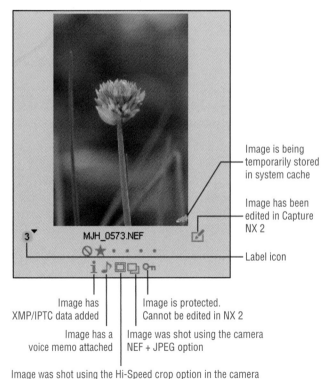

Image is being temporarily stored in system cache

Image has been edited in Capture NX 2

Label icon

MJH_0573.NEF

Image has XMP/IPTC data added

Image is protected. Cannot be edited in NX 2

Image has a voice memo attached

Image was shot using the camera NEF + JPEG option

Image was shot using the Hi-Speed crop option in the camera

Figure 2.15

Figure 2.16

Rating icon

You can use the Rating icon to indicate what star ratings you've applied to a photograph. Typically, you apply star ratings to indicate how good or bad an image is. You'll assign a zero-star rating for most of your images, and then assign more stars to indicate higher-quality photographs. After you apply stars, you can sort your thumbnails by their star ratings to quickly find your best images. I explain my star rating recommendations later in this chapter. For now, to change your star ratings, follow these steps:

1 Hover your mouse over the thumbnail.

2 Click the star icon underneath the name of the file (Figure 2.17). If you want three stars, click on the third star icon.

3 Wait for the Current Task info to disappear. At this point, the photo will have the new star rating saved to the file.

Edited icon

The Edited icon appears on NEF images only if they have been changed or manipulated in Capture NX 2. Also, this icon is displayed if you have edited the photograph in Nikon's free image browser called View NX. Above the edited icon, an orange lightning bolt is displayed if that image is being temporarily stored in the system cache.

see also

Chapter 3 has more information about the system cache.

The XMP/IPTC icon indicates whether any keyword or copyright data has been added to your image. You can't do anything by clicking this icon.

The Voice Memo icon lets you know whether you have an audio file attached to your image. Professional Nikon cameras such as the D3 and D2Xs have the ability to record voice annotations along with photographs.

The High Speed Crop icon displays on thumbnails that are shot with your camera's Hi-Speed crop mode. This mode is available only on higher-end cameras, such as the Nikon D2Xs models.

Figure 2.17

The NEF-JPEG Pair icon is a great tool that indicates that you actually have two images that you shot together in JPEG and NEF (RAW) mode. This icon helps remind me that I need to apply the same metadata and tags to both the JPEG and the NEF file. Otherwise, I might miss applying keywords to one of the files.

The last icon you might see under the thumbnail is the Protected icon. This indicates that you have write-protected your image, which means that you have locked your image from being modified or saved. You can apply this setting in your camera by pressing the Protect button. Alternatively, you can apply the setting by choosing File ➞ Protect File in Capture NX 2.

Applying labels and star ratings

Most photographers use labels and star ratings to help them organize their images. Star ratings are different than labels, but both should

generally be used together to help you better organize and sort your photographs. For example, a rating of one star might mean that you think the photograph is a great image. A rating of zero stars might mean that the image isn't anything special and doesn't deserve to be separated out for any reason. I recommend that you be stingy with your star ratings and reserve higher star ratings for only the best images. My philosophy is that most images should have low star ratings, and just a few fantastic photos should have higher star ratings.

Labels, on the other hand, are generally used for sorting images by how they will be used. For example, if you return from a photo job like a wedding and want to quickly mark the photographs that are bad, then you can apply a yellow label. Red labels can be used to mark photos you select for your client to see (these are called selects). Green labels could be used to identify the photos the client has approved for printing or purchase. You could use a blue label

to indicate the photos that need to be edited for white balance. Here's one example of a labeling and rating workflow:

1 **Mark all bad photos with a yellow label.**

2 **Mark all selects with a red label.**

3 **Mark all photos that need to be edited with a blue label.**

4 **Filter images so that you see only red and blue photos.**

5 **Rate any superb photos with one star.**

6 **Rate the best photo of the shoot with two stars.**

Labels

Table 2.1 shows some recommendations for using labels. The recommendations are based on the popular Adobe Bridge model. Adobe Bridge is a photo browser used by many imaging professionals to view, keyword, and organize their images. Adobe Bridge uses five main colors to define image labels.

Labels can be applied to your photographs in a number of ways. Here are four methods:

- Click the color label drop-down menu under the thumbnail (see Figure 2.16).

- Click the Labeling and Rating toolbar (Figure 2.18).

- Press 1 for red, 2 for orange, and so on.

- Click the label value from the metadata pane.

Figure 2.18

Table 2.1
Labels and Suggested Uses

Label	Name	Suggested Use
0	No label	Not labeled, no decisions made
1	Red	Select
2	Orange	Bad, delete
3	Yellow	Second
4	Green	Approved (by the client)
5	Cyan	Review
6	Blue	Unassigned
7	Purple	Unassigned
8	Magenta	Unassigned
9	Pink	Unassigned

The great thing about using labels is that you can change them to any usage you want. You can't change the numerical values, but you can change the colors and descriptions. Some photographers like to come up with their own labeling method, and Capture NX 2 allows you to make changes as you see fit. To do this, go to the menus and choose Edit → Preferences → Labels. (Mac users will choose Capture NX 2 → Preferences → Labels.) The Labels section of the Preferences dialog box appears, as shown in Figure 2.19, where you can customize the labels. To change the color of any label, simply click on the color swatch and use the resulting color picker to choose a new color. To change the name of the label, highlight the existing name and type a new name. For example, if you want your Green label to read Approved, then just type Approved in the text field.

Figure 2.19

Most photographers use a variety of software programs in their workflow, and each software package has a different way of dealing with labels. For example, Adobe Bridge uses the color red for a "selected" value. Other software uses red to indicate "bad." Because there is so much disparity among programs, the programmers of Capture NX 2 gave users the ability to maintain compatibility with other programs by selecting from the Default Settings drop-down menu shown in Figure 2.20.

I suggest that you maintain compatibility with whatever program you use the most. I tend to use Photoshop and Adobe products a lot, so I maintain compatibility with Adobe Bridge CS3.

You can see from Table 2.2 that the vast majority of my images will be no-star images. In fact, out of 1,000 images, probably 990 will be no star. That doesn't necessarily mean that the other 990 images are bad; rather, it just means that I don't think they are excellent. I use photos that have a no-star rating all the time in my professional work. Maybe they are used to illustrate concepts or travel locations or something else of interest.

The one-star ratings are reserved for the few images I think have exceptional merit. These are the pictures that I would submit to an editor for use in a story. They would be the images that I would first show to the bride after a wedding, or the best shots from a vacation that I might consider printing. Out of 1,000 shots, maybe nine or ten earn the one-star rating.

Figure 2.20

Star ratings

Star ratings have a different purpose. They are generally used to help you rate the overall quality of an image. After a photo shoot, for instance, you might choose a bunch of photos as keepers with the Red label, but maybe only one of those photographs is truly a winning image. In that case, you use a one-star rating for the photo. Table 2.2 shows my recommendations for using star ratings.

Two stars are used for the cream of the crop from a specific photo shoot. For example, at a wedding, the two-star photo is the shot that the bride wants enlarged into her wall print. From a vacation, the two-star rating goes to the very best image of the entire trip.

Table 2.2
Star Ratings

Stars	Usage
No stars	Average, mediocre shot
*	Excellent images from the group. Definitely worthy of printing or displaying.
**	The very best image from a group.
***	The very best image of my entire year of shooting.
****	The cream of the crop. The best images of my lifetime. Reserved for maybe the top 10 or 20 images I will ever create.
*****	The single best photo I've ever taken.

Three stars are used for the best images from the entire year. I use three-star ratings as a way to help me find the best images in my portfolio. When clients want to see the best photographs I'm capable of producing, then I show them the three-star images. In my archives, I have just a few three-star images. I'm pretty stingy with my ratings and don't want to clutter my portfolio with pictures that are second rate.

Four-star images are the best of my lifetime. I don't have any four–star shots in my archive right now. Maybe one day I'll live up to my potential and finally produce a four-star image.

Five-star ratings are reserved for a time when I'm old and gray and want to show the single best shot of my life. Perhaps this rating will go unused in my lifetime.

Star ratings are fairly consistent across software platforms. You generally find that if you rate a photo as a two-star image in another program, such as Adobe Bridge or Photo Mechanic, then it will also appear as a two-star image in Capture NX 2.

You can do the following to add star ratings to photographs:

- Click the star value under the thumbnail.

- Click on a photo to highlight it, then click the Labeling and Rating toolbar (located at the bottom of Figure 2.21).

- Press Ctrl+1 (⌘+1) for one star, Ctrl+2 (⌘+2) for two stars, and so on.

- Click the star value from the metadata pane.

A final note about the Labeling and Rating toolbar: You can easily move and relocate this toolbar to a different spot on the screen by clicking on the small triangle on the lower corner. I sometimes move the toolbar up a little higher on my screen so that it is closer to my thumbnail images when I add labels. It makes it easier to move my mouse from the image to the star rating button and back.

Figure 2.21

Comparing images in the browser or editor

There are many times when you want to compare two images side by side so you can judge which one is better. For example, you might have taken a few photos of your daughter and want to quickly compare the two to determine which one to continue editing. Alternatively, you might have taken a series of action photos of a football play and want to choose the sharpest of the bunch. Capture NX 2 provides a couple of ways to do this.

The first thing you need to do is to select some images to compare from the Browser window. Do this by clicking on an image and then holding down your Ctrl (⌘) key. Next, click a second image so that it is highlighted. Then right-click one of your images and choose Compare Images (Figure 2.22).

Figure 2.22

Selecting the Compare in Browser option displays these two images in the front and the rest of your thumbnails, which are grayed out, in the back (Figure 2.23). This provides an easy and quick method to compare images side by side. If you want to go back to your browser, simply click to the side of your images and they disappear.

You can compare up to four images at a time in this way. You can also make the photos larger or smaller by resizing the Browser pane.

Selecting the Compare in Editor option actually displays the photos in the editing window of Capture NX 2. Here, two images are opened simultaneously and tiled side by side for comparison. Capture NX 2 allows you to do this with a maximum of two images. The major difference between simply opening the two images and selecting Compare in Editor is that Capture NX 2 tiles them together, as shown in Figure 2.24.

Finally, say that you have made a bunch of changes to an image, and you want to know what the changed version looks like in comparison with the original. Choose View→ Compare with Original and Capture NX 2 places the original photo next to your current photo in the editing window, as shown in Figure 2.25. This is a neat utility to help you quickly judge the improvements you've made to your images.

Figure 2.23

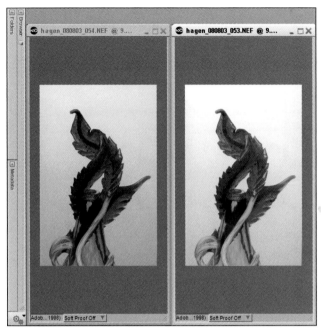

Figure 2.24

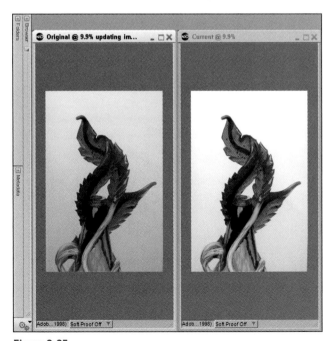

Figure 2.25

Filtering and sorting images

Capture NX 2's filtering and sorting tools can help you quickly find the images you are looking for.

The Filter toolbar, shown in Figure 2.26, is one of the most practical new additions in Capture NX 2. It enables you to quickly filter out the photos you don't want to see while allowing you to view the images you are interested in seeing.

Say that you want to show only NEFs that have red labels and a rating of one star. Start the search by clicking the Red Label button in the Filter toolbar, and then click the one-star button. Click on the File Format filter and choose NEF only. It is simple and quick, just the way all tools should be designed!

Let's go through the Filter toolbar options to better learn how to use each of the tools, starting with the Labels filter.

When you click on a label filter, a little check mark displays to the left of the filter area. The check mark means that you are actively filtering the browser by your criteria. Clicking the check box removes your filter choices and reverts back to no filter.

Star ratings filter

Filtering by star ratings works much like filtering by labels. To view your one-star photographs, click on the first star in the Filter toolbar. The little triangles underneath the star ratings are used to help you view images that are more than or less than a certain star rating. Figure 2.28 shows an example where the filter displays only images that are at least one star but not more than two stars.

Figure 2.28

Figure 2.26

Labels filter

To use the Labels filter (Figure 2.27), click on the label type that you want to show. This hides all other images with different labels and shows only the images with the label you have selected. You can also choose to view multiple labels by clicking on other label buttons. For example, if you want to show all the red and green labels, click on the red and green label buttons. The logic here is that the Filter toolbar shows red and green, but not any of the other color labels.

Figure 2.27

File type filter

The next section of the Filter toolbar, shown in Figure 2.29, is the File Type filter. This is a drop-down menu that enables you to view your images by JPEG, NEF, or TIFF. The NEF + JPEG | TIFF option shows all images in the folder, but it shows only the NEF image from your NEF + JPEG pair. In other words, if you shot your photos in your camera in NEF + JPEG, this filter hides the JPEGs and shows only the NEFs.

Table 2.3 summarizes the File Type filter.

Table 2.3
File Type Filter

Menu Selection	Description
NEF + JPEG \| TIFF	Shows all images, but only the NEF if you have a JPEG/NEF pair
NEF \| JPEG \| TIFF	Shows all images in the folder
NEF only	Shows only NEFs in the folder
JPEG only	Shows only JPEGs in the folder
TIFF only	Shows only TIFFs in the folder

Figure 2.29

Sort option

Another one of the great features of the Filter toolbar is the Sort option (Figure 2.30). Sorting is different than filtering in that you can arrange the photos that are currently being shown by criteria such as name, date shot, file size, and so on. You also have the ability to sort first by one criterion and then by another criterion. For example, you can sort all your images first by date shot and then by file type.

Figure 2.30

Metadata Pane

I talked about sorting images in the previous section because sorting is important for adding keywords and metadata to your images. In fact, the next step in your workflow, after renaming, labeling, and rating, is adding metadata.

Adding keywords, tags, and contact information to all my images is an integral part of my workflow, and I strongly encourage you to do the same thing. Keywords and tags give you the

ability to use a catalog program such as Adobe Lightroom or Expression Media to search for your images based on keywords. I can't imagine any other way of managing my database of images.

About Metadata

Metadata is defined as data about the data. What this means is that metadata can be used to describe a photograph. Say that you have a photograph like the ship photograph shown in Figure 2.31. The metadata for that photo describes what the photograph is, so that you don't have to visually search for the photo, but rather you can search the metadata. In this case, the metadata I used for the photograph contains keywords, copyright information, ratings, and categories. Figure 2.32 shows the keywords I used to describe the photograph: Tall Ships, Tacoma, Washington, Sail, and Puget Sound.

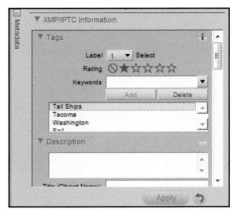

Figure 2.32

Capture NX 2 uses the current International Press Telecommunications Council (IPTC) standard for all the keywords and metadata that you add to your photographs. The IPTC created this global standard for metadata in the hope that all software manufacturers incorporate it into their software. What this means is that any keywords you add in Capture NX 2 can be used in other programs like Adobe Bridge, Apple Aperture, or Photo Mechanic. Alternatively, Capture NX 2 can read any keywords or tags that you add from other programs that use the IPTC standard. This cross-platform functionality is very important to many photographers because it allows them to use any program to add or read keywords.

Why are keywords so important? One reason is that after your image archives accumulate 5,000 or 10,000 photos, it becomes very difficult to find photographs by simply browsing for them. It doesn't take long to tire of searching through folders of images to try and find that one amazing photograph you took in Borneo last year.

Adding keywords allows you to search your entire database by important terms. In this case, you can search for the terms "Borneo" and

Figure 2.31

"vacation" and "monsoon" and quickly find that classic photo of you standing in a rainstorm during your once-in-a-lifetime trip to the rain forest.

In order to use keywords effectively, you need some type of program that indexes and databases all your photographs so you can search for them at a later date. As mentioned earlier, Capture NX 2 isn't a database program because it doesn't have any method for searching keywords or metadata across your entire hard drive. There are many other programs on the market that work for searching and archiving your images. These are programs like Adobe Lightroom or Expression Media. My favorite program for managing my files is Expression Media. I find it to be the most flexible and comprehensive program out there.

Even though Capture NX 2 won't let you search your database, the keywords you add here can be used and viewed by any other program that follows the IPTC standard.

Adding metadata

Okay, let's talk about how to add metadata to your images. Open the metadata pane by clicking on the + symbol above the Metadata title. Move the vertical scroll bar up to the top so you can see the Tags area. Notice that all the main areas in the metadata pane can be rolled up by clicking on the small triangle next to the section title (Figure 2.33).

At a minimum, I add the following metadata for every photo in my archive:

- Keywords

- Copyright notice

- Contact information (creator, address, e-mail, phone, and Web site)

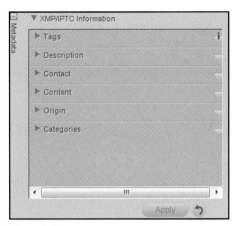

Figure 2.33

The other sections in the metadata pane are useful for some photographers, such as photojournalists (the Content section) or stock photographers (the Categories section). Let me quickly run through each of the areas so that you better understand how to use them.

- **Tags:** These are the labels, ratings, and keywords (Figure 2.33). I have already covered labels and ratings, so I won't duplicate that information here, other than to say that the example shown in Figure 2.32 has a label equal to 1 and a rating of one star.

- **Keywords:** Keywords are probably the best method for finding and cataloging your photographs. Each image should have three to seven keywords. I caution people not to get too prolific in their keywording; otherwise, keywords lose their effectiveness. For example, the photograph shown in Figure 2.34 has keywords "Boats," "Gig Harbor," "Kayak," "Mt. Rainier," "Summer." These keywords are specific and targeted for this image. If I include other keywords such as "sail masts," "snow," "fir trees," "blue sky,"

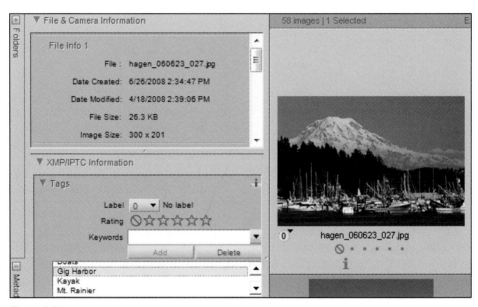

Figure 2.34

"clouds," "fish habitat," "guy standing on the top deck of the boat third from the right," and so on, then this photo might appear for just about any search I perform on my photographs.

tip

The trick to using keywords is to be concise and specific.

- **Description:** This area, shown in Figure 2.35, contains the copyright notice, title, and description of the image. At a minimum, you should always type the copyright information for every photograph you own. Simply write your full name and/or business name. In my case, I write "Mike Hagen—Out There Images, Inc." for the copyright. Use the

description and title areas if you are sending your photograph to a newspaper or magazine that might need to know a little more about the photo. I type the who, what, where, when, why, and how information in this section.

- **Contact:** I always provide my contact information in my photographs (Figure 2.36). Because my photos pay my mortgage, I want potential clients to have a way to track me down if they are interested in buying my image for their project. To that end, I type data in all these fields.

- **Content:** Use this section to help identify your photos based on the geographical area in which they were shot. For example, if you had a fashion shoot in Milan, then type all the important information in the Content section. This section is typically used by photographers who do advertising photography or work on assignments for media firms.

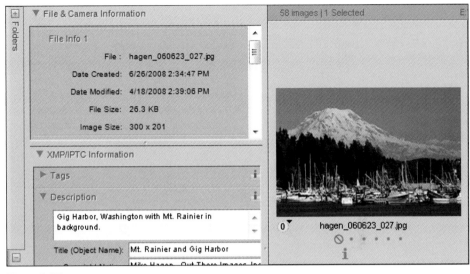

Figure 2.35

- **Categories:** To be honest, I don't do a lot with the Categories section. The concept here is that you can organize your photographs by categories and then search the photos within a category. Some example categories might include Wildlife, Landscape, Portrait, Architecture, Wedding, Product, Fashion, and so on.

Figure 2.36

The following are final notes about the metadata pane in Capture NX 2:

- **Try to batch process your data entries.** Select a number of similar images in the Browser by using the Filter toolbar or by Ctrl-clicking (⌘-clicking), and then type the common keywords for those images. When you finish typing, click Apply at the bottom of the pane. After you click Apply, a progress window opens. If you are keywording hundreds of photographs, this window stays up for a few minutes while Capture NX 2 writes all the metadata to the files.

- **Typing keywords in Capture NX 2 can be slow compared to other software packages.** There are many other programs that do the job much better and faster. I personally like Photo Mechanic, Adobe Lightroom, and Expression Media for my keywording. Each of these programs has a more efficient keywording interface.

- **If you try to keyword hundreds and hundreds of photos at the same time in Capture NX 2, you might crash your computer system.** On multiple occasions, I've tried to add a large set of keywords to 300 photos and have had the program lock up. To get around this problem, I recommend using a program specifically created for keywording, like Photo Mechanic, Adobe Lightroom, or Expression Media.

Bird's Eye and Zooming

Now that all your images are organized, sorted, labeled, keyworded, and copyrighted, it is time to open one and inspect it for quality, blemishes, and other details. Open an image from the Browser so you can use the zooming tools.

There are several ways to zoom into your image and navigate around. I'll start with the Bird's Eye pane and then give you some keyboard shortcuts. Figure 2.37 shows the Bird's Eye pane, which is located at the upper right of the Capture NX 2 window.

Figure 2.37

You can use any one of the following methods to zoom in or out of your photographs using the Bird's Eye tool:

- Click the magnifying glass button with the plus sign (+) to zoom in to your image, or click the magnifying glass button with the minus sign (−) to zoom out.

- Type a zoom value into the zoom text box.

- Click and drag the zoom slider up and down.

- From the menu, choose View → Zoom In or View → Zoom Out.

- Press Ctrl++ (⌘++) to zoom in or Ctrl+− (⌘+−) to zoom out.

Zoom values have to do with how the pixels in your photo match up with the pixels on your computer monitor. A zoom value of 25 percent

means that four pixels in your picture are compressed into one pixel in your monitor. Thirty-three percent means that three pixels in your photo fit into one pixel in your monitor. One hundred percent zoom means that one pixel in your photo fits into one pixel in your monitor.

Press Ctrl+0 (⌘+0) to size the photo to your viewable screen. Press Ctrl+Alt+0 (⌘+Option+0) to immediately zoom to 100%.

In general, you should zoom to 100% to judge sharpness. Higher zoom ratios cause your photo to look pixilated on your computer monitor. Anything less, and it can sometimes be hard to determine whether the photo is sharp.

When you zoom in, the Bird's Eye view creates a gray area to show what segment of the photo you are looking at. To look at a different area,

simply click on the Bird's Eye view and move the viewing area to a different part of the photo (Figure 2.38). Alternatively, you can use the scroll bars on your photograph to move around. A third way is to move your mouse over the photograph and press the spacebar on your keyboard. This turns your cursor into a hand that you can use to drag the photo around while holding down the mouse button.

tip

The spacebar method is the easiest and quickest way to move your photograph around when you are zoomed in.

Figure 2.38

Workspaces

Another one of the improvements in Capture NX 2 is the advent of customizable workspaces. For years, other programs such as Photoshop have allowed users to configure their work environment as they saw fit. For instance, if you wanted the browser on the right side of the window and the tools along the bottom of the window, then the program would allow you to place them there and save that arrangement.

Creating your own workspace

Capture NX 2 now gives you that same ability. Creating your own workspace is as simple as arranging the window however you want it and then saving that workspace. I'll talk about the details of that process in a minute. For now, let's go through the four default workspaces in Capture NX 2, which are described in Table 2.4.

To access the workspaces, either choose the workspace selector in the Activity toolbar or choose Window → Workspaces. Note that if you don't have an additional monitor attached to your computer, you won't be able to access this menu item.

If you need to work with thumbnails only, you can choose the Browser workspace. If you want to work with all tools at once, the Multi-Purpose workspace is the best choice. Pick the workspace that best suits your individual needs.

To create a custom workspace, simply position your palettes, tools, and panes where you want them to be on your computer monitor. To select a pane, click on the undock triangle by the pane's label (Figure 2.39). To move the pane, click the lightly checkered area underneath the undock triangle. To resize the pane, click and drag the crosshatched diagonal area at the lower corner of the palette.

Let's make a custom workspace that maximizes the size of the Edit List so that you can see more steps than are visible in the default size. Start by undocking the Edit List palette and then dragging the crosshatched corner to increase the size.

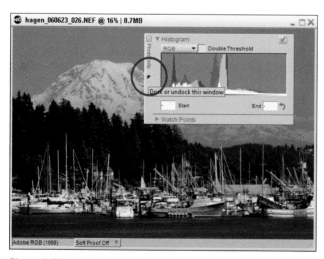

Figure 2.39

Table 2.4
Default Workspaces in Capture NX 2

Workspace	Shortcut	Description
Browser	Alt+1 (Option+1)	Use this for sorting, browsing, labeling, tagging, and keywording.
Metadata	Alt+2 (Option+2)	Best for reviewing and adding metadata to your images.
Multi-Purpose	Alt+3 (Option+3)	Use this when you have a large monitor and you want to browse and edit photographs at the same time.
Edit	Alt+4 (Option+4)	Useful when you are only editing images. Provides maximum space for the editing window.

Now, position the palette where you want it on the screen. Also, move your Histogram and Bird's Eye palettes out of the way. When your workspace is configured to your taste, follow these steps:

Figure 2.41

1 **Choose Window → Workspaces → Save Workspace (Figure 2.40).** The Save Workspace dialog box appears.

2 **Type a new workspace name.** The example in Figure 2.41 uses the name "Tall Edit List."

Figure 2.40

3 Click OK.

4 Check that your new workspace was properly saved by choosing Window → Workspaces → My Workspaces → Tall Edit List (Figure 2.42).

Configuring NX 2 for multiple monitors

Another of Capture NX 2's newest features is its ability to be configured for working on multiple monitors. Most photographers like to work with

Figure 2.42

Over time, you might create a number of different workspaces and then have the need to delete one, change one, or apply a different keyboard shortcut. You can easily manage your workspaces by choosing Window → Workspaces → Manage Workspaces. Once there, you can add and delete workspaces from your My Workspaces window.

When you finish managing your workspaces, click OK.

see also

You can also apply your own keyboard shortcuts to your custom workspaces. I cover this in more detail in Chapter 3.

their photographs on one screen and all the tools and thumbnails on a second screen. We do this for a few reasons:

• To maximize workspace.

• To enable the use of a laptop and a second, color calibrated screen.

• To keep the clutter of tools and windows on one side while just the photo is on the other side. This helps you judge the photo on its own merits without any distractions.

To use Capture NX 2 on two screens, go to the Workspace Selector menu shown in Figure 2.43. Choose Additional Screen, and then pick which element you want to place on the second screen. Your initial choices are

- **Desktop.** This means the normal computer desktop.

- **Browser.** This means that your browser will be on the second screen.

- **Metadata.** This means the metadata browser will be on the second screen.

Figure 2.43

After you choose the element to place on the second screen, you can swap the screens from left to right by going back to the Workspace Selector and choosing Swap Workspaces (Figure 2.44). In other words, if you put the browser on the second screen, then you can swap the screens so that the browser is on the first screen. Some people like to work with the browser on the left and the editing screen on the right. It is a matter of preference.

Figure 2.44

My habit is to work so that my browser is on my left screen and my editing is done on my right screen. I don't have a significant reason for doing it this way, other than that's the habit I've formed over the last few years.

There are a few more things that you need to know when you use two screens.

- **The Workspace Selector menu always travels with the Browser screen.** If you move your browser to the right-hand screen, then you might have to search a bit to find the Workspace Selector to swap the screen back to the left side.

- **Some workspaces can't be used with another.** For example, you can't show the Edit screen on the second monitor if you have chosen the Edit screen to appear on the first monitor. This is kind of an obvious point, but many people have asked why some screens are grayed out from the menu, such as those shown in Figure 2.44.

- **Capture NX 2 doesn't give you the option of using multiple screens if it doesn't detect a second monitor.**

- **After you start using multiple monitors, you can save your workspace as I discussed earlier.**

Okay, that's it. Now you know everything you need to know regarding setting up the Capture NX 2 interface. It is time to properly configure Capture NX 2's preferences so that the program operates faster and more efficiently.

3

Speeding Up NX 2 and Setting Preferences

Most users of Capture NX 2 acknowledge that it isn't the fastest program in the world. Any extra performance you can squeeze out of it can greatly enhance your experience, and there are some easy and quick ways to increase the speed of Capture NX 2. Also, by going through the system preferences step by step, you can set up the program to your own liking.

In this chapter, I show you some simple methods for improving the speed of Capture NX 2. I cover general approaches, as well as setting up system preferences.

How to Speed Up Capture NX 2

Previous versions of Capture were undeniably slow. When using the older Capture versions 3 and 4, I sometimes had to wonder whether or not I had clicked a button because the program would take forever to render the change. Fortunately, the programmers of Capture NX 2 have aggressively worked at improving the software's speed, and the result is a program that is reliable and fast.

There are a few tried-and-true methods for speeding up Capture NX 2. These range from the obvious (use a fast computer) to the less obvious (use presets). The following sections discuss my recommendations for improving your user experience in NX 2.

Use a fast computer

The most important thing you can do to speed up Capture NX 2 is use a computer with a fast processor and a lot of RAM. There is a lot of conversation out there about whether PCs or Macs are the best or fastest, but the truth is that both computer platforms work fine for photo editing. I have used Capture NX 2 on both a PC and Mac and haven't found that one dramatically outperforms the other.

I strongly recommend a dual-core processor or a quad-core processor with a speed of at least 2GHz. A lot of RAM is mandatory, and a minimum target should be at least 4GB. Anything less than this makes it hard to multitask and have multiple programs open at the same time. Another thing that greatly enhances your experience with Capture NX 2 is to use hard drives with very fast read and write times. The current state-of-the-art drives have a minimum of 7,200 RPMs, but the faster 10,000 RPM drives are even better. As always, more speed is better!

Use a scratch disk

In the Preferences section, I explain how to set up Capture NX 2 for fully utilizing a scratch disk. The purpose of a scratch disk is to provide a fast-access memory location for Capture NX 2 to hold temporary data. Your computer works faster if you enable it to keep the temporary files on a second disk rather than the primary start-up disk. This drive should ideally have the fastest data transfer rate possible. I recommend using an external drive with either USB 2.0 or FireWire 400/800 compatibility. An internal drive or an external FireWire 800 drive is the fastest of all.

Increase your cache file

There are two types of cache files in Capture NX 2: the Browsing cache and the Editing cache. The Browsing cache is used when your file browser is opened. Capture NX 2 has to render each thumbnail preview from the file, and it takes a lot of processing power to do this. After Capture NX 2 renders all the thumbnails, it saves the data as cache so that when you are scrolling through the folder, it shows you the images much more quickly. It won't have to re-render all the thumbnails.

The Editing cache allows NEF images that were previously opened with Capture NX 2 to open more quickly. Opening an image from cache is much faster than regenerating it each time from your hard drive. The Editing cache is literally a running history of all the images you have opened in Capture NX 2. The amount of space you allocate to the cache determines how many files you keep in this memory location. As you continue to open new files, the old ones are pushed out.

Set your cache so that it is as large as possible. Preferably, your cache should be unlimited. Your cache directory should be on a separate drive, so that your computer can quickly write image data to and from this drive. If you use your computer's main hard drive, the read/write process can be slower because the computer tries to read/write program data and image data to the same drive. How to properly configure your cache is covered later in this chapter.

Create and use presets

The next strategy for working faster in Capture NX 2 is to create preset settings for your commonly used actions. Presets are adjustments that you save and then access in the future.

The goal with using presets is to be able to quickly apply a setting to your image so you don't have to create new adjustments from scratch every time. Common presets I use are

- Sharpening for output (print)
- Sharpening for screen (web)
- Size image for web/email
- Black and White conversion
- Sepia conversion
- Add contrast
- Add saturation

see also

The process for saving adjustments is covered in detail in Chapter 10.

You access these saved adjustments from the gear symbols that you find all around the Capture NX 2 window (Figure 3.1). Click on any gear icon, choose Load Adjustments, and then select the preset you want to use. If you've never saved any of your settings, then your Load Adjustments area will be empty.

Figure 3.1

Work in a consistent flow

You should generally work from the top of the screen to the bottom when you make improvements to your image. I almost always start with the Develop pane (Figure 3.2) and then migrate down to the Adjust pane (Figure 3.3). There are many reasons for this, but the most significant is that when you make a change to a previous step, it temporarily turns off the changes you made in the steps below.

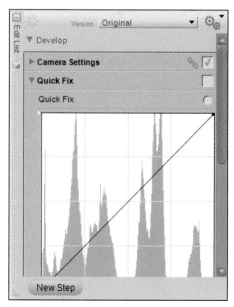

Figure 3.2

For example, say that you click the New Step button to add a step to boost the color and then add another step for a color control point. These adjustments appear in the Adjust pane as new steps (Figure 3.4). If you go back to the Develop pane and make a change, then the new steps you added are temporarily turned off. To see the effect of the saturation and color control point, you have to go back and select the check boxes to turn them on again one by one. You can turn off this feature by going into the General Preferences and putting a check box into the Edit List section (see page 66).

Another reason for working from the top of the screen to the bottom is that all the RAW settings, such as White Balance, Highlight protection, and Exposure compensation, are located in the first pane. These settings should be adjusted first because they have the most impact on the quality of the image.

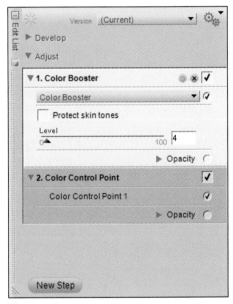

Figure 3.4

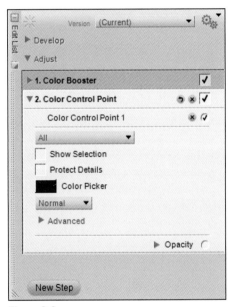

Figure 3.3

All these extra clicks of the mouse add time to your editing process and can bog you down. With experience, you can start with your Develop settings and then move on to your new steps. Follow a consistent pattern and you'll be happier with the speed of Capture NX 2.

see also

The Develop pane is covered in Chapters 4 and 5 and New Steps in the Adjust pane are covered in Chapters 6 and 7.

Batch process

Most of the time when you use Capture NX 2, you work on one image at a time, such as when you want to make a single print from your vacation to Aruba. But there are times when it makes sense to process a few hundred photographs at a time rather than process them one by one.

For example, if you come back from Aruba and discover that all your images have the wrong white balance, then you should use a batch process to change them all at once. Fixing the white balance one at a time can take hours to complete.

Capture NX 2 is set up to enable you to batch process just about any type of setting. You can literally make the change on one image and then apply it to the remaining images with a few clicks of your mouse. Batch processing is one of the biggest time-savers available to you, so make sure you learn it well.

see also

Batch processing is covered in Chapter 10.

How to Change System Preferences

Similar to other programs, Capture NX 2 has a bewildering array of background settings you can use that have profound impact on your workflow and speed. Most people don't make changes to the system preferences in fear that they might irrevocably change something and forget to change it back. By the end of this chapter, however, you should be comfortable working with and changing the Capture NX 2 system preferences. These are important changes, and you get better images if you make them now rather than later.

To open the Preferences window, choose Edit→ Preferences→General. You can also press Ctrl+K (⌘ + K). You can see the Preferences window in Figure 3.5. On a Mac, choose Capture NX 2→ Preferences→General.

The following sections explain the system preferences and how to set them up for ideal performance.

General

The General preferences tab is used for setting system defaults, such as the Open With Application, measurement units, Save as location, and temporary file data location. Follow along as I describe each setting.

Open With Application

Use the Open With Application to select the software program to which you want to send your photo for further work after you finish editing it in Capture NX 2.

The Open With Application setting is used to tell NX 2 which application to export images to in the event that you want to perform an editing task that is not available in NX 2, such as the Photo Merge or panorama feature in Photoshop. The Preferences setting is where you tell Capture NX 2 what program you want to use to continue working on your image after you've finished in NX 2.

A good example of why you use the Open With command is if you want to create a panorama from five NEF photographs. You first process them in Capture NX 2 so they have the correct white balance, colors, and so on. Then you send those five photographs to Photoshop to do the panorama merge. To send your photo directly to Adobe Photoshop from Capture NX 2, choose File→Open With. This converts your files to TIFFs and opens them in Photoshop. You don't have any other option than converting the file to a TIFF before it is sent to your program of choice.

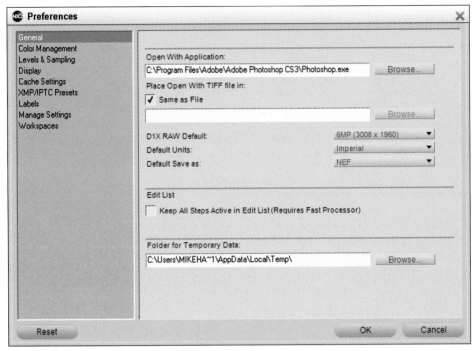

Figure 3.5

Most photographers use Photoshop as their Open With Application, but some people like using other image editors such as Corel Draw or GIMP. To finish setting up this area of the preferences, click Browse and navigate to your Photoshop program file on your computer. You can see what it looks like on my computer in Figure 3.6.

Figure 3.6

Place Open With TIFF file in

This preference enables you to select where to save the new TIFF. As mentioned earlier, when you choose the Open With command, Capture NX 2 automatically creates a flattened TIFF of the image you are currently working on. Generally, you need to save the new TIFF in the same folder as your original image, but you can elect to save it elsewhere if you choose.

D1X RAW Default

This line item is used to set the default size of the files taken with the Nikon D1X camera (Figure 3.7). The D1X has the unique capability to use the same NEF file to generate 6MP images or 10MP images. If you use the D1X, then my suggestion is to use the 10MP setting as your default, because it will offer you the largest file and the best image to work with.

Default Units

This preference lets you decide to use inches or millimeters as your default units when working in Capture NX 2 (Figure 3.8). This impacts settings such as printer resolution, sizing images, and so on. Because I'm based in the USA, I leave mine set for Imperial (inches). If you are in a country that uses the metric system, then go ahead and select Metric. To change the settings, click the pull-down menu next to Default Units and choose Metric or Imperial.

Default Save as

Use this preference to tell Capture NX 2 what option to place as the default format type when you use the Save As function. If you find that you typically save your images as JPEGs, then setting this menu item to JPEG can save you time by eliminating the need for you to set it

Figure 3.7

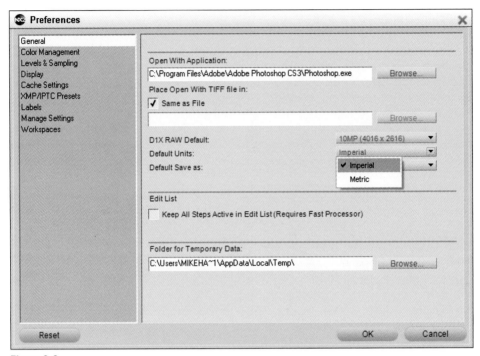

Figure 3.8

manually every time you choose the Save As menu item. My default is generally set to NEF, but the other choices here might benefit you:

- **Same as original file.** Defaults to the original format of the photo on which you are working

- **Previous file format.** Remembers the last file you saved in Capture NX 2 and uses that as the default

- **NEF.** Saves as an NEF

- **JPEG.** Defaults to JPEG

- **TIFF.** Defaults to TIFF

This doesn't mean that you have to save every photograph you create in the default format; it just means that this is the first option that appears when you choose the Save As command from the File menu.

Edit List

If you leave the Keep All Steps Active in Edit List (Requires Fast Processor) option deselected, then the editing of a step in the Edit List palette causes the following steps to be temporarily disabled. If you select this option, the subsequent steps remain active. The upside to using this feature is that Capture NX 2 won't automatically disable your downstream steps any time you make a change in your Edit List. The downside to using this feature is that it takes a huge amount of processing power to keep all the steps active.

If you have a fast computer, then go ahead and select this option. If you have a slower computer, don't use this option. If you do keep it off, however, then you'll have to go through and reactivate each of the steps one by one when you make any change to a previous setting.

Folder for Temporary Data

As discussed earlier, this option is a great way to increase the speed of Capture NX 2. This option enables you to choose a folder on any hard drive to use as a storage location for Capture NX 2's temporary file data. The default setting saves your temporary data to your computer's main hard drive, which slows down the read/write processes from Capture NX 2. If you choose a folder location on a secondary hard drive with a very fast connection to your computer, then Capture NX 2 can quickly read/write data and speed up its performance.

Another option is to use a second internal hard drive. In my computer, I have an additional 120GB hard drive that is dedicated to my temporary files. I use it for all my applications that make use of temporary file folders. Figure 3.9 shows that this is my Z drive, and it is built right into my computer.

Remember, using a separate disk other than your primary start-up disk greatly decreases the time it takes to read or write temporary file data in Capture NX 2.

Color Management

The Color Management section determines your working color spaces and your printing profiles. This is one of the more important windows in the entire program. Understanding the correct way to set up your color profiles will go a long way toward helping you create beautiful prints and beautiful output. If your color management settings are properly configured, you can save hours of time during printing by not having to fix mistakes or reprint images with odd color casts.

Figure 3.9

see also

You can find more information on color management in Chapter 9.

Default RGB Color Space

This drop-down list determines the default color space that you work in when you open an image in Capture NX 2 (Figure 3.10). In general, there are two main color spaces that photographers work in: sRGB and Adobe RGB (1998). Your color space determines the size of the color gamut that you apply to your photographs. Adobe RGB is a larger color space than sRGB, so it naturally follows that you would want to use the larger color space. Bigger is always better, right?

The answer to this question is actually a bit more complicated. RAW files do not have defined color spaces; they are simply files that record all possible colors that the camera is capable of capturing. It isn't until you convert the photo for printing or output that you actually define the color space. Fundamentally, that's what you are doing in Capture NX 2—converting images from their RAW state to another state that you can use (JPEG, TIFF, print, and so on).

The way to determine what color space you should use is to ask yourself what type of output you will use for your images. Are you printing your photographs on an inkjet printer or at the photo lab down the street? Are you posting your images on the Internet, or are you preparing them for print in a book, magazine, or other publication?

Each output device has a different color space that it is capable of producing. For example, most commercial printing labs use the sRGB color space. Therefore, it makes sense to work in the sRGB space if you are printing at places like MPix,

Costco, Ritz, and so on. If you aren't sure about the color space your lab uses, you should ask for specific details. On the other hand, most modern inkjet printers can utilize most (if not all) of the colors represented in the Adobe RGB color space. Therefore, it makes sense to work in the Adobe RGB space if you are printing on modern Epson, HP, or Canon inkjet printers.

sRGB IEC61966-2.1
✓ Adobe RGB (1998)
Apple RGB
CIE RGB
ColorMatch RGB
HP DJ 6900-Premium Paper(tricolor+black)
HP DJ 6900-Premium Paper(tricolor+gray)
HP DJ 6900-Premium Paper(tricolor+photo)
HP DJ 6900-Prem Plus Photo(tricolor+black)
HP DJ 6900-Prem Plus Photo(tricolor+photo)
HP DJ 6900-Prem Plus Photo(tricolor+gray)
HP OJ 6300-Prem Plus Photo(tricolor+black)
HP OJ 6300-Prem Plus Photo(tricolor+gray)
HP OJ 6300-Prem Plus Photo(tricolor+photo)
HP OJ 6300-Premium Paper(tricolor+black)
HP OJ 6300-Premium Paper(tricolor+gray)
HP OJ 6300-Premium Paper(tricolor+photo)
HP PSPro B9100-Advanced Photo Glossy
HP PSPro B9100-Advanced Photo Satin
HP PSPro B9100-Advanced Photo Soft-Gloss
HP PSPro B9100-Aquarella Art Paper
HP PSPro B9100-Artist Matte Canvas
HP PSPro B9100-Everyday Photo Matte
HP PSPro B9100-Hahnemuhle Smooth Fine Art
HP PSPro B9100-Hahnemuhle Watercolor
HP PSPro B9100-Premium Paper
NTSC (1953)
PAL/SECAM
SMPTE-C
Wide Gamut RGB

Figure 3.10

One of the most frequently asked questions at the workshops I lead is, "What happens if I work in Adobe RGB and then print on an sRGB printer?" What people are really asking is whether they can just stay in Adobe RGB for all their work and not worry about the colors when they print. The answer is that using this approach can cause your colors to shift. The reason is that, because Adobe RGB is so much larger than sRGB, the printers can't reproduce all the colors that you send. So, the printer at the commercial lab uses the next closest color that it can produce, and you get a change in colors. Sometimes the change is minor, and sometimes the change is major. It depends on factors such as the specific printer's capabilities and the type of paper used.

Table 3.1 shows my recommendations for setting your color space. Notice again that your color space choice depends on where you output your images.

Capture NX 2 shows you which color space you are currently working in for each image. You can see which color space your photo is currently in by looking at the bottom-left side of the photo window. Thus, in Figure 3.11, the example image is in the Adobe RGB space.

The next choice under the Default RGB Color Space is the Use this instead of embedded profile option. If you select this check box, then Capture NX 2 automatically converts your image from its native workspace (that is, what you set in your camera) to the Default Workspace when you open the image. If you leave the check box empty, Capture NX 2 leaves your file alone and keeps the native workspace from the camera.

My habit is to set my Default Workspace at the beginning of my editing session based on Table 3.1 and then select the Use this instead of embedded profile option. This way, I know for sure that all my photos are converted to the appropriate workspace as I edit.

Figure 3.11

Table 3.1
Color Space Recommendations

Output	Color Space
Inkjet printer (Epson, HP, and Canon)	Adobe RGB (1998)
Photo lab (Costco, drug store, and online)	sRGB
Advertising, magazines, books	Adobe RGB (1998)
HD TV	sRGB
Web site	sRGB

CMYK Separation Profile

Most photographers won't have to worry about this section, as it is designed for people who are doing four-color TIFF separations for printing presses. If a customer asks you to do CMYK separations before you send files to him or her, then ask what profile you should choose. Each printing press has a different standard, so you need to make sure you use the correct one.

Printer Profile

Setting your printer profile is an important step in getting great prints. For now, choose the printing profile that most closely matches your printer and paper type. In the example shown in Figure 3.12, I selected HP PSPro B9100-Advanced Photo Satin as my printer profile. If you set it incorrectly and use this profile in your printing process, you are almost always guaranteed to have significant color shifts in your output because your printer will use the wrong profile.

see also

More about printing from Capture NX 2 is discussed in Chapter 9.

sRGB IEC61966-2.1
Adobe RGB (1998)
Apple RGB
CIE RGB
ColorMatch RGB
HP DJ 6900-Premium Paper(tricolor+black)
HP DJ 6900-Premium Paper(tricolor+gray)
HP DJ 6900-Premium Paper(tricolor+photo)
HP DJ 6900-Prem Plus Photo(tricolor+black)
HP DJ 6900-Prem Plus Photo(tricolor+photo)
HP DJ 6900-Prem Plus Photo(tricolor+gray)
HP OJ 6300-Prem Plus Photo(tricolor+black)
HP OJ 6300-Prem Plus Photo(tricolor+gray)
HP OJ 6300-Prem Plus Photo(tricolor+photo)
HP OJ 6300-Premium Paper(tricolor+black)
HP OJ 6300-Premium Paper(tricolor+gray)
HP OJ 6300-Premium Paper(tricolor+photo)
HP PSPro B9100-Advanced Photo Glossy
✔ HP PSPro B9100-Advanced Photo Satin
HP PSPro B9100-Advanced Photo Soft-Gloss
HP PSPro B9100-Aquarella Art Paper
HP PSPro B9100-Artist Matte Canvas
HP PSPro B9100-Everyday Photo Matte
HP PSPro B9100-Hahnemuhle Smooth Fine Art
HP PSPro B9100-Hahnemuhle Watercolor
HP PSPro B9100-Premium Paper
NTSC (1953)
PAL/SECAM
SMPTE-C
Wide Gamut RGB

Figure 3.12

Intent

Figure 3.13 shows that there are four rendering intents you can choose from. A rendering intent is basically an algorithm (program) that converts your colors from one color space to a different color space. As mentioned earlier, sometimes you have to convert images from Adobe RGB to sRGB. The rendering intent defines how Capture NX 2 redefines colors between spaces.

In general, you should pick Perceptual or Relative colorimetric, as these are best suited to photography because they produce the most visually pleasing color conversions. Table 3.2 describes each intent and how it should be used.

The final option in this window is Use black point compensation. Most printers have a different tonal (brightness) range than your computer monitor. Selecting this option maps the black point in your image to the black point in your printer so that your blacks are nice and rich. I recommend selecting this option because I like my blacks to render as black in my prints. However, if you find that you lose too much detail in your shadows, then you might deselect this option so your blacks maintain some detail.

If you select the Use this profile when printing option, then Capture NX 2 always defaults to that profile each time you print. The trouble begins when you start to use a different paper or if you use a different printer. For example, say Capture NX 2 sends the data to the printer using Advanced Photo Satin paper when you wanted to use the Hannemuhle Smooth Fine Art paper. My recommendation is to leave this option deselected and set up your printer profile in the Printer dialog box when you are ready to print.

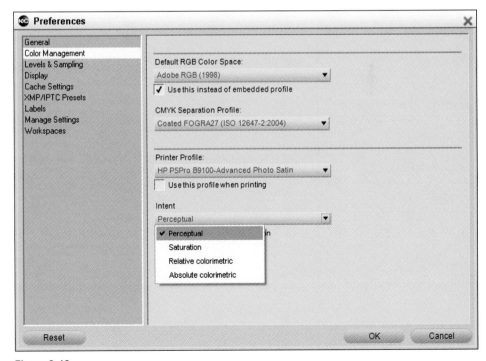

Figure 3.13

Table 3.2
Rendering Intents

Intent	Explanation
Perceptual	Maintains colors to the printed images; appears natural to the human eye. I use this rendering intent most of the time.
Saturation	Produces highly saturated colors. Typically used for business graphics. Not appropriate for photography.
Relative colorimetric	Maps all the colors that fall outside of the gamut (that is, sRGB) and then remaps them to the closest reproducible color. This is also a good choice for photography.
Absolute colorimetric	Similar to Relative colorimetric, except that it matches the white points of the starting profile to the target profile. This rendering intent can cause color shifts that are undesirable, so I don't recommend using it for photography.

Levels & Sampling

Figure 3.14 shows the Levels & Sampling preferences. The Levels & Curves area is for setting your black, white, and neutral point values. When using the Curves tool in Capture NX 2 (Figure 3.15) you can use the dropper tools to set your black, white, and neutral points for your photograph.

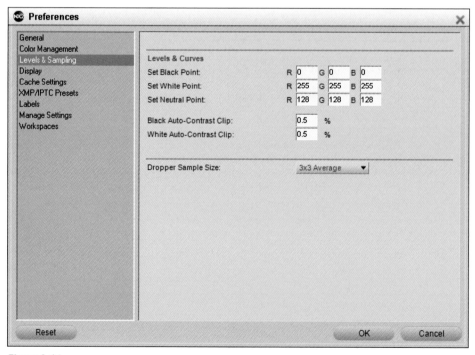

Figure 3.14

Figure 3.15

Clicking in your photo with the Black Point dropper sets that specific brightness value to 0 (zero). A level of 0 means pure black, while a level of 255 means pure white. The midpoint between 0 and 255 is 128, so call that the neutral point.

Sometimes, when setting your white point, you don't want to use 255 because that represents pure white. Thus, when you print your photo, anything in your photograph that has a value of 255 is completely blown out and won't show detail. The same concept holds true for your black point. Anything that has a brightness value of 0 is completely black and won't show any shadow detail. Therefore, some photographers like to change black points and white points to allow some remaining detail in their photographs (Figure 3.16).

The Black/White Auto-Contrast Clip areas are for setting the preset when you click Auto Contrast in the Curves dialog box. The default setting is to clip 0.5% of your highlights and shadows for each color channel (Red, Green, and Blue). Some photographers like to reduce that value to retain more highlight and shadow detail. A good setting for this might be something between 0.05% and 0.1%.

Finally, Dropper Sample Size is used to determine how many pixels your droppers use when setting the black, white, and neutral points. The drop-down list allows a point sample, a 3x3 average, or a 5x5 average. Point sample means that the dropper samples only the individual pixel that you click on. The 3x3 average samples 9 pixels, while the 5x5 average samples 25 pixels. I use the 3x3 average for my sampling.

tip

Use 6, 6, 6 for your black point and 249, 249, 249 for your white point to preserve shadow and highlight details.

Figure 3.16

Display

Use the Display preferences to customize what is displayed on your screen while using Capture NX 2 (Figure 3.17).

Grid

Capture NX 2 enables you to display a grid over your picture while editing. You can activate the grid by choosing View → Show Grid. The grid is useful for making sure your horizons are level and your trees are vertical. The default color of the grid is orange (Figure 3.18), but you can change the grid color by clicking on the color patch next to Grid Color. Sometimes, the grid color matches the colors in your image and it can be hard to see the grid. Set the grid color so that it is easily visible when overlaid on your image.

You can also change how many gridlines are shown by modifying the numbers in the Gridline Every box and the Subdivisions per Line box. Set a higher number of gridlines if you want more precision when aligning or rotating your image.

Selection Overlay

Selections are used to prevent or allow changes to your image. For example if you convert your image to black and white, you can use a selection to select portions of the image to keep in color or portions of the image to turn to black and white. Capture NX 2 enables you to view the selection as a green overlay. This color is fine for most of your work, but you can pick any color you want by clicking on the Color box. Other image-editing programs use red for the selection overlay, so you can change the color to be consistent with your other software. Also, you

Figure 3.17

Figure 3.18

can change the opacity of the Selection Overlay by clicking and dragging the Opacity slider. This slider defines how bright the overlay is on the image. A low opacity shows the selection as a light color overlay, and a high opacity shows the selection as a dark color overlay.

see also

Chapter 6 covers selections and overlays in more detail.

Image

The Auto-Hide On-Image Elements option allows Capture NX 2 to automatically hide things like the grid, active selections, watch points, and control points when you aren't actively working on the photo. I like to keep this check box selected because it allows me to see the photo

without all the clutter. To show the elements, all you need to do is hover your mouse over the photograph. To hide the elements, just move your mouse off the photograph. Simple!

Cache Settings

As previously mentioned, Capture NX 2 uses two cache types to speed up your working environment: a Browsing Cache and an Editing Cache (Figure 3.19). The Browsing Cache is used when you are viewing thumbnails in the browser, and the Editing Cache is used when you work on images.

Browsing Cache

To speed up the display of thumbnails, Capture NX 2 creates a temporary cache (memory) of all the thumbnails in a folder. When you first open

Figure 3.19

a folder, Capture NX 2 has to build your thumbnail previews from scratch, and this takes quite a bit of time, especially on large photographs. Caching the thumbnail previews lets you quickly scroll through the folder from top to bottom without having to rebuild each thumbnail every time you view it in the browser. For example, if you go back to view the initial images in the folder, it reloads much faster because the thumbnails are stored in cache.

You can't control the size of the Browsing Cache, but Capture NX 2 shows you how much memory you are using for the thumbnails. If you need to, you can click Clear Cache to reclaim hard drive space. This action deletes all the cached thumbnails that have been stored.

Editing Cache

The Editing Cache allows faster loading of images that you have previously opened. The way this works is the first time you open an NEF photo in Capture NX 2, it opens it from the hard drive where it is stored. Then, as you make changes to your image, Capture NX 2 saves (caches) each of those changes as discrete history states. If you step back through history, Capture NX 2 calls up the cached version of the file rather than completely rebuilding it from scratch. This saves a substantial amount of time in your editing process.

The Use Image Cache option turns the cache feature on or off. I recommend selecting this option for the reason mentioned earlier.

Clicking Clear Cache allows you to delete your temporary cache files from memory. You generally won't need to do this unless you have to reclaim some hard drive space on your computer.

If you select the Cache Files Saved Within the Editor option, then Capture NX 2 creates a cached version of your image each time you choose Save or Save As. I recommend selecting this option in order to save time in the future when you reopen the same file.

When you run batch processes, you can cache each of the batched images if you select the Cache Files Created in a Batch Process option. I don't select this option because my batch processing typically goes through a few hundred images at a time. I normally don't go back through each of my images from a batch session, so I don't have a need to cache the results.

The Cache Location should typically be placed on a separate disk drive. Ideally, you'll use an external USB/FireWire drive or a secondary drive built into your computer. The faster the drive you use, the faster Nikon Capture NX 2 operates.

Selecting the Limit Cache Size option allows you to restrict how much of your hard drive you use for a cache. If you have a dedicated hard drive for the cache, then I recommend leaving this option deselected so Capture can utilize all of the space on that drive. If you don't have an external hard drive and are worried about using too much disk space for the cache, you can limit the amount of cache by moving the slider. You should make the cache size as big as possible. I like to set mine to at least 15GB if I have the space on my computer's built-in drive. If I am working with an external drive, then I don't limit the cache size (that is, I leave the option deselected).

By default, Capture NX 2 utilizes 2GB of space for cache files. If the allocated space fills up, then Capture NX 2 deletes the oldest files and replaces them with the newer ones as you work.

XMP/IPTC Presets

This section is used to create metadata presets for keywording, captioning, and rating your images (Figure 3.20). Extensible Metadata Platform (XMP) is Adobe's standard for embedding metadata into images, and the International Press Telecommunications Council (IPTC) is a global standard used by all corporations (including Nikon and Adobe) for embedding metadata into images.

Figure 3.20

see also

See Chapter 2 for more about the importance of adding keywords and copyright information to all your images.

Use the XMP/IPTC Preferences to make templates that you can apply to your photos through a batch operation. This saves time when you have many images that need to have the same metadata added to the file. For example, to create a template for your Copyright and Contact information, follow these steps:

1 Click the New button.

2 Type a name for your new template, such as Copyright & Contact Info.

3 Deselect the Tags, Content, Origin, and Categories check boxes. You might need to scroll down to deselect some of the boxes.

4 Type your Copyright Notice; for example, Mike Hagen – Out There Images, Inc.

5 Type your Contact information, such as name, address, phone, e-mail, Web site, and so on.

6 Click OK.

You've now created a template that you can apply to your images from the browser. To apply the new template to your photographs, follow these steps:

1 Open your browser.

2 Select all the images in a folder. Press Ctrl+A (⌘+A).

3 Click the gear icon in the lower left of the browser and choose Load XMP/IPTC Preset → Copyright_Contact Info.

That's it. You have now applied the metadata preset to all the images in your browser. Now you can use the batch processing capabilities to apply this XMP/IPTC preset to a number of images at once. This is a great way to save time in your workflow.

Labels

The Labels section (Figure 3.21) is used to allow you to customize your color labels. As mentioned in Chapter 2, photographers typically use labels to indicate how their images will be used. A photograph that you select for a project might get a red label. A photograph that the customer selects might get a green label.

Figure 3.21

There are as many ways to use labels as there are photographers, so you can use this section of the Preferences window to customize labels so they fit in your personal workflow. However, there are other people and organizations that you sometimes need to work with, so it is good to use a labeling convention that is consistent with the rest of the photo community. If you click the drop-down list (Figure 3.22), you find a list of other software packages. Capture NX 2 supports compatibility with these programs by simply choosing the program you want to emulate.

Of course, you have the ability to create your own standard as well. To do this, just type whatever name you want by the color swatch.

Also, you can click on the color swatch to change the color to something else. After you change the label names and colors, this will become your Custom menu item in the drop-down list.

Manage Settings

At the beginning of this chapter, I talked about using presets as a method for speeding up Capture NX 2. The Manage Settings section is where you determine which presets (settings) you can see in the Load Adjustments submenu of the Batch menu.

Figure 3.22

Figure 3.23 shows that I already saved a number of settings in Capture NX 2. If I select the check box next to any of the settings, then those are viewable from the Load Adjustments menu (Figure 3.24).

You can also add adjustments that you previously saved to your hard drive. For example, I can save an adjustment and then e-mail it to you. Then you can save that adjustment file to your hard drive and add it to Capture NX 2 as a preset for use in your own workflow. To add adjustments this way, click Add and navigate to the file on

your hard drive. In contrast, click Delete to completely delete a highlighted setting from Capture NX 2.

Workspaces

In Chapter 2, I talked about workspaces and how to save and access them. This section of the Preferences window allows you to apply different keyboard shortcuts for accessing different workspaces.

Figure 3.23

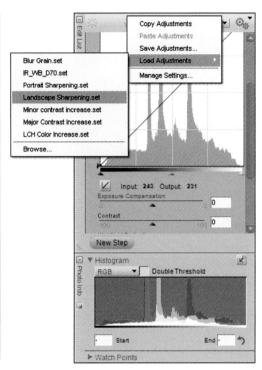

Figure 3.24

Default Workspaces

There are four default workspaces in Capture NX 2 as shown in Figure 3.25:

- **Browser:** Used to browse and sort through images.

- **Metadata:** Used to review and add metadata to images.

- **Multi-Purpose:** Used to browse and edit images at the same time.

- **Edit:** Used only when editing images.

To quickly access the Browser workspace, press Alt+1 (Option + 1) on your keyboard. I don't see any reason to change the default shortcuts unless you use these key combinations in other software packages.

My Workspaces

Use this section to manage your own custom workspaces. If you create your own custom work environment(s), then you can change a shortcut or delete it from this menu. Also, if you click Add, you can create a new workspace based on the current palette and screen arrangement you have selected. After you click Add, you're prompted to type a name for the new workspace.

Figure 3.25

Develop Pane Overview and Camera Settings

A lmost everything you do in Nikon Capture NX 2 is represented in the Edit List. White Balance, Highlight Recovery, Color Control Points, Crops, Rotations, Retouching Brush, Sharpening, Saturation, Hue, and Black & White Conversions all appear as New Steps on the right side of the workspace.

The Edit List has two main areas: the Develop pane and the Adjust pane. The Develop pane is used to change and apply RAW settings. In this chapter, I examine the Develop pane and explain how it affects your workflow.

Overview of the Develop Settings

The purpose of the Develop pane (Figure 4.1) is to allow you to work on the underlying RAW data of your photograph. All the fundamental settings for your NEF are included in this section. Any changes you make to your settings on items such as white balance, tonality, saturation, and noise reduction are being applied directly to the RAW data set.

Figure 4.1

It should be assumed that the changes you make here are more elemental (perhaps better) than the changes you might make in the Adjust pane. However, most of the changes you make in the Develop pane are very slow to render. For example, if you make a change to noise reduction, you'll quickly find out that it can take 30 seconds to 5 minutes for the effect to fully render, depending on the speed of your computer. Because of this issue, I recommend doing as few adjustments as possible in the Develop pane and doing as much of your work as you can in the Adjust pane.

Some things must be done in the Adjust pane, such as White Balance, Highlight Protection, and Moirè Reduction. But, there are many other things that you can accomplish just as well, and

much faster, in the Develop pane. These include adjustments like curves, noise reduction, and saturation. For example, you can make a curves adjustment in the Develop pane under Quick Fix, or you can do a curves adjustment as a New Step in the Adjust pane (Figure 4.2). Both fundamentally do the same thing, but the Quick Fix curve is working directly on the NEF data, while the Adjustment curve is working on top of the base NEF data.

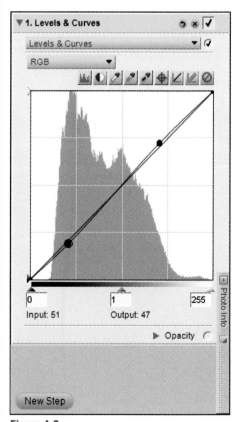

Figure 4.2

From a workflow standpoint, the time you spend in Capture NX 2 can be greatly reduced by performing your image enhancements in the Adjust pane rather than in the Develop pane. Do the minimum amount possible in the Develop pane, and then quickly move on to the Adjust pane. If necessary, I recommend doing the following things in the Develop pane:

- **White Balance**
- **Picture Control**
- **Exposure Compensation**
- **Highlight Protection**
- **Shadow Protection**
- **Color Moirè Reduction**
- **Image Dust Off**
- **Vignette Control**

Although you can make changes to the following settings in the Develop pane, I recommend performing them later in the Adjust pane:

- **Noise Reduction**
- **Curves**
- **Contrast**
- **Saturation**
- **Red-Eye Reduction**

Following this approach saves you lots of time, because these changes take more time to process in the Develop pane than they do as New Steps. Now, let's go into the settings and understand how they work.

Camera Settings

The Camera Settings area shown in Figure 4.3 is only available if you are working on a Nikon NEF image that was taken in a Nikon digital camera. This area won't be available if you are working on a JPEG or a TIFF. Camera Settings are primarily used when you want to change some of the RAW parameters of your image after you take the shot. For example, if you make a mistake with white balance when you take the photo, you can change it in the Camera Settings area of Capture NX 2. The adjustments that appear in the Camera Settings list are White Balance, Picture Control, and Noise Reduction.

White Balance

The purpose of white balance is to filter the colors in your image so that they have a neutral colorcast. White balance is one of the most important parameters in all of digital photography

because it has such a dramatic impact on the look of the photograph. You should endeavor to get your white balance set correctly in the field, at the time of exposure. However, if you don't set it correctly, or if you want to try a different value, then you can make those changes here.

Simply speaking, your goal with white balance is to render the whites in the scene so that they come out white in the photograph. When you set your white balance in the camera, you are technically modifying the colors of the image to neutralize the colorcast. If you take a photo with the correct white balance, then your image will have accurate colors. If you take a photo with an incorrect white balance, your image might come out looking too warm (red) or too cool (blue).

All light sources have a different *color temperature*, expressed in degrees *Kelvin*. A higher temperature light source gives off a blue

Figure 4.3

The color of light on a cloudy day has a blue cast. If you don't filter the light properly, then anything you photograph ends up with a blue colorcast in your image. The appropriate white balance setting for this type of photograph is Cloudy, or approximately 6,000K. This setting modifies the colors of the image by adding red so that your white shirt ends up looking white.

Many photographers like to shoot their photographs using the camera's Automatic White Balance setting. This allows your camera to evaluate the overall color of the image and then calculate what it thinks is the best white balance filter to apply. I find that the Auto White Balance setting on most cameras tends to give images an overall blue colorcast. Even the highest-end camera systems are often fooled by scenes that are dominated by one color or if there isn't a natural white present in the photo (like a cloud or a shirt). To show a real-world example of Auto White Balance, look at Figure 4.4. It shows the top image with Cloudy White Balance and the bottom image with Automatic White Balance. The difference in color is obvious. Auto White Balance adds a significant blue colorcast.

To get away from this blue bias that results from Automatic White Balance, my recommendation is to set your white balance manually in the field as you take your image. For example, if it is a cloudy day, then set your white balance for Cloudy. If you are indoors under incandescent lighting, then set your white balance for Incandescent. You will almost always find that manually setting your white balance in the camera leads to a more accurate color in your final image. Additionally, setting it correctly in the camera means that you don't have to fix it later in your computer!

colorcast. An example of a higher color temperature light source would be an overcast day (6,000K). A lower temperature light source, such as an incandescent light bulb (2,800K), gives off a red/orange colorcast.

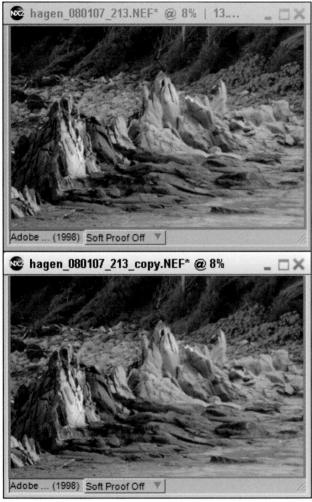

Figure 4.4

One of the advantages of shooting RAW images is that the white balance settings are only instructions for the file. What this means is that white balance can be changed at any time in the future. If you shoot a photograph with Cloudy White Balance, then that instruction is encoded into the RAW image file. You can choose to use that white balance setting (instruction), or you can choose to change it later in Capture NX 2.

There are two general approaches to changing white balance in Capture NX 2. The first method is by setting a color temperature that you decide you want for the image. This is called Set Color Temperature. The second method is by picking an area of the photograph that you know to be neutral color. This is called Set Gray Point. Let's go through each method.

Set Color Temperature

To access the white balance settings, click on the Develop pane, and then click the triangle next to Camera Settings. Select the Set Color Temperature option from the first drop-down list in the White Balance section (Figure 4.5). There is a text area that shows you what the Camera WB is for your image. In the example shown here, the Camera WB value was Cloudy, A2.

Figure 4.5

There are many times as a photographer that you want to see what different white balance settings might look like in your image. For example, maybe you took a photograph of a sunset and you originally used the Direct Sunlight white balance setting. If the photo doesn't look warm enough, you can change the value to something else, such as Cloudy or Shade, to see

how the image might respond. If you want to modify your original white balance setting, then make a change under the New WB drop-down list. There are nine choices (Figure 4.6).

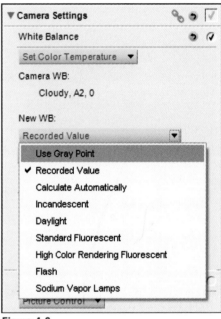

Figure 4.6

Here's a list of the White Balance values and when to use them:

- **Use Gray Point.** Use this when you have a neutral color element in the photo to set as a gray point value.

- **Recorded Value.** Use this when you are happy with the white balance value used when you captured the photo.

- **Calculate Automatically.** Use this when you want the camera to automatically select the white balance.

- **Incandescent.** Use this when the photo was taken with standard incandescent or tungsten light bulbs.

- **Daylight.** Use this when the photo was taken with ambient light generated by the sun (clouds, shade, direct sun).

- **Standard Fluorescent.** Use this when the photo was taken under fluorescent lights (approximately 4,200K).

- **High Color Rendering Fluorescent.** Use this when photo was taken under newer high-color rendering (full-spectrum) fluorescents.

- **Flash.** Use this when you use a flash (Speedlight or strobe) for the lighting in the photo.

- **Sodium Vapor Lamps.** Use this when the photo was taken under mixed lighting in a typical sports venue that uses sodium vapor lights.

Don't click the first choice in the list, Use Gray Point, because I cover this value in the next section after you learn about Set Gray Point. The Recorded Value is the white balance that you set in the camera when you took the image. If you like the way you set it in the camera, then just leave your white balance set for Recorded Value. Calculate Automatically sets the white balance the same way that your camera's Automatic White Balance calculates it when you take the photo. As mentioned earlier, I generally find that the Automatic White Balance setting results in a blue colorcast.

All six of the remaining options—Incandescent, Daylight, Standard Fluorescent, High Color Rendering Fluorescent, Flash, Sodium Vapor Lamps—are used when you have a general idea of the type of light that was used for the image. If you took the photograph on a cloudy day, then

you would choose Daylight. When you choose Daylight, you notice right away that the program activates another submenu where you can specify the type of daylight used in the photo, such as Direct Sun, Cloudy, or Shade.

After you choose the type of light, then you can further adjust the white balance by moving the Fine Adjustment slider. Moving the slider to a lower Kelvin value adds a blue cast to the image, while moving the slider to a higher value adds red. You should adjust this slider until you are happy with the results of the image.

Beyond the Kelvin values, you can also adjust the Tint. The purpose of Tint is to add either green or magenta to your image. The negative values add magenta, while the positive values add green. Most people don't have any need to adjust the Tint; however, this setting is generally used to correct for fluorescent lighting and other odd colorcasts you might come across. Most of the time, I leave Tint set at 0.

tip

I like to use Cloudy White Balance for my outdoor and travel photography. This gives my photographs a pleasing warm colorcast.

One of the most frequent questions people ask me at my workshops is whether there is a correct value for white balance. The answer is mostly "no," because if your photo looks good to you, then that's probably the correct white balance. I generally opt for a little bit warmer colorcast in my images. When I'm photographing outdoors, I generally use a white balance of 6,200K or so. If other people look at my images, they might think they are a bit too warm, and that's okay!

The point of the Set Color Temperature white balance tool is to give you creative control over your image. You wouldn't necessarily use this tool if perfect color accuracy was your goal. In that case, you would use the Set Gray Point value.

Set Gray Point

The Set Gray Point value (Figure 4.7) is used when you need perfect color accuracy in your image and you are using a tool like the WhiBal reference target or a standard gray card in your image. For example, if you want to take a photo of a bird and be sure that the color of the plumage is rendered accurately, then you would use the Set Gray Point value. On the other hand,

if you guess at the white balance (for example, Cloudy), then you are taking a chance that the colors might be off.

Sometimes it is okay to interpret the colors based on how you feel the photo should look, such as with a sunset or a landscape scene. In these cases, color accuracy isn't always the goal; rather, the feeling or mood is more important. However, there are many types of photographs in which it is critical that the colors in the image are perfect. For example, a company might hire you to photograph its new product for an advertising campaign. The campaign manager will want to make sure the colors of the product are rendered accurately, so you need to be spot-on with your white balance.

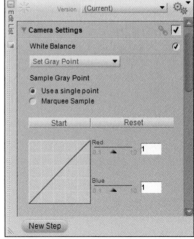

Figure 4.7

Typical situations in which you want to make sure that you have perfect colors include the following:

- **Portraits**

- **Weddings**

- **Product photography**

- **Advertising**

If you need color accuracy, then you'll want to use the Set Gray Point value shown in Figure 4.7. To use it properly, your picture needs something in it that is a truly neutral color (like the feathers on the pelican in Figure 4.7). Sometimes you luck out with your shot, and you have an element that is white or gray that you can use to set your colors. Shooting a wedding is a typical place where you have lots of whites and grays to choose from, such as the wedding dress or the gray cummerbund on a tuxedo. For example, in Figure 4.8, the bride's veil is a good place to set your gray point. Other times, however, you have to manufacture your neutral color in the photo by placing a gray target in the scene and then photographing it (Figure 4.9).

To use the Set Gray Point value, follow these steps:

1 Place a gray (or WhiBal) card into the scene.

2 Take a photo of the scene and card.

3 Remove the gray card and take the photo of the same scene without the gray card.

4 When you get back to your computer, use the photo that contains the gray card to set your white balance by activating the Set Gray Point value in Nikon Capture NX 2.

5 Decide if you want to sample a point or if you want to sample an area.
Sampling an area is generally more accurate. Sampling a point is used when your gray point is very small.

6 Click Start. If you are sampling an area, then click and drag your dropper symbol across a region of gray (Figure 4.10). If you are sampling a single point, just click on the gray point.

Figure 4.8

caution

Don't forget to click Start before you begin to sample the gray point in your photo. If you forget, then you won't actually sample the gray point.

Figure 4.9

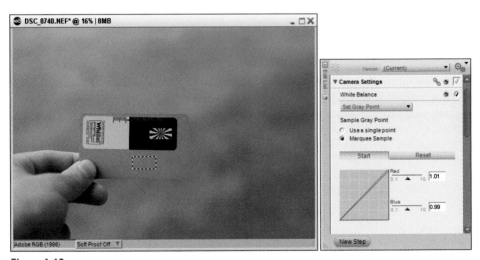

Figure 4.10

Beyond the Use a single point option and the Marquee Sample option, you can also manually change the ratios of red and blue by moving the sliders in the little graph below the Start button. In Nikon cameras, white balance is controlled by changing the percentages of blue and red. If you want to warm up the scene, simply move the Red slider to the right. If you want to cool the scene down, move the Blue slider to the right. Be careful though, because only a tiny adjustment in the slider results in a big change in the colors of the image.

If you are good at controlling the sliders, you can arrive at a decent white balance for your photo; however, I don't adjust these sliders in my real workflow because it takes too long to get an accurate result and I can almost always get a better white balance setting by using the other methods described previously.

Picture Control

Picture Controls are settings that help give your image a certain look. For example, you might like vivid images with lots of color saturation for your landscape photographs. In this case, you'd use the Vivid Picture Control. Alternatively, you might prefer using the Neutral Picture Control for your portrait photography so people's skin tones are rendered accurately.

The Picture Control options in the Camera Settings pane shown in Figure 4.11 change depending on the type of camera you use to take your image. For example, if your photo is from a Nikon D200, then Picture Control defaults to Non-Picture Control. If you use a newer camera like the D700, then your default choice will be

called Picture Control. Picture Control is a newer concept that was introduced with the Nikon D3 and D300 camera bodies and is now becoming the new standard for Nikon image files.

Non-Picture Control is the same thing as Optimize Image settings inside cameras such as the Nikon D2X, D200, D70, D80, D40, and D60 (see Figure 4.12). These are global changes aimed at setting your colors, contrast, hue, and initial sharpening. Making changes in the Non-Picture Control area results in exactly the same look and feel as if you set the same values in your camera.

Figure 4.12

Non-Picture Control (Optimize Image) settings are truly instructions to your NEF image that can be changed at any point in the future. In general, you should set these up in your camera body to help you achieve a certain look before you ever edit the photo on your computer. But if you want to change these settings later, you can make the changes in the Picture Control pane. Table 4.1 shows the five Non-Picture Control settings and how they are generally used.

Figure 4.11

Table 4.1
Non-Picture Control Settings

Setting	Description
Color Mode	Determines overall brightness and color gamut of the image
Sharpening	Enables you to adjust the amount of in-camera sharpening
Tone Compensation	Determines the image contrast that was set in the camera
Saturation	Determines the overall amount of color saturation that was set in the camera
Hue Adjustment	Allows you to alter the hue of the image without affecting brightness or saturation

Color Mode settings are used to help bias your image toward an overall color saturation. Figure 4.13 shows the Color Mode choices in Capture NX 2. Mode I is the lowest saturation mode and is generally used for portraiture. Mode II is the most accurate color mode and is used when you want a natural look to your image. Generally, Mode II is used for advertising or product photography where the client wants the most accurate colors possible. Mode III is the highest saturation color mode and should be used when you want your colors to really pop. I use Mode III for most of my travel and landscape photography. Table 4.2 summarizes each Color Mode setting.

Sharpening under the Non-Picture Control menu should really be termed capture sharpening in the sense that you are sharpening when you capture the image. This is different than output sharpening, which you typically do when you are preparing the image for print. I cover output sharpening in Chapter 7. My general approach is to leave the Picture Control (or Non-Picture Control) sharpening set to either none or low, because I prefer to sharpen my images at the end of my editing process by using the Unsharp Mask (USM) tool. I prefer this approach because

sharpening is an aggressive process that creates halos around the edges in the photograph. If you do it too early in the process, it can negatively affect the quality of your images.

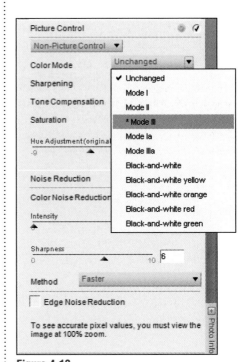

Figure 4.13

Table 4.2
Nikon Color Modes

Color Mode	Description
I	Low saturation. Used for portraiture.
II	Accurate colors. Used for advertising and product photography.
III	Highest saturation. Used for travel and landscape photography.
Ia	Low saturation. Used for portraiture. Optimized for inkjet printing.
IIIa	Highest saturation. Used for travel and landscape photography. Optimized for inkjet printing.
Black-and-white	Used for quick black-and-white conversions. (These aren't usually as good as doing a separate black-and-white conversion in the Adjust pane.)

Other photographers like to do a little bit of sharpening early in the process so the image looks sharp to their eyes while they are editing. Then they turn off the Picture Control sharpening before using the USM tool for output sharpening. I think this method is also a good approach, but it takes an extra step to remember to turn off Picture Control sharpening.

Figure 4.14 shows the Tone Compensation settings under Picture Control. Tone Compensation is used to either quickly add contrast or take away contrast from your image. In general, I keep Tone Compensation set for Normal.

see also

If I need to add contrast later, I use curves, contrast/brightness, or the LCH editor. Curves are discussed in Chapter 5 for the Quick Fix pane and in Chapter 7 for the Adjust pane. Contrast/brightness, the LCH editor, and Unsharp Mask are also discussed in Chapter 7.

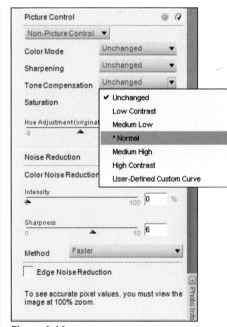

Figure 4.14

You can make some pretty creative photos by using different tone curves. In fact, you can even define your own tone curves by selecting User-Defined Custom Curve. I know of quite a few photographers who create their own custom curves and then upload them to their cameras to create their own signature style.

Saturation (see Figure 4.15) is used to quickly add punch to your image with some additional color right away. I set Saturation for Normal when I photograph people and set it for Enhanced when I photograph travel and landscape scenes. If you want to add more saturation to your image, I recommend using another tool in the Adjust pane, such as the LCH editor or a Color

Control Point. Both of these methods give you more control than the Saturation setting in the Picture Control area.

If you use a newer camera such as the Nikon D90, D300, D700, or D3, you use a different menu group called Picture Control, as shown in Figure 4.16. There are four native picture controls that are supplied from Nikon called Standard, Neutral, Vivid, and Monochrome. Additionally, there are three D2X simulation modes that allow your new D90/D700/D300/D3 camera to have the same look as the older D2X camera.

Finally, you have Hue Adjustment. To use this setting properly, you have to memorize the color wheel shown in Figure 4.17 and understand what happens when you rotate the wheel a few degrees clockwise or counterclockwise. This is fundamentally a color replacement tool.

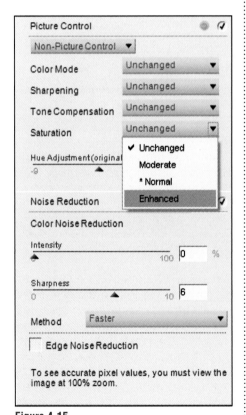

Figure 4.15

Figure 4.16

Figure 4.17

For example, if you set the adjustment for –9 degrees, then you replace all the colors in your image by another color on the color wheel that is 9 degrees apart. Say, for example, you are starting with the color red. If you rotate the color wheel 9 degrees clockwise, then the existing red colors turn more magenta. If you rotate the color wheel 9 degrees counterclockwise, then the existing red colors shift more orange. The truth is that most photographers don't use the Hue Adjustment Picture Control very often.

Picture Controls are a great way to be able to use different camera bodies on the same shoot while still having the same overall look for all your images. Since the inception of digital photography, professional photographers have always noticed color differences among their camera bodies. Thus, an image from a Nikon D70 would have a different look than an image from a Nikon D200. That made it difficult for a photographer to use different cameras on the same job. Now, with Picture Control, you can choose a group of settings across camera bodies and have the same resulting look. This is a great development!

As previously mentioned, the four default Picture Control choices are Standard, Neutral, Vivid, and Monochrome. Each of these options applies a group of settings to your image, and these settings can be individually modified by clicking the Advanced menu (see Figure 4.18). Here you can see the similarity to the Non-Picture Control settings discussed previously. The available settings are Sharpening, Contrast, Brightness, Saturation, and Hue.

Figure 4.18

Each Picture Control group setting (Standard, Neutral, Vivid, Monochrome) has different values for each of the Advanced settings. For example, Neutral has a very low saturation setting, while Vivid has a high saturation setting. Table 4.3 shows each of the standard Picture Control settings and their general settings.

To better understand what the Picture Control settings do, I put together an example of the four default Picture Control settings in Figure 4.19. The top left photo shows Standard control, the top right picture shows the Neutral control, the lower left photo shows the Vivid control, and the lower right photo shows the Monochrome control. Notice how the Vivid setting has the most color and the most contrast of all the images, while Neutral has the least color and least amount of contrast.

Table 4.3
Default Picture Control Settings

Picture Control	Description	Typical Uses
Standard	Applies slightly increased saturation, sharpening, and contrast.	Used for general photography.
Neutral	Applies a minimum amount of changes to image. No extra contrast, sharpening or saturation.	The goal is to maintain a neutral look. Used for portraits of people.
Vivid	Adds significant contrast, sharpening, and saturation.	Used for landscapes, travel, and nature when you want a vivid look to the photo.
Monochrome	Converts pictures to monochrome by eliminating all color.	Used for black-and-white, sepia, cyanotype, and so on.

When using Picture Control, I recommend setting your camera for Neutral when taking portraits of people. This helps ensure accurate skin colors that aren't oversaturated. I recommend Vivid for your travel and landscape photos to give the photos some additional color saturation and contrast.

Capture NX 2 also gives you the ability to create your own custom Picture Controls by using the Picture Control Utility (Figure 4.20) and saving them to a list. You can apply these settings to any NEF image you've ever taken with a Nikon digital camera by opening the photo in Capture NX 2 and selecting your custom Picture Control

Figure 4.19

from the drop-down list. Also, you can export any of your custom Picture Controls to your camera bodies by clicking Export in the Picture Control Utility, as shown in Figure 4.20. To activate the Picture Control Utility, click the box/ gear icon next to the Reset button in the Picture Control pane.

The Picture Control Utility allows you to design your own personal look and then save it for future images. Make a custom setting for your image and then click Export to save the new setting to your memory card. Insert the memory card in your camera and upload the new setting from your camera's menu.

Finally, I want to point out that you can apply the newer D700/D300/D90/D3 Picture Controls to older Nikon camera bodies. That's a wonderful thing, because you can now have the exact same look and feel to your images no matter what camera you are using. For example, if you are taking photos at a wedding with two camera bodies, like the Nikon D200 and the Nikon D700, you can process the files in Capture NX 2 and set both groups of images for the same Picture Control. There are several applications for this, such as shooting with different camera bodies during a vacation or perhaps matching new images with old images from a commercial photo job for a client.

Figure 4.20

To apply Picture Control settings to images from older camera bodies, follow these steps:

1 Open the Nikon NEF image from the older camera body in Capture NX 2.

2 Click the Picture Control drop-down list.

3 Choose Picture Control (rather than Non-Picture Control).

4 Select the Picture Control to apply to the image from the older camera.

Noise Reduction

The last setting in the Camera Settings menu is Noise Reduction (Figure 4.21). Taking photographs at higher ISO settings often results in your photos having a grainy look. This is a digital phenomenon called noise. Digital noise is generally considered to be a bad thing for your image, so Nikon Capture NX 2 has a Noise Reduction setting to help reduce the grainy look.

Figure 4.21

The Noise Reduction setting works well, but I urge you to be very careful when you are applying it because you can ruin an image very quickly. The reason why is that Noise Reduction is a setting that actually blurs pixels together to help remove the color noise you tend to get at high ISO values.

There are two sliders you can choose: Intensity and Sharpness. The higher you raise the Intensity, the lower the noise. However, the price you pay with more noise reduction is a softer (blurrier) photograph. To counteract the softening from the Intensity slider, you can increase the Sharpness setting. Adjusting these two settings is kind of like pushing the gas pedal and the brake pedal in your car at the same time. Each fights the other.

If you apply Noise Reduction in the Camera Settings pane, you are effectively applying it globally. In other words, you are applying the noise reduction to all areas of the photograph. Figure 4.22 shows what it looks like when you globally apply noise reduction to an image. This photo has an intensity level of 27% and a Sharpness level of 5. There isn't any noise now, but the Noise Reduction totally wiped out all the detail and sharpness in the elk's fur coat. Sometimes, finding the right balance between the two is very difficult.

Typically, the only areas in a photo that really need noise reduction are the shadow regions of the image. This is because the shadows are where your image is underexposed and where the camera has a hard time detecting detail. If you do try to brighten the shadows in Capture NX 2, noise frequently becomes very apparent.

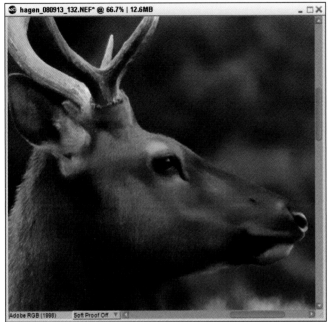

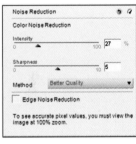

Figure 4.22

The best way to apply noise reduction is to simply paint it into only the areas that need it. As you'll learn in Chapter 7, if you apply Noise Reduction as a New Step (rather than in the Develop pane), then you can apply the effect locally rather than globally by using a selection tool. In other words, you can paint in the noise reduction for the shadows where it is most needed and leave out the noise reduction for the midtones and highlights of the photo.

Edge Noise Reduction

There is only one choice available for Edge Noise Reduction: on or off. Turn it on by clicking the check box (Figure 4.23). The concept of edge noise reduction is a little difficult to wrap your head around, but sometimes noise artifacts are easier to

see on edges than they are on surfaces. This is because noise frequently looks jaggy or splotchy and can make a straight edge look bumpy.

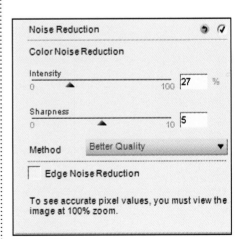

Figure 4.23

In order to see the effects of Edge Noise Reduction, you have to zoom in to 100%. The effect is subtle and sometimes almost impossible to see. Use this setting if you notice any jags appearing along lines or edges in your photograph.

Active D-Lighting

Finally, one additional setting is available to you in the Camera Settings pane if Active D-Lighting was activated in your camera body before you took a photograph. For example, the D700, D300, D90, and D3 cameras allow you to activate a command called Active D-Lighting that helps you bring out the shadow detail in high-contrast images. Figure 4.24 shows what this menu item looks like in the D700 camera.

The menu item in Capture NX 2 (Figure 4.25) allows you to change the amount that the program amplifies shadow data. When you take an image in your camera with Active D-Lighting turned on, it actually underexposes by a little bit in order to preserve highlight details while also amplifying the brightness in the shadows. If you turn off Active D-Lighting in Capture NX 2 after you've taken the image, then all you are really doing is turning off the shadow enhancement.

Figure 4.26 shows the dramatic effect Active D-Lighting has on your photographs. The image on the left has Active D-Lighting turned on to High, while the image on the right has Active D-Lighting turned off. I generally set Active D-Lighting for High whenever I'm taking images of landscapes, sunsets, or any other high-contrast scene.

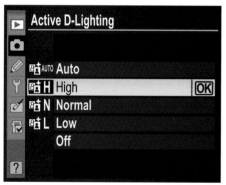

Figure 4.24

Figure 4.25

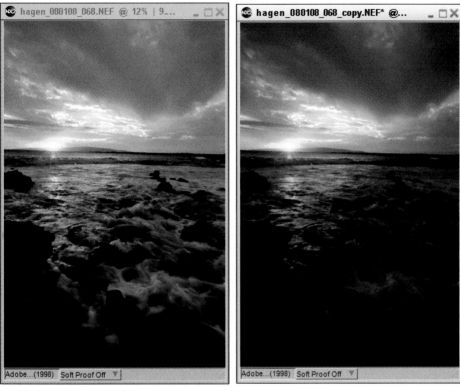

Figure 4.26

Develop Pane Quick Fix and Corrections

The Quick Fix pane is designed to enable you to literally make quick fixes to your image without having to open up New Steps or use Control Points. After setting your white balance and Picture Control in the Camera Settings pane, the next step in your Capture NX 2 workflow is to make adjustments in the Quick Fix pane and the Camera & Lens Corrections pane. These areas don't always need to be used in your workflow, but there are a few good tools that are beneficial to enhancing your images.

I will also show you how to use the Photo Info palette to make good judgments when adjusting your images. Let's start with the Quick Fix settings.

The Quick Fix Pane

Figure 5.1 shows the Quick Fix pane with Curves, Exposure Compensation, Contrast, Highlight Protection, Shadow Protection, and Saturation. As I described in Chapter 4, changes you make in the Develop section of Capture NX 2 work directly from the RAW data of the image. The changes you make here impact all pixels in the image, hence the term global adjustments. This is in contrast to a change you'd make in the

Adjust pane, which would allow you to selectively apply the change using a selection tool, such as the Selection Control Point tool or the Selection Brush tool.

From a workflow standpoint, you can use the Quick Fix tools in place of other tools, such as New Steps or Control Points in the Adjust pane. Use the Quick Fix section if the changes you want to make need

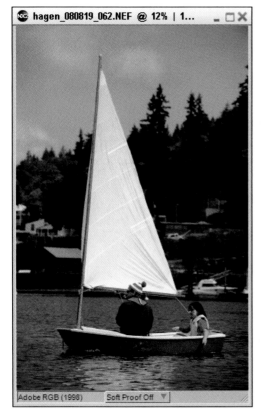

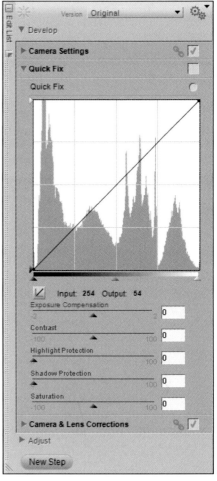

Figure 5.1

to be applied globally. However, if you need to brighten up one section of the photograph, such as the blue sky, then it is best to do your fixes in the lower Adjust pane by using a Control Point or a New Step. The general approach to using the Quick Fix section is to start with the curve and then work your way down through the Exposure Compensation, Contrast, Highlight Protection, Shadow Protection, and Saturation adjustments.

Curves/Levels/Histogram screen

The curve in the Curves/Levels/Histogram screen is actually a combination of both the Levels adjustment and the Curves adjustment. You can modify the Levels adjustment by clicking and dragging the black, gray, and white sliders at the bottom of the graph (Figure 5.2). You can modify the curve just like you would with any other image-editing program. Click on the diagonal line and then lift up or down on the line to change brightness.

Curves

A curve graph is organized in a way that helps you make tonality (brightness) adjustments to your photograph. The bottom axis of the curve represents the original data of the image, with shadows/blacks on the left and highlights/whites on the right. In the middle of the axis are the midtones/grays. This axis has a numerical scale from 0 to 255. The number 0 represents pure black, the number 255 represents pure white, and the middle tonality is 128. Photographers often refer to middle brightness (midtone) as level 128.

The vertical axis of the curve represents the new data for the image; otherwise called the output. The bottom of the axis is level 0, the top of the axis is level 255, and the middle is 128. If you

have a perfectly diagonal line from the lower left to the upper right, such as the one in Figure 5.1, then all the data from the original photo will be the same as the data in the new photo.

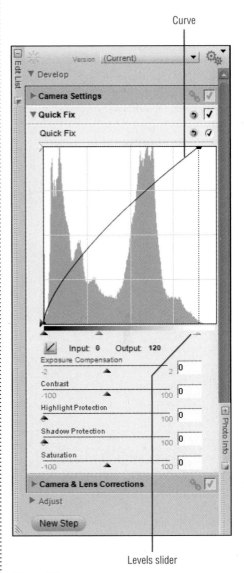

Figure 5.2

If you take the middle of the curve and lift it up as in Figure 5.3, the photo gets brighter. In this example, the input value is 128 and the output value is 192. Conversely, the photo gets darker if you click and drag the curve down. If you place your mouse on the point you just created on the curve, you can see the numerical values of the Input (original) data and the Output (new) data at the bottom of the graph.

If you lift up the right side of the curve, you increase the brightness in the highlights; if you pull down the left side of the curve, you decrease the brightness in the shadows. This is called a high-contrast s-curve and is shown in Figure 5.4. Most photographs benefit from a subtle s-curve to slightly increase the contrast. In this photo, a high-contrast curve causes the boat to stand out from the dark background because the curve brightens bright pixels (sail) and darkens the shadows (trees).

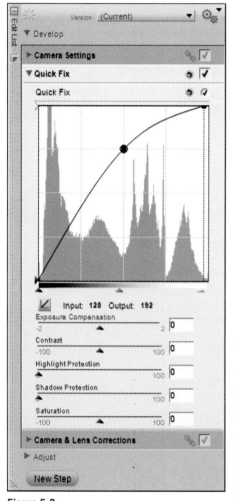

Figure 5.3

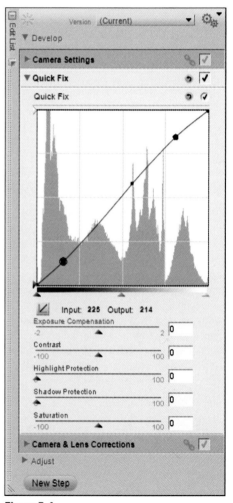

Figure 5.4

If you want to decrease the contrast in the photo, draw a reverse s-curve like the one shown in Figure 5.5. You use this type of curve when you want to suppress the highlights while increasing brightness in the shadows.

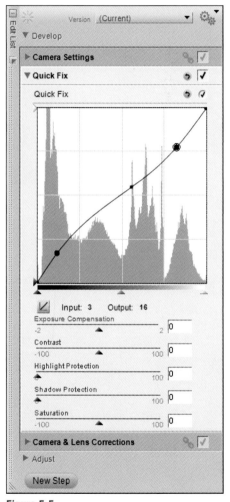

Figure 5.5

You can place up to 18 points on a curve, but the reality is that you don't need any more than two or three. In general, you are going to make an adjustment to the highlights, another in the shadows, and perhaps one in the midtones. Also keep in mind that you generally only need to make a small adjustment for a curve to do its magic. Don't draw big sweeping curves and expect your photographs to still look good. If you do, you end up with significant discolorations and a lot of digital artifacts. Keep your curves simple and controlled.

Note that when you move your mouse in the photograph, a tiny dot slides up and down the curve. The dot's position changes depending on the brightness of the pixel that your mouse hovers over. If you place your mouse over a white cloud, for example, the dot is positioned in the upper-right corner of the curve. On the other hand, if you place your mouse over a dark region, the dot is positioned in the lower-left corner. The purpose of the dot is to give you information about the brightness of the pixels in your photograph.

If you want to darken the clouds, hover your mouse over the clouds and look at the position of the dot on the curve. Then click and drag the curve down from this area until you're happy with the change. I use this feature all the time when I make adjustments. For a portrait, I hover my mouse over the model's face and then make the adjustment in the correct tonal range.

The vertical axis of the curve also has adjustments you can make. There is a black slider at the bottom and a white slider at the top that you can use to adjust the minimum and maximum output levels for the new photograph. Most of the time, these can be left at 0 and 255, but you can change them if you want. Moving the black slider upward causes your blacks to become brighter, or grayer. Sometimes you'll do this to try and retain some detail in the shadows of your image. Moving the white slider downward causes your whites to become darker, or grayer. Sometimes you'll do this to retain detail in the highlights.

Histogram

Another important note about the curve is that the histogram for the image is shown behind the curve. The histogram always shows the original data of the photo, even when you make changes to the curve. In other words, it doesn't change in real time based on each new curve change. If you want to see the histogram change in real time, watch the Photo Info palette at the bottom of the window. Your histogram is a tool that you can use to help you judge the changes you make on your image.

If your histogram shows data all the way over to the right side and you try to increase the brightness of your photo, then you run the risk of blowing out the highlights in the image. For example, If there is data against the right edge of the histogram and you increase the brightness of the photo, that data is pushed beyond level 255 and becomes washed out. The histogram is a great tool to help maintain detail in the highlights and shadows.

Levels

The three sliders at the bottom of the Quick Fix curve should be used simultaneously when adjusting the curve. The left slider is colored black and represents level 0. The right slider is white and represents level 255, and the middle slider is gray and represents level 128. Figure 5.6 identifies each of these sliders.

The black slider defines the black point of the photo, and the white slider defines the white point of the photo. For example, if you move the black slider to the right, you effectively define brighter pixels as the new black point. This has the effect of darkening your photograph. In contrast, if you move the white slider to the left, you effectively define darker pixels as the new white point, which brightens your photo.

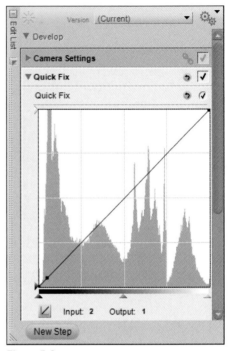

Figure 5.6

Typically, you want to move the black point slider and the white point slider to the location at which your histogram data starts. Figure 5.7 shows a good example of a photo that needs some brightening. The photo on the left is the original, and the photo on the right is the same image after a quick levels adjustment. You can see that I moved the white slider down until it met the beginning of the data in the histogram. This effectively sets those pixels as the new white point value.

Notice that I didn't make any adjustment to the black slider, because this part of the histogram already has data right to the edge. Moving the black slider to the right would darken the shadows even more. You probably noticed that I changed the middle gray slider as well. I moved

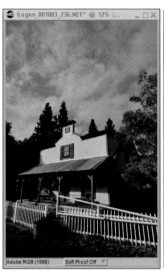 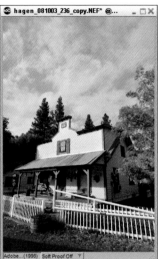 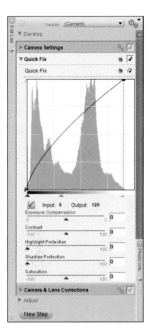

Figure 5.7

it to the left, which increases the brightness of the midtones in the image. For this photo, the midtones are the tree leaves and the blue sky.

tip

Moving the midtone slider to the left brightens the photo. Moving it to the right darkens the photo.

If you want to reset the curve and levels adjustments back to the starting point (default), click the small curve icon with the straight line, which is found below the main curve. This straightens the curve, removes all your curve points, and sets the levels sliders back to 0, 128, and 255. Alternatively, you can remove your curve points one by one by clicking and dragging them off the edge of the graph.

Exposure Compensation

Exposure Compensation is used to brighten or darken all pixels in a photograph. You accomplish this by adjusting the slider to the right or left, which increases or decreases the overall brightness of the photo by moving the histogram to the left or right. The numerical values are supposed to approximate brightness changes in terms of photographic stops. For example, a +1 value closely mimics an increase of one stop in brightness in your image. The hope is that the result is similar to a +1 exposure compensation in your camera.

The main purpose of the tool is to help you brighten or darken photos that were poorly exposed in the camera. You need to be careful about making changes with this tool, however, because it affects all pixels by the same amount.

If your histogram looks like the one in Figure 5.8 and you increase Exposure Compensation, you will quickly clip a large percentage of the whites in the sail and in the clouds.

I recommend changing the Exposure Compensation only if the photo you are working on is dramatically underexposed. That way, you can brighten the photograph without running the risk of clipping the highlights. If you do end up losing highlight detail when using the Exposure Compensation slider, try to recover some of those lost highlights with the Highlight Protection tool (covered later in the chapter). Generally speaking, the Curves/Levels tool is probably a better choice if you need to add a little brightness to the photograph because you have much more control over the highlights, midtones, and shadows.

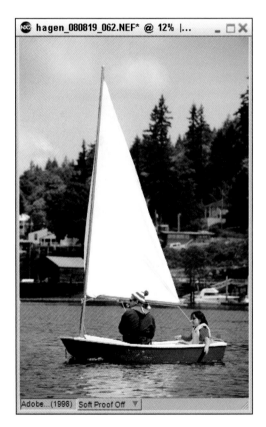
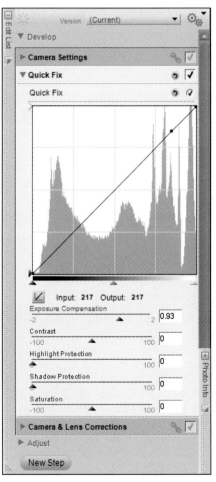

Figure 5.8

This tool isn't the same as doing exposure compensation in your camera. Fundamentally, exposure compensation in your camera changes the actual shutter speed and/or aperture to allow more light onto the sensor. A +1 adjustment in the camera actually doubles the amount of light (photos) that lands on the sensor. In comparison, Exposure Compensation in Capture NX 2 moves the histogram to the right or to the left only. It makes existing image data brighter or darker.

One final note: The Exposure Compensation slider is only available on NEF images and isn't available for JPEGs or TIFFs.

The Contrast slider

The Contrast slider gives you a quick and easy way to control the contrast of an image. Contrast is defined as the difference in brightness between the shadows and highlights. A high-contrast image has a lot of blacks and whites, whereas a low-contrast image has more midtones and grays. Figure 5.9 shows the same image with two different contrast settings. The photo on the left has a contrast value of +75, whereas the photo on the right has a contrast value of −75.

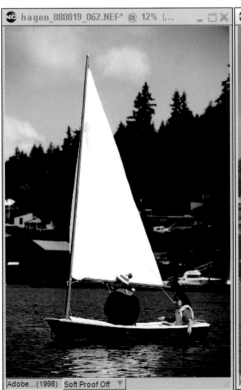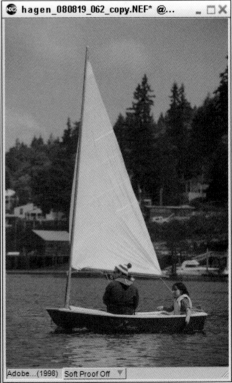

Figure 5.9

The Contrast slider either squishes the histogram toward the middle or stretches it out toward the edges. Low contrast means that all pixels are pushed toward middle tonality. High contrast means that all pixels are pushed toward the highlights or shadows.

This is a relatively heavy-handed tool and not useful for subtle image enhancement. Just like with the Exposure Compensation tool, if you want to make subtle changes to contrast, it is probably best to draw an s-curve in the Curves/Levels tool for more control. For most of my work, I leave the Contrast setting at 0 because I like to add contrast using other tools, such as Control Points, New Steps, or curves.

The Highlight Protection slider

I think the most useful tool in the entire Quick Fix pane is the Highlight Protection slider. This tool alone is worth its weight in gold because of how many times it has saved my photos from deletion. Its purpose is to help recover the lost highlights in an image, and I've used it more times than I can count to pull back details in white shirts, snow, wedding dresses, and clouds.

Move this slider up as high as you need to go in order to push detail back into the highlights. In the photo in Figure 5.10, I used a Highlight Protection value of 67 to push detail back into the sail of the boat. If you watch the histogram closely when you make the change, you'll notice that just the right side is affected by the slider. This is great, because it doesn't change the overall tonality of the image; rather, it just moves the highlights down from level 255 to a lower level.

A value of 0 means that there is no change to the image, whereas a value of 100 is the maximum amount of recovery possible. If you haven't recovered enough highlight detail at the setting of 100, then your highlights were exposed beyond recovery. The Highlight Protection tool can't recover data that isn't there, but it can help recover data that is very close to the edge of the histogram.

The general approach to using the Highlight Protection tool is to move the slider just to the point where you regain your highlight details. If you move it too far beyond that amount, then your highlights might actually turn out looking a bit gray and dull. That being said, there's no problem with setting the slider to 100 in order to recover details that might have otherwise been lost. It is a bigger problem to have no highlight detail than it is to have somewhat gray highlights.

The Shadow Protection tool

Just as the Highlight Protection tool helps regain lost highlights, the Shadow Protection tool helps recover details in the shadows. This is another tool I use extensively in my workflow because it works so well. To recover shadow detail, move the slider to the right until you are happy with the adjustment. In Figure 5.11, I used a Shadow Protection value of 29 to bring out more detail in the trees behind the sailboat.

If you pay attention to the histogram when you move the slider, you can see that this tool modifies only the left side. It doesn't change the overall tonality of the image, but increases the brightness of the darkest areas.

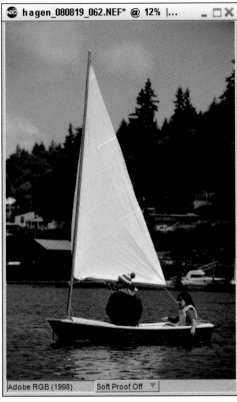

Figure 5.10

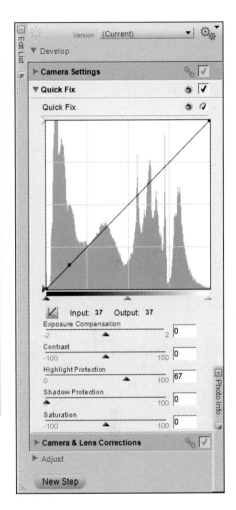

Be careful that you don't increase the Shadow Protection value too far. If you do, you run the risk of bringing out noise from the shadows. The noise always appears as blotchiness or graininess where it used to be solid black. Increase the slider to the point at which you can see the shadow detail and then back it off slightly. You might also try zooming in to 100% to see whether you can detect any noise. If so, then back off the slider or apply Noise Reduction to fix the noise problem.

It's okay to use the Shadow Protection tool and the Highlight Protection tool on the same photograph. I frequently use both tools on the same image, especially if it is a high-contrast photo like the sailboat in Figure 5.11.

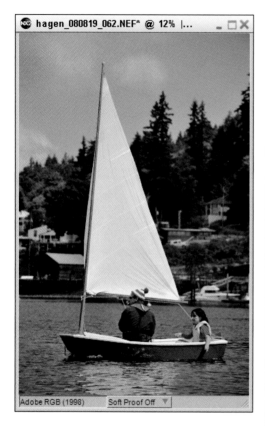

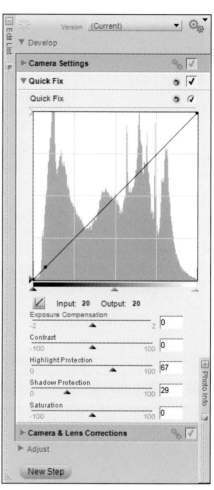

Figure 5.11

The Saturation slider

The last tool in the Quick Fix pane is the Saturation slider. This tool simply increases or decreases color saturation globally throughout the image. It takes all colors and applies an equal amount of saturation to every pixel. It is a pretty heavy-handed adjustment and can make your photo look too garish if you move the slider too far. In the example in Figure 5.12, I set the Saturation for +50. I think it is too much. What do you think?

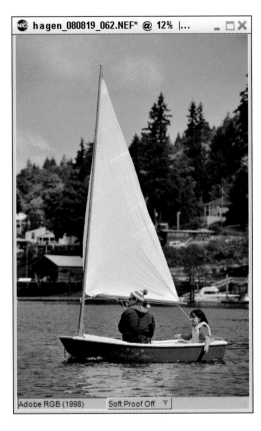

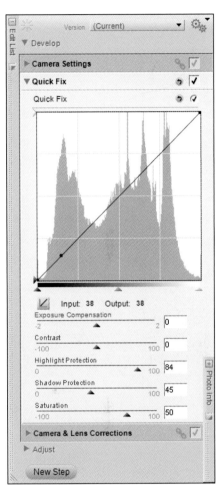

Figure 5.12

Every photo is different, so the setting you choose for your own photograph will vary. Sometimes setting the saturation to +5 results in a beautiful shot, and other times, you need +75 to make the photo look right.

In my workflow, I rarely adjust the Saturation slider in the Quick Fix pane. The reason is that there are better tools for doing this, such as the Color Control Point or the LCH editor in the Adjust pane. These other tools provide

substantially more control and have the added benefit of allowing you to selectively apply the adjustment to specific areas of the photograph in conjunction with a selection tool.

Just as the title says, this is a quick fix and is aimed at quickly making adjustments to your images when you are in a hurry. If you understand these limitations, go ahead and use the tools in the Quick Fix pane.

Before moving on to the Camera & Lens Corrections pane, I want to point out one final thing: You can reset the settings for the entire pane by clicking on the Reset button, which is the circular arrow at the top of the pane (Figure 5.13). This resets every setting in the Quick Fix pane to the default value.

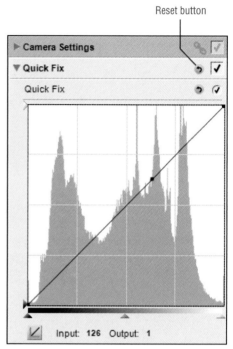

Reset button

Figure 5.13

Camera & Lens Corrections

The Camera & Lens Corrections pane is the last section of the Develop Pane, and it isn't usually applied to your image unless you have some obvious moiré, color aberration, red-eye, or vignette problems in your photo. If you are happy with your image after adjusting the Camera Settings and the Quick Fix pane, feel free to skip over the adjustments in Camera & Lens Corrections (Figure 5.14) and move directly into the Adjust pane.

Figure 5.14

Color Moiré Reduction

Moiré patterns appear in your image when you take photographs of regular repeating textures. For example, if your image contains a screen door, you might see a mild discoloration pattern appear over the area of the screen. The discoloration looks like a bunch of wavy lines and sometimes comes out brown, green, purple, or some other unpleasing hue. The example shown in Figure 5.15 has purple lines on the right side of the screen door mesh.

Figure 5.15

Moiré patterns appear in digital photographs because the pattern of the mesh matches closely with the pattern of the camera's sensor. The sensor has a hard time determining how to interpret the tightly repeating patterns and creates an unwanted wavy pattern in these regions. If the patterns appear in your photograph

and you want to eliminate them, place a check mark in the circle next to the step. Next, click the drop-down list to choose the strength of the pattern reduction.

I encourage you to use the lowest strength possible that removes the moiré pattern. A stronger setting can adversely affect the rest of the photograph and might cause it to become soft. Moiré reduction is actually a noise-reduction utility and works by blurring the pixels to help reduce the pattern generation.

Note that Moiré Reduction is not available on JPEG and TIFF images.

Image Dust Off

This tool is used to automatically remove dust spots from your images that are caused by dust on your camera's sensor. Image Dust Off registers the dust's location on your sensor and then automatically clones out the dust in your affected photographs. Using the tool requires some forethought, however, because you have to take a Dust off ref photo in your camera body before you use the tool.

For example, if you were on a trip to the Gobi Desert and noticed your photos had dust spots, you would then go to your camera's menu system and choose the Dust off ref photo function, such as shown in the D700 in Figure 5.16. Your camera maps the location of dust in a special RAW file called an NDF (Nikon Dust File). Make sure that you never delete that NDF photo because you use it in Capture NX 2 to remove the dust from your real photographs.

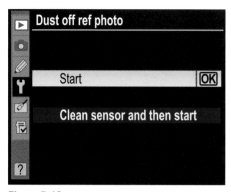

Figure 5.16

When you get back to your computer, download the NDF image to the same folder of images that have dust on them. Open any of your NEF photographs that have dust in Capture NX 2 and activate the Image Dust Off function (Figure 5.17). The Dust off ref photo can only be used on NEF images and isn't an option available on JPEG or TIFFs.

You need to tell Nikon Capture NX 2 where the photo is, so click Change to point it to the correct folder where the NDF file is stored. After you make the selection, Capture NX 2 automatically removes any dust from the image by cloning nearby pixels over the dust spots.

Figure 5.17

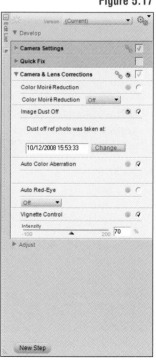

This can be a big timesaver if you have hundreds of photos with dust on them and you had the forethought to take a Dust off ref photo in your camera. You can automate this step by using the batch processing utility to fix the dust on all images that were affected by the same sensor dust.

caution

One note of caution: If your sensor gets another piece of dust on it, then you need to take another NDF image for Capture NX 2 to fix the dust.

Auto Color Aberration

If you use lower-quality third-party lenses in your photography, you might find color fringing or halos around the edges of your subjects. This color aberration typically appears along things like telephone lines or tree branches, and it looks like a purple, cyan, or red fringe that bleeds into the surrounding photo. Usually, fringing is not noticeable unless you zoom in to 100 percent and look carefully at transitions between light and dark elements in the image.

By default, this feature is always turned on for NEF images, and I recommend keeping it set that way. It doesn't adversely impact your image if you don't have fringing, but it does dramatically help eliminate color aberration if it does exist. Figure 5.18 shows an example of where this tool helps the image. The top photo has the Auto Color Aberration control turned on, whereas the bottom photo has Auto Color Aberration turned off.

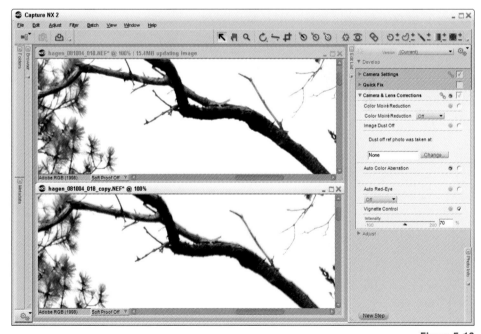

Figure 5.18

The difference in the two photographs is dramatic! The bottom photo has a significant amount of cyan fringing on the top of the branch and red fringing along the bottom of the branch. The Auto Color Aberration control removes all the fringing and cleans the photo right up!

The Color Aberration Control tool is a separate tool in Capture NX 2 that gives you more control over color aberration. You find this tool by clicking the New Step button in the Edit List, then choosing Select Adjustment → Correct → Color Aberration Control.

see also

For more details on Color Aberration Control, see Chapter 7.

Auto Red-Eye

If your photograph contains red-eye, then turning on this feature allows Capture NX 2 to automatically remove red-eye in your subject's eyes. Auto Red-Eye is available for NEF, JPEG, and TIFF images and generally works very well, as you can see in Figure 5.19. The photo on the left is the original shot, and the photo on the right was fixed by turning on the Auto Red-Eye function.

If you find that the Auto Red-Eye tool doesn't successfully remove the red-eye, you can use the Red-Eye Control Point tool to do a better job, because this tool lets you manually click on the eyes to fix the red-eye.

Figure 5.19

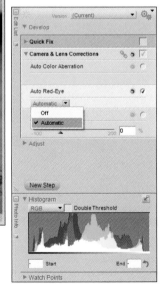

see also

For more on the Red-Eye Control Point tool, see Chapter 8.

Vignette Control

In photography, a vignette is defined as the darkening of the corners in an image. Sometimes a vignette helps the look of a photo by keeping the viewer's eyes centered on the subject. Other times, a vignette is considered a detracting element in the photo, especially if it appears in an area of solid tonality like the sky (Figure 5.20).

Depending on your preference, you can use the Vignette Control slider to either add a vignette to or remove a vignette from a photo. Negative values increase vignetting at the corners, whereas positive values decrease vignetting.

Each lens that you own has a different vignette effect. Some lenses produce an obvious darkening of the corners, whereas others produce no

Figure 5.20

discernable vignetting. Vignetting also depends on which camera body you are using. For example, my Nikon 70-200mm f2.8 does not vignette at all on my DX sensor D300 camera, but it does produce a minor vignette on my full-frame FX sensor D700.

Fisheye Lens

This final setting in the Camera & Lens Correction pane is available only if the image was photographed using the Nikon 10.5mm f2.8 AF DX fisheye lens. A fisheye lens takes a photo with a 180-degree field of view. In order to accomplish this, the lens wildly distorts the scene and bends all the lines to make the image fit on the sensor. Figure 5.21 shows an example photo taken with the 10.5mm fisheye.

If you want to eliminate the distortion, you can turn this step on by placing a check mark in the circle in the corner of the setting window. This makes the image look as though it was taken with a lens with rectilinear correction. The top image in Figure 5.22 shows this effect. Activating the step actually crops out a substantial amount of information from the photo. This happens because you have to stretch the corners of the image in order to make lines in the image look straight.

Capture NX 2 gives you the option of keeping all the data in the photo by selecting the Include areas where there is no image data option. The bottom photo in Figure 5.22 shows what this looks like. You can then crop the photo to your liking or even create a panorama. Capture NX 2 also lets you choose what color to place in the empty areas by clicking the drop-down list. I chose white for this example.

That sums up all the controls available in the Camera & Lens Corrections pane. Before moving on to the Adjust pane, I want to make sure you understand how to use the Photo Info palette.

Figure 5.21

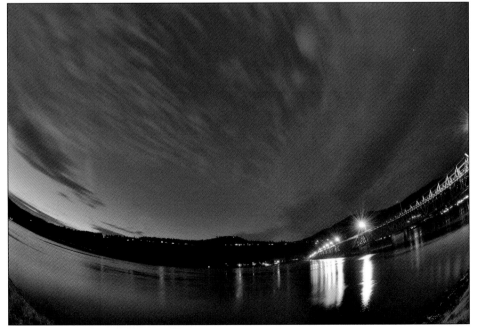

Figure 5.22

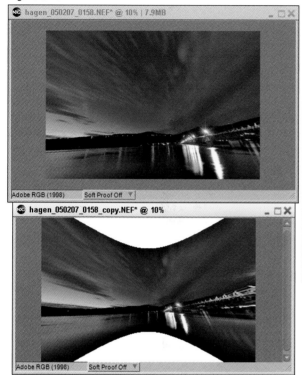
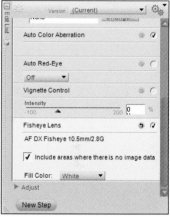

Using the Photo Info Palette

The Photo Info palette is found at the bottom of the screen in Capture NX 2. There are two sizes for this palette, small and large. Use the larger size if you want to have a more detailed view of the histogram. To activate the larger size, click the small box in the upper right of the palette (Figure 5.23). Also, to access all the features of the palette, click the small triangle next to the Watch Points section.

Purpose of the palette

The purpose of the Photo Info palette is to show you the highlights and shadows in your image so that you don't lose them while making adjustments. The goal in a lot of your image editing is to preserve highlight and shadow detail, and the Photo Info palette helps you do that through the use of the Histogram, the Double Threshold, and Watch Points.

The typical example for where the Photo Info palette can be helpful is in a high-contrast image like the one shown in Figure 5.25. Some of the Adirondack chairs are in bright sunlight, whereas other parts of the image, such as the tree trunks, are in deep shadow. If I want to add a curve or some additional saturation to the image, then I have to be careful that I don't blow out the highlights or lose detail in the shadows. The Photo Info palette gives me tools that help me watch or monitor the image in real time as I make changes.

Figure 5.23

Histogram

This histogram can be shown as an RGB composite or as a single channel. You make the selection for the histogram by clicking the drop-down list at the top of the palette. The composite histogram shows you all color channels together by overlaying the Red, Green, and Blue channels on one graph. By selecting another channel, such as the Red channel, you can have the histogram display only the red data for the photograph (Figure 5.24).

A histogram is a graphic representation of all the pixels in your photograph. The left side of the histogram represents the shadows, and the right side of the histogram represents the highlights. True black is equal to level 0 and is the farthest left data point in the histogram. True white is

equal to level 255 and is the data point farthest to the right in the histogram. Everything between level 0 and level 255 is a different brightness.

Figure 5.24

The height of the graph represents how many pixels are present at that brightness level. For example, the midpoint of the histogram is level 128. A big hump in the graph in the middle of the histogram means you have lots of midtones. Big spikes on the ends of the histogram mean you have lots of shadows and lots of highlights.

In the Adirondack chair photo, you can see that the right side of the histogram has a spike that butts up against the edge. This means that there are pixels in the photo that are at or above level 255. Anything above level 255 will be completely washed out when you print the photo. In other words, no ink will be put down on the paper during printing. It is always a good idea to know where these spots are in your photograph, and the histogram has a neat method for showing you where those blown-out areas are.

If you want to see just the highlights in this photograph, click and drag on the right side of the histogram, as shown in Figure 5.25. This causes Capture NX 2 to create a blinking region on your image that clearly shows the highlights (Figure 5.25). At the bottom of the histogram,

Figure 5.25

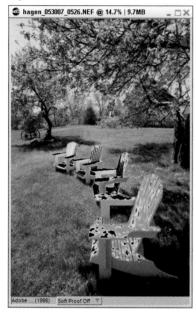

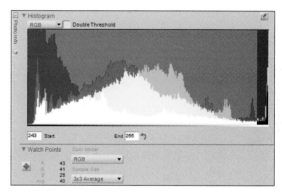

you'll see some numbers that say Start and End. These represent the tonal range that is now blinking in the photo. In this example, I have selected from level 243 to level 255.

You can do the same thing for the shadows in your photograph in order to quickly identify the locations where you might lose detail if you make the photo darker. I recommend highlighting from level 0 to level 7 to see which areas of the photo are in danger of losing detail. Notice when you highlight an area of the histogram that the photo blinks with the color that is being clipped. For example, if you highlight the left side of the histogram in Figure 5.25, you see large regions of blue blinking in the photo. This is because the Blue channel is being clipped in the shadows more than any of the other channels.

Now that you can see where the highlights and shadows exist in your image, you can make adjustments and watch those areas to make sure they don't move any closer to the edges of the histogram.

Double Threshold

The next utility to help you quickly find highlights and shadows is called the Double Threshold tool. Clicking the Double Threshold tool temporarily turns most, if not all, of the image gray. Anything that is colored gray lies between levels 0 and 255. In other words, anything that is gray isn't being clipped in the highlights or in the shadows. Figure 5.26 shows what the Adirondack chair photo looks like when you first click Double Threshold.

Figure 5.26

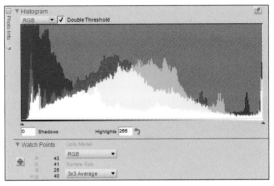

It is clear that the Adirondack chairs in the direct sun have portions that are being clipped in the highlights, because those sections have turned white in the Double Threshold view.

note

You can also try to recover some of these highlights in the Quick Fix pane by using the Highlight Protection slider.

If you move the sliders underneath the histogram, you can quickly see the regions of the photograph that are close to being clipped. Figure 5.27 shows that the white regions are highlights and black regions are shadows. In this case, the highlights are present on the tops of the chairs, while the shadows are under the trees.

As you make changes and improvements to your photograph, you should periodically click the Double Threshold tool to make sure that you aren't losing any more detail in the highlights and shadows. If you are losing detail, reduce the intensity of your adjustments until you don't see any problem areas. A good value for setting the Shadows threshold is about level 6 or 7. A good value for setting the Highlights threshold is around level 248 or 249.

You can type these values in the number boxes, or you can move the sliders with your mouse. Also, if you want to clear the Double Threshold range, just click the Reset button (the curved arrow) next to the Highlights number box.

It is important to note that Double Threshold doesn't actually alter your image in any way. It is just a tool to help you easily find the highlights and shadows in the photo. To turn off the gray Double Threshold view, deselect the check box.

Figure 5.27

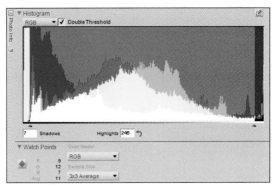

Watch Points

You use watch points to give you numerically accurate data about specific points in your photograph. Clicking the target button changes your mouse cursor to a crosshair and enables you to place a watch point directly on the image. You can place a total of four watch points in the photograph. You can move a watch point by clicking and dragging it to another position. You can remove a watch point by clicking the X in the Watch Point pane or by dragging the watch point off the photograph.

Watch points allow you to watch the brightness levels in your photo while you make adjustments. The watch points update their data in real time to let you know whether you are close to clipping the highlights or the shadows. Again, the number 255 means your pixels are completely blown out

with no detail, and the number 0 means your pixels are completely black with no detail. If your pixels are between 0 and 255, then technically detail still exists in that area.

For my fine-art prints, I generally use the Double Threshold tool to show me where my highlights and shadows are. Then I drop a watch point on both of those spots. As I make adjustments to the photograph, I can watch those points to make sure they stay between 6 and 249. The values 6 and 249 are good estimates to approximate the brightness values required for an ink jet printer to be able to print detail.

In Figure 5.28, you can see that Point 1 is at 254 for the highlights, and Point 2 is at 6 for the shadows. If I want to maintain detail in the highlights, I need to readjust my curve or use the Highlight Protection tool to bring down the brightness for this tonal range.

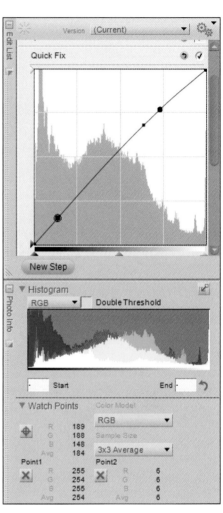

Figure 5.28

The watch point data is broken down into R, G, B, and Avg. The R value stands for Red channel brightness, G stands for Green, B stands for Blue, and Avg stands for the average of the three. When you are making adjustments to your image, you don't want any of the three color channels to clip (fall below 0 or above 255). If any channel does clip, then that region of your photo will have an odd colorcast during printing. Specifically, that color won't be represented in the final print.

see also

Printing is discussed in detail in Chapter 9.

As stated earlier, a good range in which to keep your levels is between 6 and 249. As long as all channels (R, G, B) are between these numbers, then your print will represent all the colors in the digital file.

There are a few different sample sizes you can use for the watch points. Figure 5.29 shows that you can use average sample sizes of 5x5 pixels, 3x3 pixels, or a Point Sample (single pixel). I generally set my sample size for 3x3. Use the larger size if you want to average an area such as a person's cheek. Use Point Sample if you want to know the brightness value of a specific pixel.

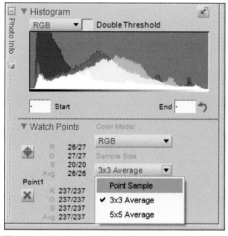

Figure 5.29

Figure 5.30 shows that there are two different color models you can use for Watch Points: RGB and HSB. RGB stands for Red, Green, Blue, while HSB stands for Hue, Saturation, Brightness. As already discussed, the RGB color model is built around brightness values from 0 to 255. This is the most common color model and is the easiest to use for your image editing.

The HSB model is a little more difficult to understand. Hue stands for the color of the pixel based on the 360-degree color wheel. For example, the color red is around 30 degrees on the color wheel, blue is somewhere around 275 degrees, and green is around 135 degrees. Saturation values range between 0 and 100, with 0 being no saturation and 100 being maximum saturation. Brightness is also a range between 0 and 100, with 0 being completely black and 100 being completely white.

I haven't used the HSB color model for any of my photo editing, and I doubt that you will either. Keep the color model set for RGB until you have a specific need to use the HSB model.

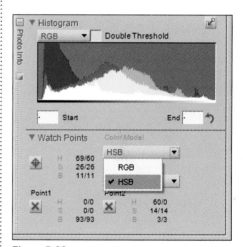

Figure 5.30

Using the Adjust Settings

After you work in the Develop pane, the next area you move to in your workflow is the Adjust pane. The settings and adjustments you perform here reflect the true power of Capture NX 2. The Adjust settings are powerful because they allow you to apply image enhancements locally or globally through the selection tools or through Control Points.

This chapter covers the background and general operation of the Adjust settings, including the theory behind New Steps and the correct approach to using them. Let's get right to it.

New Steps Overview

The New Steps pane in Capture NX 2 is found below the Develop pane on the right side of your screen (Figure 6.1). Just about any new adjustment you activate from the menu or from the New Step button appears in this pane as a New Step.

Figure 6.1

There are many ways to activate New Steps, and each of them adds an Adjustment step in the Edit List stack. You can activate a New Step in the following ways:

- Click the New Step button.

- Use the Adjust menu and select any of the settings.

- Use the Filter menu and select any of the settings.

- Click on a Control Point icon.

- Click on a Selection tool. Selection tools can be accessed through the Adjust menu, by choosing one of the Control Point tools, or by clicking the New Step button in the Develop pane.

When you activate a New Step by clicking the New Step button, the adjustment is unnamed and shows a drop-down menu titled Select Adjustment. In other words, the step doesn't have an adjustment applied to it yet. You have to click on the Select Adjustment menu to determine the adjustment the step will perform. Figure 6.2 shows an example of setting the adjustment for Saturation/Warmth.

There are quite a few adjustments you can select from the menu list, and many of them are found in the second-level menus from the Select Adjustment drop-down list. For example, to do a Saturation adjustment, as shown in Figure 6.3, choose New Step → Select Adjustment → Color → Saturation/Warmth.

Figure 6.2

Figure 6.3

When you activate a New Step by clicking a Control Point icon, the step looks a little different (Figure 6.3). For example, notice how the options in the step now include settings such as a color picker, size, and color percentages, as well as opacity adjustments.

see also

Chapter 8 covers the details of using Color Control Points.

Each of the adjustments in the Adjust pane (except for Control Points) can be changed to another adjustment if you want. To do this, simply click on the name of the adjustment and choose a new one. Everything in the Adjust pane area of the Edit List can be modified, changed, copied, or saved.

The great benefit of New Steps is that they are simply instruction files for the image that are nondestructively applied to the image and saved in the original RAW file. If you close your image and save all the changes as an NEF file, you can come back to the settings in the future and easily modify them should you want to change the look of the image.

Unlike traditional layers in Photoshop, a New Step does not duplicate the image and substantially increase the file size. Rather, New Steps are simply instructions that don't appreciably increase file size. New Steps are nondestructive in the sense that they do not affect the underlying NEF file in any way whatsoever. At any point in the future, you can eliminate a New Step, modify it, or even change what the New Step is supposed to be.

Understanding all the icons and check boxes in a New Step can be daunting the first time you work with the program. Figure 6.4 details the buttons and icons in the New Steps. The example here is for a D-Lighting adjustment, but the buttons are fairly consistent across all the adjustments in Capture NX 2.

In contrast, when you activate a New Step by using the Adjust Menu at the top of the screen, the New Step appears in the Edit List with the same name that you activated from the menu. If you choose to do a Black and White Conversion from the menu by choosing Filter→ Black and White Conversion, then the New Step appears right away with the name Black and White Conversion in the adjustment step.

Figure 6.4

Global versus local changes

As I mentioned in the introduction, New Steps can be applied globally or locally. A global adjustment is one that affects the entire image. For example, if you create a new black and white adjustment, then it affects all the pixels in the scene across the whole image. In the example shown in Figure 6.5, I added a New Step for Black and White Conversion. The left image is the original photo, and the right is the one with

the conversion. Obviously, the change to the image was global in the sense that all pixels in the image are now in grayscale.

If I don't want the conversion to be applied across the image, I can use a selection tool (such as the Selection Brush) to take the adjustment away from the top of the lighthouse, as shown in Figure 6.6. This is called a local adjustment, and it is done using a selection tool that creates a mask. Masks are covered in more detail later in this chapter.

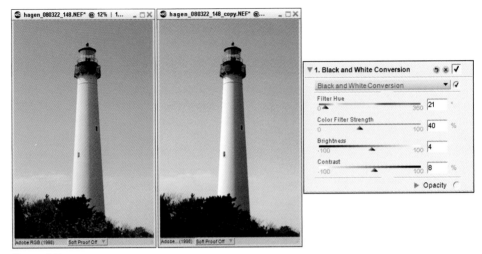

Figure 6.5

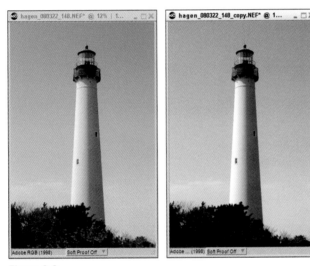

Figure 6.6

Correct order to apply New Steps

The order you apply adjustments can be important to creating an efficient workflow. You quickly find out that if you make a series of adjustments and then you want to go back to the top of your adjustments to change something, all the steps below that adjustment become inactive. It isn't a problem, but you have to go back through each of the steps and reactivate them, which takes more time.

Here's my suggestion for the order in which you should apply New Steps:

1. **Apply global tone and contrast adjustments, such as Levels & Curves, D-Lighting, White/Black/Neutral Control Points, and LCH Editor.**

2. **Add a Noise Reduction step if necessary.**

3. **Apply color and brightness adjustments, such as LCH Editor, Color Booster, Color Control Point, and Saturation/Warmth.**

4. **Fix blemishes with the Auto Retouch Brush and Red-Eye Reduction tool.**

5. **Prepare the image for output with the Size/Resolution and Crop tools.**

6. **Sharpen the image for output with the Unsharp Mask or High Pass.**

The general approach to working in Capture NX 2 is to start with the large fixes first, such as brightness, contrast, noise reduction, and color. Then, move into the local fixes, such as fixing the sky, the flowers, or a person's face. When the photo looks the way you want it, fix the little details such as dust, power lines, jet contrails, and red-eye. Finally, size your photo for output and sharpen it to your own preference.

I left out quite a few other options here in my workflow suggestions. For example, if you are doing a Black and White Conversion, do that first, and you won't have to do any color work. Additionally, if your photo needs a little Color Aberration Control or Gaussian Blur, then deciding where those steps go in the process is up to you.

In your workflow, you will invariably need to go back and modify one of the previous adjustments. When you do this, the adjustments below automatically turn off! Don't worry, nothing bad happened; it is just an idiosyncrasy of Capture NX 2. Go back through and click on the steps to reactivate them. One of the reasons why the steps turn off is to let you see the impact of the change you are making without the subsequent steps getting in the way. Another reason is to save computer processor resources, because every change you make has to be rendered through the subsequent steps, and that can take quite a while if you are using a slower computer. If you want to keep all the steps active when you make changes, put a check in the "Keep All Steps Active" box in the General Preferences dialog box (Edit ➤ Preferences).

If you get in the habit of making your adjustments in the correct order right from the beginning, then you won't have to go back through and reactivate each step one by one.

Using versions

Capture NX 2 enables you to make as many different versions of your photograph as you want and save all the versions in the same NEF file. For example, from a single image, you can create a black-and-white version, an 8-x-10-inch crop, a saturated color version, and a 20-x-30-inch enlargement, all without creating multiple copies of the same image. Each version you create is saved inside the NEF file as a separate instruction file. Figure 6.7 shows the Versions menu at the top of the Edit List.

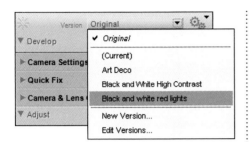

Figure 6.7

To create a new version, follow these steps:

1 Modify the image with adjustments, New Steps, control points, and so on.

2 Click the Versions menu and select New Version.

3 Name the version.

4 Click OK.

Adding a new version to your NEF file increases the size by a relatively small amount. If you start with a 15MB NEF, then creating a file with new versions can add anywhere between 1MB and 5MB of additional data to the file. This is a small penalty to pay for disk storage, especially if you consider how much space it takes to save three or four different photos from the same file in another image-editing program.

Accessing your versions is as simple as clicking the Versions menu at the top of the Edit List and choosing one of the items in the list. Figure 6.8 shows an example of four different versions of this classic 1956 Chevy taillight. Each version is from the same file, and I only have one image to track.

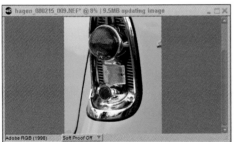

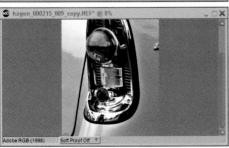

Figure 6.8

If you are working on a JPEG or TIFF image, you can still work with versions, but you have to save your JPEG/TIFF as an NEF in order to keep the versions. This is a great way for JPEG shooters to realize some of the benefits of working with RAW. Also, it is a great way for Canon, Olympus, and Pentax shooters to use their TIFFs/JPEGs in Capture NX 2. If you do shoot RAW from other camera manufacturers and want to edit those files in Capture NX 2, convert the image to a TIFF in Photoshop, and then open the TIFF in Capture NX 2 for more work.

Masks and Selections

The power of Capture NX 2 comes down to its capability to apply an adjustment to a local area, region, or color. In other editing programs like Photoshop, you sometimes have to work diligently to apply an adjustment to a particular region of a photograph. For example, if you wanted to change the color of the sky differently than you wanted to change the color of the library in the image shown in Figure 6.9, you'd have to expend a lot of effort making selections in some image-editing programs. In this example, the original image is on the left, and the modified image is on the right. I used control points to make selections for the sky, the building, and the grass. It was as easy as clicking on the image to selectively apply the saturation adjustments.

What is a selection?

Selections are used to allow or prevent changes to parts of a photograph. In a photo that includes blue sky, you might select the blue sky so that as you increase saturation, nothing else in the photograph is affected by the saturation. There are many ways to make selections in Capture NX 2,

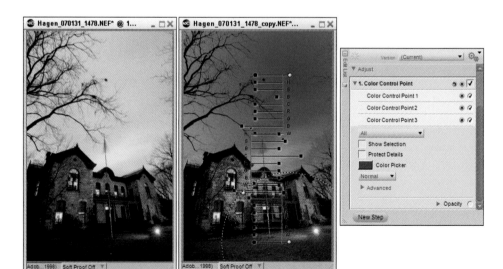

Figure 6.9

and all the selection tools are in the upper-right corner of the toolbar. Figure 6.10 shows all the selection tools and their names.

Selection control point Fill/Remove tool

Lasso Selection Selection
tool brush gradient

Figure 6.10

You can make a selection first by clicking on a selection tool, or you can make the adjustment first and add the selection later within the new adjustment step. In the first approach, you would follow this method:

1 Click on a selection tool, such as the Selection brush.

2 Create your selection on the photo.

3 Click the new adjustment step in the Edit List, and select the adjustment you want to apply to the Selection: for example, Curves, Saturation, Black/White Conversion, and so on.

The second approach works like this:

1 Make an adjustment to the photograph: for example, Curves, Saturation, or Black/White Conversion.

2 Click a selection tool, such as the Selection brush.

3 Create the selection on the photo so that the adjustment is applied only within your selection.

The second approach is more intuitive to me, so that's the one I typically use. I like to make the adjustment on the whole image and then use a selection tool to apply it to a local area.

Viewing the mask

After you create a selection, the adjustment step has a new area in it that lets you view the selection (or mask) in different ways. Figure 6.11 shows the three different viewing methods available from the Selection drop-down list. Each view gives you a different method for judging how well or poorly you have selected your region.

There are three primary ways to view the mask from the drop-down list in an adjustment step:

- **Hide selection.** This is the normal default view, and it shows the photograph without the selection in place. This view allows you to see the effect of your adjustment on the photograph.

- **Show overlay.** This allows you to quickly and easily see what is selected by viewing the green transparent overlay. Anything colored green is selected. Anything not colored green is not selected.

- **Show mask.** This displays the selected region in white and the concealed region in black. Memorizing this simple phrase can help you understand the masks: White reveals and black conceals. In other words, white allows the change to occur, while black prevents the change.

In Capture NX 2, all the selection tools at the top of the screen have a plus symbol and a minus symbol next to them. The plus symbol allows the adjustment to happen inside the selection and the minus symbol prevents the adjustment from happening inside the selection. Another way to

look at it is that plus reveals the adjustment and minus conceals the adjustment. You use the plus/minus symbols quite often when you work on your images. For example, in this photo of the sunset (Figure 6.12), I used the Plus Selection

Gradient to apply a Curves adjustment just to the water. The top photo shows the effect of the selection in the water, and the bottom photo shows what the selection looks like. Remember, white reveals and black conceals.

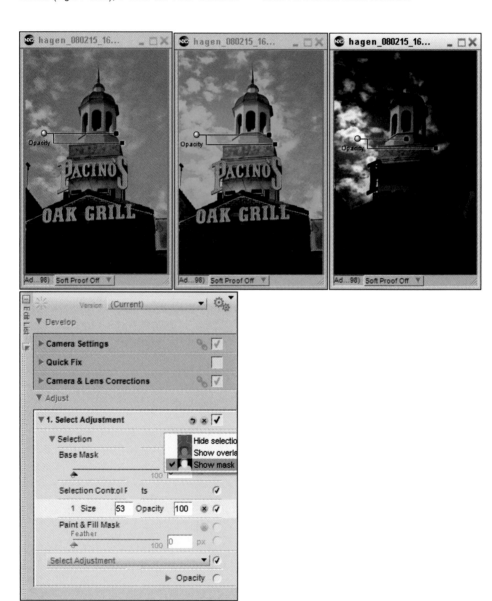

Figure 6.11

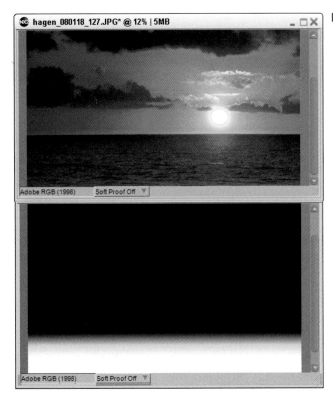

Figure 6.12

Selection menu

After you create a selection, there are a few additional controls available to you in the Selection menu. The first is the Base Mask percentage and the second is the Paint & Fill Mask Feather.

Base Mask percentage controls how much of the base image you allow through the black part of your mask. 100 percent doesn't allow any of the base image through, while 0 percent allows all the base image through. In other words, at 0 percent the current adjustment does not affect the image; at 100 percent the current adjustment has full effect on the image.

Paint & Fill Mask Feather lets you apply a softer edge to the selection when you use the Selection Brush, Selection Gradient, or Fill/Remove tool.

Choosing a larger pixel size makes your selection more diffused and softer at the edges, as shown in Figure 6.13. Here, the radius for the selection in the bottom photo was 100 pixels, and it created a much softer edge.

Now that you understand a little about selections, let's go through each of the selection tools in Capture NX 2.

Selection Control Point

The Selection Control Point tool (Figure 6.14) uses four criteria to make a selection: color, texture, saturation, and proximity. An example of using the Selection Control Point tool is shown in Figure 6.14. In this photo of Pacino's Oak Grill

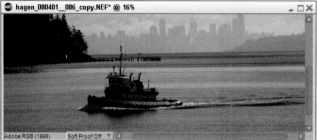

Figure 6.13

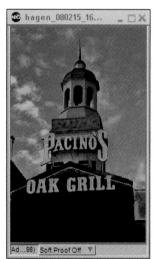
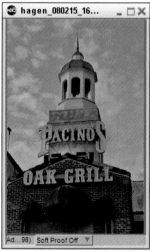

Figure 6.14

restaurant, I wanted to brighten up the brick facade with a D-Lighting adjustment without altering the bell tower or the sky. I started a New Step and chose Select Adjustment → Light → D-Lighting. I adjusted the brightness of the step for the foreground and then added a Plus Selection Control Point to the front of the building. The Selection Control Point limited the D-Lighting step only to the region in the Selection Control Point.

If you want to take the adjustment away from a region, click Minus Selection Control Point. A Selection Control Point does all the thinking for you and is one of the easiest and most powerful tools in all Capture NX 2. Simply click it on the thing that you want to select and it does the rest. Amazing.

The right side of Figure 6.14 in the Edit List shows the Selection menu. The Base Mask percentage slider determines how much the mask prevents or allows the base adjustment to impact the photo outside of the selection. If you set it for 0%, it fully allows the selection to work. Setting it to 100 allows 100% of the adjustment through. Typically, you'll leave the value set for 0% unless you found that the effect was too intense and you wanted to decrease the impact of the adjustment on the photo.

The Size adjustment and Opacity adjustment can be typed into the step in the Edit List, or you can move the sliders on the Selection Control Point that you placed on the photo. Size is used to change the diameter of the selection. Opacity is used to determine how much of the adjustment you let through inside the selection. One hundred percent allows the Adjustment, through while 0% prevents any adjustment from coming through.

Finally, the Paint and Fill Mask adjustment is grayed out right now because I haven't used any of the other selection tools in combination with this Selection Control Point. If I add a Selection Brush to this step, then the Paint and Fill Mask area would be active.

Lasso tools

The Lasso tools are difficult to use in the real world. They are similar to the Lasso tools in Photoshop in that they require you to draw the selection freehand. In order to be good with the tools, you need to be adept with a computer mouse or a Wacom pen tablet. After you draw your selection, you can modify the Edge Softness

at the upper right of the screen to better blend the edges of the selection. If you didn't do a good job with your selection, you should choose a larger pixel value for the Edge Softness.

There are four different Lasso tools available from the menu. To access these tools, click on the Lasso tool button and hold down your left mouse button. Then, select one of the tools. These tools are

- Lasso

- Polygon Lasso

- Rectangle Marquee

- Oval Marquee

Figure 6.15 shows an example of using the Polygon Lasso. I drew around all the lines of the building to create a selection. Then, to add the

Figure 6.15

effect of the adjustment (LCH editor in this example), I clicked the Fill/Remove tool and then on the photograph itself. The Fill tool, which is discussed later in the chapter, can be found in the upper-right corner of Capture NX 2.

The Lasso tool is so hard to use that I rarely work with it in my image editing. The Selection Control Point and the Selection Brush are much better and easier tools to use in the program.

Selection Brush

The Selection Brush is a fantastic tool that enables you to paint in an adjustment step anywhere you want. It is intuitive and simple to use because the Plus Brush adds the effect of the Adjustment and the Minus Brush takes the effect away. For those of you who are used to working on layer masks in Photoshop, it works the same way as painting black and white on a layer mask: Plus paints in a white mask that allows the effect, and Minus paints in a black mask that prevents the effect.

The example shown in Figure 6.16 is of a Ben & Jerry's ice cream van where I wanted to make the background blurry so the van was visually separated from the trees. I added a Gaussian Blur adjustment step and then painted the Gaussian Blur into the background with the Plus Brush. The upper-left photo is the original shot and the big photo in the middle is the image with Gaussian Blur painted into the background. The lower-right photo shows what the overlay looked like after I painted it in with the Plus Brush.

The last option for the Selection Brush is the Pressure Control menu. There are four choices: None, Opacity, Size, and Opacity and Size. These options enable you to use your Wacom tablet pen to adjust the size of brush or the opacity of the brush depending on how hard you press with the Wacom pen.

Figure 6.16

tip

If you make a mistake using the Brush tool, you can easily repair it by selecting the Minus Brush and painting over the area. If you need to change the size of the brush, the menu bar at the top of the screen has additional adjustments for Brush Size, Brush Hardness, and Opacity. There's also a simple keyboard shortcut that enables you to change the brush size by pressing the bracket keys:] and [.

Selection Gradient

Gradients are used to gradually apply an effect across a region. Generally, they are used in situations where you have a distinct horizon line with a bright sky and a dark foreground. In this scenario, your goal is generally to brighten up the foreground but not impact the sky in any way. Capture NX 2 has two Gradient selection tools: Linear Gradient and Radial Gradient.

Linear Gradient

As mentioned previously, the classic use for this tool is to brighten the foreground while keeping the sky untouched. The example shown in Figure 6.17 is of a sunset in Hawaii where the sky is well exposed but the water is underexposed. To brighten the water, I applied a Levels & Curves adjustment step to brighten the scene and then used the Plus Selection Gradient to allow the adjustment over the water, but prevent the adjustment over the sky. The upper-left photo is the original, and the upper-right photo is the improved photo. The lower left shows what the gradient looks like in the mask view.

To apply the Linear Gradient selection, click the Plus Gradient button and start the gradient in the portion of the photo in which you want the adjustment to be fully applied. In Figure 6.18, I started the gradient in the water because I wanted the water to be brightened up by the Levels & Curves adjustment. Stop the gradient

Figure 6.17

line over the area in which you want to prevent the adjustment. In the example in Figure 6.17, the gradient is stopped at the horizon because I didn't want the sky to be impacted at all by the Levels & Curves adjustment.

After you place the gradient, you can modify the midpoint by moving the middle slider box on the gradient line. In this example, I moved the midpoint right up against the edge of the horizon to create a hard line gradient.

Radial Gradient

The Radial Gradient is used to apply an adjustment radially from a midpoint rather than linearly like the Linear Gradient. A good use for this tool is to add a vignette effect to your image, as shown in Figure 6.18. For this example, I darkened the photo with a Levels & Curves adjustment and then applied the darkened effect to the edges with the Radial Gradient. You can see the impact clearly in the image on the right side.

The photo on the upper left is the original image, and the photo on the lower left is what the Radial Gradient mask looks like. You can see that the mask is black in the middle, which prevents the effect of the Levels & Curves adjustment from being applied to some parts of the image while it darkens other parts. The mask radially fades to white, which allows the effect of the adjustment and gives the photo the new look.

Fill/Remove tool

The last selection tool is the Fill/Remove tool. The purpose of this tool is to fully allow or prevent the adjustment step. For example, if you use the Selection Brush to apply an adjustment to your photo and then decide that you want to start your selection over from scratch, you can click the Plus Fill/Remove tool to eliminate all the masking work you've done so far. It is an easy way to wipe out the existing selection and begin the process again.

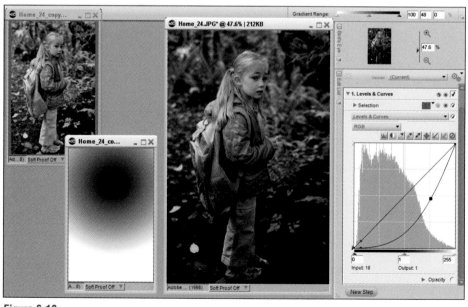

Figure 6.18

caution

Don't forget to click on the photograph after you've chosen the Fill/Remove Tool, otherwise the tool won't be applied to the image.

To use this tool, follow these steps:

1 **Click the Plus Fill /Remove tool.**

2 **Click on the photograph to activate the tool on the image.** When you do this, it will wipe out any selection you have made for that particular step.

Opacity Controls

The Opacity section of an adjustment is found at the bottom of the New Step area. To open the Opacity section, click the small triangle next to the word Opacity. Figure 6.19 shows the Opacity controls for a typical step.

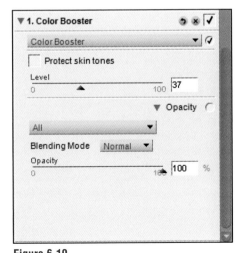

▼ 1. Color Booster

Color Booster

☐ Protect skin tones

Level

0 100 37

▼ Opacity

All

Blending Mode Normal ▼

Opacity

0 100 100 %

Figure 6.19

The other main use for the Fill/Remove tool is to fill in your Lasso selections after you draw them. In Figure 6.15, I demonstrated an example where I used the Polygon Lasso to draw a selection around a building. To apply the adjustment step inside the selection, I have to click the Fill/Remove tool and then click on the image. If I don't do this, then the adjustment will never be applied inside the Lasso.

Opacity, by its simple definition, controls how much of the adjustment step you allow to impact the photograph. A low opacity means that you prevent most of the adjustment from affecting the image, and a high opacity means that you allow all the adjustment to affect the image.

There are three opacity choices in the drop-down list: All, RGB, or Luminance_Chrominance. Each method lets you selectively apply the adjustment to a different aspect of the image. The following sections explain each of the options.

All

The All setting applies the New Step adjustment to all channels in the image, including the RGB (Red, Green, Blue) and the Luminance/Chrominance. Most of the time, you will leave the opacity control set for All because you want to just control the intensity of the adjustment to the image. Lowering the opacity lowers the overall effect of the new step.

RGB

This drop-down list allows you to apply the step only on a specific color channel, such as the Red channel. RGB stands for Red, Green, and Blue. All digital images from your camera are RGB images and are composed of these three primary colors. The RGB opacity menu item allows you to apply the adjustment to any combination of color channels that you see fit.

For example, you might want to apply a Black & White adjustment to your photo, but allow a little bit of one color channel to come through, as shown in Figure 6.20. In this case, I kept the Red and Blue channels at 100% and moved the Green channel down to 32%. This allows some of the Green channel data to shine through while preventing any Red or Blue data from shining through. Zero percent prevents the effect on that color channel, and 100% allows the effect on that color channel.

Luminance_Chrominance

Luminance refers to the brightness data in your photograph, while Chrominance refers to the color data. Sometimes when you make adjustments to a photograph, a color shift that you don't necessarily like may appear. For example, a Curves adjustment sometimes causes a mild color shift around areas of high contrast. If you want to eliminate the color shift but keep

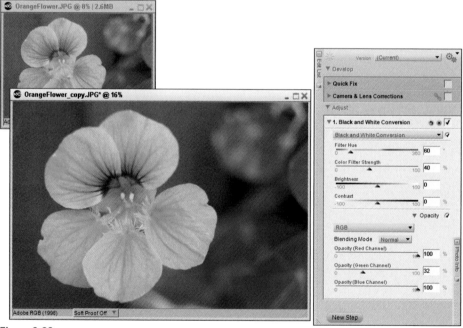

Figure 6.20

the effect of the adjustment, you can move the Chrominance slider to 0% and the Luminance slider to 100%. This prevents any of the effect on the colors and allows the effect on the brightness.

Blending Modes

The last section in the Opacity section is the Blending Mode drop-down menu. Blending modes allow you to change how the modification you made to your image interacts with the original image. The Normal setting is the default and is what you are most used to seeing. However, when you make a change to a photograph, the new photograph can be looked at mathematically in terms of how bright or dark each new pixel is. The blending mode takes the new pixel brightness and either adds it or subtracts it from the original pixel.

You can achieve dramatically different effects in your image by selecting different blending modes. Each blending mode gives a different effect based on the type of adjustment you use. For example, the Screen blending mode looks entirely different in a Saturation adjustment than it will in a Sharpening adjustment.

Table 6.1 details each of the blending modes and what effect they have on the image.

One of the most common uses for the blending modes is when you apply High Pass Sharpening to your image. This is different than using the USM (Unsharp Mask) tool and is a method of sharpening that is preferred by many photographers. To perform High Pass Sharpening, activate a New Step and then choose Focus→ High Pass. At first, the image turns solid gray. The next step is to move the Radius slider up a little bit higher, and you will soon start to see the edges in the photo appear white, as shown in Figure 6.21.

Table 6.1
Opacity Blending Modes

Mode	Description
Normal	This is the default mode and is what you'll normally use. Increases or decreases the overall opacity (influence) of the step.
Lighten	Applies the step only to pixels that are brighter from the enhancement.
Screen	Makes every pixel brighter than the original image.
Overlay	New pixels more than level 128 will lighten image; new pixels less than level 128 will darken image. This adds contrast.
Multiply	Subtracts new pixel values from previous pixel values, making the image darker overall.
Darken	Applies only to pixels that are darker after the enhancement.

Figure 6.21

Now, change the opacity blending mode to Overlay, and the photo returns to its normal appearance (Figure 6.22). The difference now is that the photo appears sharper than before. As you can see in the example, the High Pass method of sharpening is a great approach for edge sharpening.

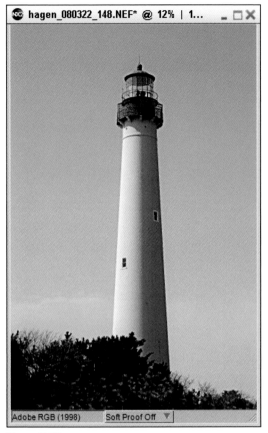

Figure 6.22

7

Applying the Adjust Settings Tools

A djust Settings are used to increase saturation, add contrast, crop, sharpen, and carry out most other photograph manipulations. The basic approach to using the Adjust pane is to do large tonal adjustments first, then move on to other adjustment types. In general, you'll use a couple Light and Color Adjustments on your image, then apply Color Control Points. At the end of your workflow, you'll crop and sharpen the image with Unsharp Mask or High Pass Sharpening.

There are many tools available in the Adjust pane. You won't use all of them in each photograph. The following sections will give you an understanding of which ones make sense to use and which ones you can leave alone.

Light

The Light portion of Select Adjustment is used for making tonality adjustments to your images. You apply these settings to modify brightness, contrast, shadows, highlights, and midtones. There are four options in the Light menu: Levels & Curves, Contrast/Brightness, Auto Levels, and D-Lighting. Most of the time, you'll just use one of the four adjustments on your photo to fix the tonality.

When you click the New Step button, you initiate an adjustment step that is named Select Adjustment, as shown in Figure 7.1. In order to do anything with the step, you need to click the Select Adjustment drop-down list and choose an adjustment such as D-Lighting, as shown in Figure 7.2. After you choose an adjustment, the step is active, and you can start making improvements to your image.

Another way to initiate an adjustment is by clicking the menus at the top of the Capture NX 2 screen. For example, the Edit, Adjust, and Filter menus all have items that will initiate new adjustment steps.

Figure 7.1

Figure 7.2

Levels & Curves

The main purpose of the Levels & Curves adjustment is to change your image's contrast and overall tonality. Some photos need to be brighter or darker, and this is one tool that gives you a lot of control over the image.

Most people who use curves for the first time are baffled by the graph and become frustrated with the operation of the tool. However, the tool is very powerful and gives you a significant amount of control over your image. I'll do my best to describe how to use the Levels & Curves adjustment in a way that makes sense so that you can begin using it in your workflow (Figure 7.3). The Levels & Curves adjustment is generally the first thing you do to an image after adjusting White Balance.

Fundamentally, the purpose of the curve is to allow you to control the tonality (brightness) of the image. The bottom axis of the curve represents the original data of the image, with shadows and blacks on the left and highlights and whites on the right. In the middle of the axis are the midtones and grays. This axis has a numerical scale from 0 to 255. The number 0 represents pure black, 255 represents pure white, and the middle of the line is 128. Photographers often refer to level 128 as middle brightness (midtone).

The vertical axis of the curve represents the new data for the image and is sometimes called the output. The base of the axis is level 0, the top of the axis is level 255, and the middle is 128. If you have a perfectly diagonal line from the lower left to the upper right like the one shown in Figure 7.3, then all the data from the original photo will be the same as the data in the new photo.

If you take the middle of the curve and lift it up, as shown in Figure 7.4, the photo gets brighter. In this example, the lower photo has been modified

Figure 7.3

by the curve, and the input value is 128 and the output value 192. Conversely, if you take the curve and drag it down, the photo becomes darker. If you hover your mouse over the point you just created on the curve, you can see the numerical values of the input (original) data and the output (new) data at the bottom of the graph.

The right side of the curve controls the highlights, so if you lift up the line over here, then you will increase the brightness in the highlights. Similarly, if you pull down the left side of the curve, then you darken the shadows. This is called a high-contrast s-curve and is shown in Figure 7.5. In this example, the top photo is the original and the bottom photo has been modified

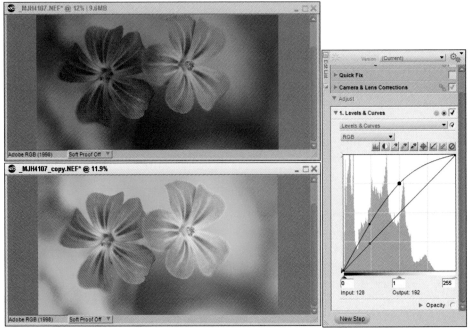

Figure 7.4

with the curve. Most photographs benefit from a subtle s-curve to slightly increase the contrast, so I find myself adding this curve to my photos quite often.

If you want to decrease the contrast in the photo, then you would draw a reverse s-curve, as shown in Figure 7.6. You use this type of curve when you want to suppress the highlights while increasing brightness in the shadows.

You can place as many points on a curve as you can fit on the line, but the reality is that you hardly need more than two or three points. In general, you are going to make an adjustment to the highlights, another in the shadows, and perhaps one in the midtones. Also keep in mind that you generally only need to make a very small adjustment for a curve to do its magic.

Don't draw big, sweeping curves and expect your photographs to still look good. If you do, you'll end up with significant discolorations and lots of digital artifacts. Keep your curves simple and controlled.

If you need to reset your curve after making some changes, you can click the Reset Current Channel button at the top of the curve. This is the button that has a single diagonal black line. You can also modify the Red, Green, and Blue channels from the Channel Selector menu. If you want to reset all these channels, click on the diagonal line with three colored diagonal lines on it. This is the Reset All Channels button. Alternatively, you can remove your curve points one-by-one by clicking and dragging them off the edge of the graph.

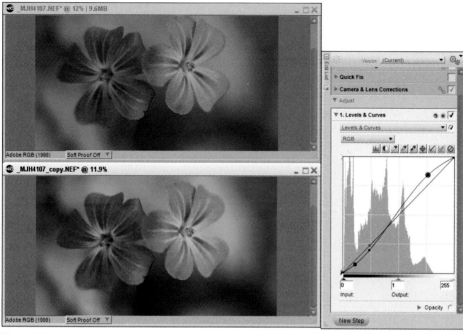

Figure 7.5

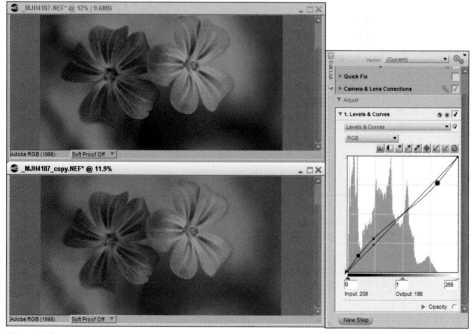

Figure 7.6

If you want to set a point on the curve for a specific spot in the photo, then you can place an anchor point from the Curves dialog box. You do this by first clicking the Anchor Point button (Figure 7.7) and then clicking on the photo where you want to adjust the brightness. After you click on the photo, a new anchor point appears on the curve. Adjust the curve up or down from the new anchor point area until you're happy with the change. I use this feature all the time when I work on images. For a portrait, I place a point on the model's face and then make the adjustment in the correct tonal range.

The vertical axis of the curve also has adjustments you can make. There is a black slider at the bottom and a white slider at the top. These sliders adjust the minimum and maximum output levels for the new photograph. Most of the time, you can leave them at 0 and 255,

respectively, but you can change them if you want. Moving the black slider up causes your blacks to become brighter, or grayer. Sometimes you'll do this to try to retain some detail in the shadows of your image. Moving the white slider down causes your whites to become darker, or grayer. Sometimes you'll do this to retain detail in the highlights.

Another important element about the curve is that the histogram for the image is shown behind the curve. The histogram always shows the original data of the photo even when you make changes to the curve. In other words, it doesn't change in real time based on each new curve change. If you want to see the histogram change in real time, then watch the Photo Info palette at the bottom of the pane. You should use your histogram as a tool to help you judge the changes you make on your image.

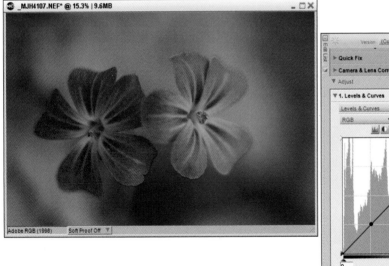

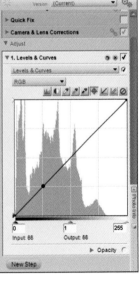

Figure 7.7

If your histogram shows data all the way over to the right side and you try to increase the brightness of your photo, then you run the risk of blowing out the highlights in the image. In the waterfall example in Figure 7.8, there is a little bit of data right up against the right edge of the histogram. If you increase the brightness of the photo, that data is pushed beyond level 255 and is blown out. The histogram is a great tool to help you maintain detail in the highlights and shadows.

caution

Be careful when using curves that you don't brighten the highlights beyond the right edge of the histogram.

At the bottom of the curve are three Levels sliders. They should be adjusted simultaneously when working in the Curves dialog box. The left slider is black and represents level 0. The middle slider is gray and represents level 128, while the right slider is white and represents level 255.

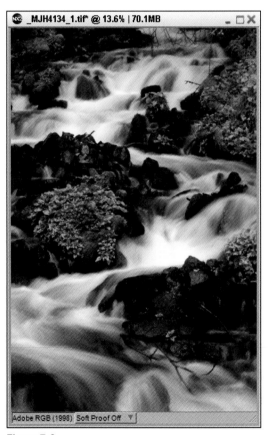

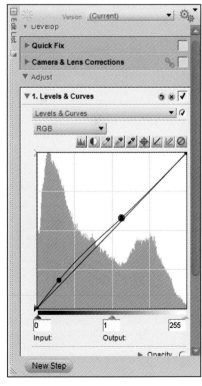

Figure 7.8

The black and white sliders define the black point of the photo and the white point of the photo. For example, if you move the black slider to the right, then you are effectively defining brighter pixels as the new black point. This has the effect of darkening your photograph. If you move the white slider to the left, you effectively define darker pixels as the new white point. This brightens your photo.

Typically, you want to move the black point slider and the white point slider to the location where your histogram data starts. Figure 7.9 shows a good example of a photo that needs some brightening. The top photo is the original, and the bottom photo is the image after a quick levels adjustment. You can see that after moving the white slider down, it meets the beginning of the data in the histogram. This effectively set those pixels as the new white point value.

Notice that I didn't make any adjustment to the black slider because this part of the histogram already has data at the left edge. Moving the black slider to the right would darken the shadows even more. You probably noticed that I changed the middle gray slider as well. I moved the position to the left, which increases the brightness of the midtones in the image.

tip

Moving the midtone slider to the left brightens a photo. Moving it to the right darkens a photo.

An alternative method for setting your white, gray, and black points is by using the Eyedropper tools from the Curves dialog box. If you have an image that has obvious white and black points in

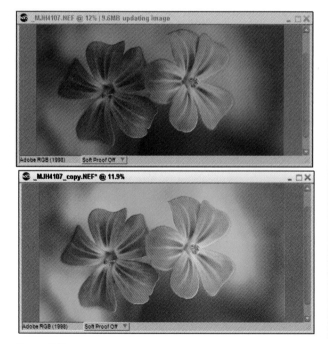
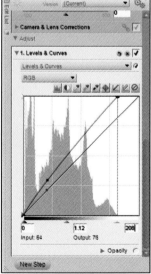

Figure 7.9

it, then this method can be a much faster way to edit your image. The photo shown in Figure 7.10 has obvious white and black areas in it that are perfect for setting the white and black points. In this case, I used the Double Threshold tool from the Info palette to find the lightest and darkest points in the image. Then I placed the white point eyedropper on the top of the guard rail. I placed the black point eyedropper on a window of the building, and I placed the gray point eyedropper on the back of the automobile.

see also

See Chapter 5 for tips on using the Double Threshold tool to find the white and black points in an image.

The top photo in Figure 7.10 is the original image that looks a little bit flat. Placing the white, gray, and black point eyedroppers is a quick and easy way to properly set the tonality and contrast of the image.

So far, I've only been talking about using the Levels & Curves tool in the RGB mode. The changes demonstrated so far have been operating on all color channels (Red, Green, and Blue) in the image. If you want, you can use the drop-down list to modify the levels and curves in each individual color channel. This method gives you much more control and is often used to modify the colorcast of an image as well as the tonalities (brightness) of the image.

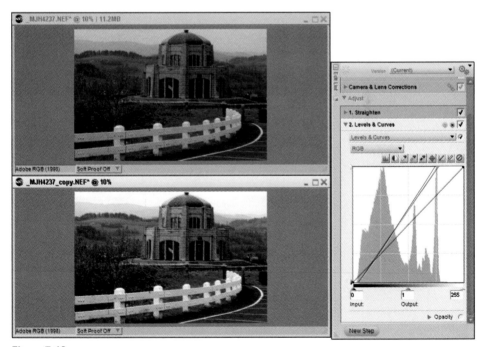

Figure 7.10

Say, for example, that you are editing a photograph that has too much blue in it. You can go into the Blue channel and pull down the middle of the curve to add in the opposite color of blue, which is yellow. The middle of the curve is used for modifying colors when you are working on an individual color channel. In Figure 7.11, the image on the left is the original shot, and I think it looks a little too blue. So, I went to the Blue channel in the Levels & Curves dialog box and pulled down the curve in the middle until I was happy with the image (right side).

Figure 7.11

Contrast/Brightness

Many photographers look at their photographs and decide that the image needs a little bit of brightening and a bit more contrast. Naturally, they select the Contrast/Brightness adjustment to edit the photo. Unfortunately, the Contrast/Brightness tool isn't very precise and doesn't provide as much control as using a Curves adjustment.

In the photo example shown in Figure 7.12, the image appears a little dark and has a bit of haze in the sky. The left photo is the original image, and the right photo has been modified with a Contrast/Brightness adjustment. This image is a perfect candidate for some curves work, but let's look at how the Contrast/Brightness adjustment affects it.

The first thing I am tempted to do with this photo is increase the brightness. So, I move the Brightness slider to the right and immediately see the image get brighter. The problem is that the Brightness slider makes all pixels brighter by the same amount. This means that the snow on the top of the mountain runs the risk of blowing out just when green trees in the foreground start to look good. If you watch the histogram when you make the change, you can see that the Brightness slider simply moves the histogram right or left. It doesn't allow you to adjust a tonal range like a Curves adjustment would.

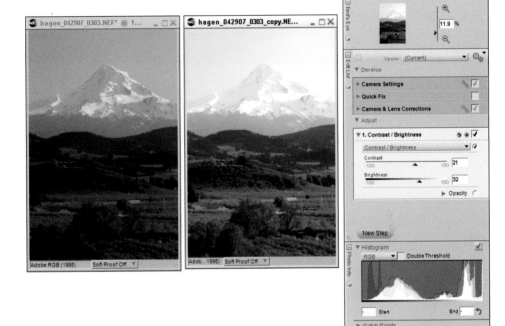

Figure 7.12

Next, I want to add some contrast to the image to try to remove the haze in the sky. A higher contrast makes the brights brighter and the darks darker by stretching out the histogram. Again, I don't have any ability to adjust the highlights separately from the shadows, so the Contrast slider can get me into trouble very quickly. In this case, the snow is already very close to being blown out, so increasing the contrast just makes the problem worse.

tip

I don't use the Contrast/Brightness adjustment in my workflow because of its limited capabilities. My recommendation is to use the Levels & Curves adjustment rather than the Contrast/Brightness adjustment.

Auto Levels

When you need to make a quick tonality adjustment to your image and want to see what an automatic fix does, try Auto Levels. You select this option by clicking New Step and then choosing Light→Auto Levels. The purpose of Auto Levels is to allow Nikon Capture NX 2 to automatically set the contrast for you. It works by setting the white point and black point for each color channel based on the criteria you set in the Preferences dialog box (Edit→Preferences→Levels and Sampling). Chapter 3 covers setting up the preferences for Capture NX 2.

Auto Levels automatically clips (cuts off) a certain percentage of the image's highlights and shadows. The default in the preferences is set to 0.5 percent, but many people like to reduce that

amount down to 0.1 percent or 0.05 percent. The lower you set your clipping percentage, the more detail you retain in the image.

Figure 7.13 shows the effects of Auto Levels on the same mountain photo that was used in the previous example (the left photo is the original; the right photo is with Auto Levels). In this case, it did an admirable job of improving the image. I find that Auto Levels tends to work very well if your photograph has a large region of white, such as with the mountain in Figure 7.13. If your image doesn't have any white, then using Auto Levels might result in a significant color shift.

tip

Change your preferences for Auto-Contrast Clip from 0.5% to 0.1% to retain more shadow and highlight detail when using Auto Levels.

There are two options in the drop-down list for Auto Levels: Auto Levels and Advanced. Auto does everything for you and uses the 0.5%

clipping value from your Preferences. The Advanced option item lets you further control the contrast and the colorcast in the photo. Moving the Contrast slider to the right increases contrast. Moving the Color Cast slider cools the image down (right) or warms it up (left).

I use Auto Levels probably 25% of the time in my image editing. If I like the results of the adjustment, I just leave it and move on to my Saturation and other necessary adjustment steps. If I don't like the results, then I go back and use a Levels & Curves adjustment step.

D-Lighting

D-Lighting is used for photographs that have obvious underexposed areas that you want to brighten. I often think of D-Lighting as the "I should have used fill flash" tool. The adjustment works by amplifying (brightening) just the shadows in an image. More specifically, it takes the left side of the histogram and moves it slightly to the right.

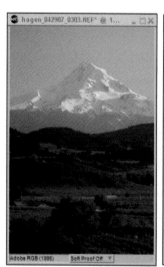
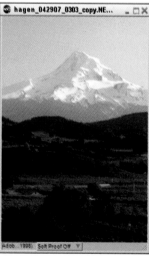
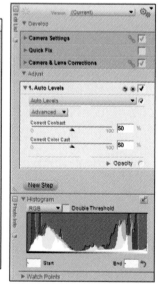

Figure 7.13

When you activate the adjustment (New Step ➜ Light ➜ D-Lighting), it immediately starts brightening the shadows with a default amount in the Faster (HS) mode. If you want to brighten your shadows even more, then move the Shadow Adjustment slider to the right until you are happy with the fix. Many times when you brighten an image, the colors become washed out. To remedy this problem, there is a Color Boost slider that is preset for 60. If you need to change the default color boost, you can increase or decrease the value. I find that 60 is about right for most photos.

The other mode available to you from the drop-down list is the Better Quality (HQ) mode, and I almost always get better results in HQ mode than in HS mode. This mode allows me to adjust the highlights as well as the shadows in the image. For example, if my image has some white clouds that I want to protect, I move the Highlight Adjustment slider to the right to try to push some detail back into the image.

The example in Figure 7.14 demonstrates a good use for the D-Lighting adjustment. This photo of balsam root flowers was taken on a bright sunny day and has a lot of detail that is lost in the shadows. I activated the D-Lighting step and selected Better Quality (HQ). The default settings were Highlights = 50, Shadows = 0, and Color Boost = 60. The default Highlights setting was too high, so I decreased it to 29. My goal was to brighten the shadows just to the point where I could start seeing detail. If I increased the value too much, the photo started to look fake. I also increased the Highlight Adjustment to protect the white clouds. Finally, I left the Color Boost at 60 because I was happy with the colors in the image.

tip

Lots of people ask me whether it's okay to use the D-Lighting adjustment in addition to a Levels & Curves adjustment. Generally speaking, you use one or the other, but it is okay to use D-Lighting to brighten the shadows and then use Levels & Curves for more precise control over the midtones and RGB color channels.

Figure 7.14

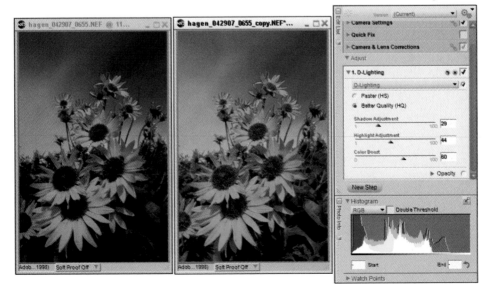

Color

There are four color enhancement tools available from the Color Adjustments menu: LCH, Color Balance, Color Booster, and Saturation/Warmth. The LCH tool is the most advanced and gives you an incredible amount of control over your image. The other three are used for quicker adjustments when you don't really need the more sophisticated controls. The Color Adjustments can be found by clicking New Step and then choosing Select Adjustment→ Color.

In my workflow, I like to do my color adjustments after finishing my tonality adjustments (for example, Levels & Curves). What you quickly find out, though, is that the LCH editor allows you to do your Levels & Curves in conjunction with your color fixes. The following sections explain each of these tools to help you understand how to apply them to your workflow.

LCH

LCH stands for Lightness, Chroma, and Hue. The neat thing about this adjustment is that it allows you to work on your image by separating the color (Chroma and Hue) data from the luminance (Lightness) data. Many times when you work on your image with a tool like Levels & Curves, a small color shift changes your brightness. This is because Levels & Curves is an RGB tool and is actually working on the three color channels (Red, Green, and Blue).

LCH lets you work on the luminance (brightness) data independent of the color data by selecting which channel you want to work on from the drop-down list. There are four channels, as shown in Figure 7.15: Master Lightness, Color Lightness, Chroma, and Hue. As you edit an image, you typically go through each of these menu items and make changes. After you finish, you shouldn't have to use any of the other options

from the Color adjustments or Light adjustments, because the LCH editor is designed to have most of what you need in one adjustment tool.

I'll start the description with the Master Lightness tool. Choose Master Lightness from the drop-down list, as shown in Figure 7.15. A Levels & Curves interface that looks almost exactly the same as the Levels & Curves adjustment described in the previous section appears. The main difference is that the Master Lightness tool doesn't have white, gray, and black point eyedroppers.

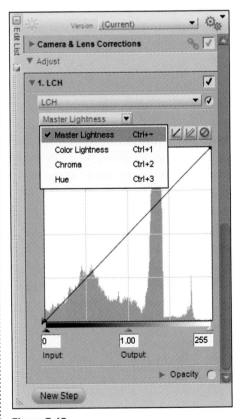

Figure 7.15

The Levels & Curves operation here is exactly the same as described in the previous section. The only difference is that you are changing lightness data rather than RGB data. This curve actually results in purer tonality changes because you aren't changing the levels of color, just the levels of luminance. I like to do my tonality (brightness/contrast) work by using the LCH Master Lightness curve because of this reason. It is my preferred method for tone control.

Figure 7.16 shows an example of a standard s-curve that is applied to the lower image. The top image is the original, and the lower image has a subtle s-curve that enhances contrast. Notice how there isn't a shift in color between the images, just an increase in contrast. The contrast is most apparent in the rocks at the bottom of the photo. Perfect.

The next step in using the LCH adjustment is to choose the Color Lightness channel from the drop-down list. This activates a color graph with a line at the midpoint of the graph. The purpose of Color Lightness is to allow you to brighten a specific color range in the photo without changing the color. This is a difficult concept to understand, but it is analogous to taking a yellow piece of paper and shining a light through it from the back side. If you shine a brighter light through the paper, the yellow is still the same—it is just brighter yellow now.

In the example in Figure 7.17, the blue sky is a little bit too bright, so I want to darken that color range. (The top photo is the original; the bottom photo has the darker sky.) In order to do this, I click on the blue portion of the Color Lightness graph and drag that portion downward. The first

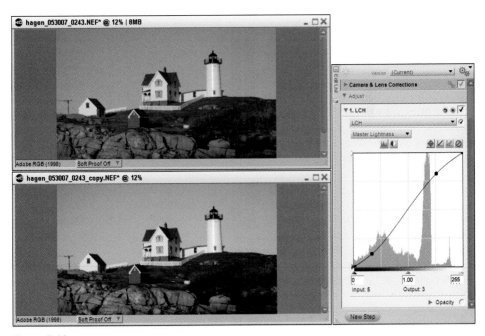

Figure 7.16

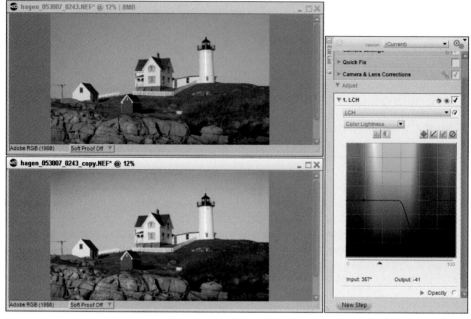

Figure 7.17

time you do this, you'll notice that not much in the photograph changes. To make the adjustment effective, you have to move the slider at the bottom of the graph to increase the width of the colors you are modifying. In this example, I increased the width to include the cyan and light blue in the image. Notice how no other colors are affected by the brightness change—just the blue sky.

If you want a more precise way to select a color, you can click the Anchor Point button at the top of the graph. The Anchor Point button looks like a crosshair, and it turns your mouse into an eyedropper after you click it. Move your mouse into the photograph and then click on the color that you want to change (blue sky in this example). You'll notice now that there is a black point on your graph for exactly the color you want to modify. Move that black point up or down depending on what you want to do.

Here's the method for using this tool:

1 Click the Anchor Point button to turn your mouse into an eyedropper.

2 Click on the color you want to modify (blue sky in this example).

3 From the Color Lightness graph, click and drag the anchor point down to darken that color range or up to brighten that color range.

4 Move the width slider at the bottom of the Color Lightness graph to include a broader range of colors.

The next factor to change in the LCH adjustment is Chroma. The Chroma channel allows you to change the saturation of the entire image or the saturation of only specific colors in the image. Saturation is defined as the vividness of a color; so, naturally, a higher saturation will result in a more vivid color.

To change the saturation of the entire image, click the triangle on the right side of the Chroma graph and move the entire line up or down. Moving it up increases saturation, and moving it down decreases saturation. This is called a global saturation control and is used when you want the entire photograph to change. I caution you, though, to be gentle with your saturation adjustments because it is very easy to oversaturate an image. Some photographers think that if a little saturation is good, then more is better! Not true. Keep your saturation adjustments under control.

The major benefit to the Chroma adjustment is that it allows you to change saturation in a single color range, rather than across all color ranges. In Figure 7.18, I want to saturate just the green grass, but leave the rest of the colors looking natural. The top photo is the original image, and the bottom has been modified by the LCH adjustment.

The Chroma graph works just like the Color Lightness graph in that it allows you to click on a section of color and increase or decrease the saturation. To incorporate more colors into the saturation change, move the slider at the bottom of the graph to the right. You can also use the Anchor Point tool to click on the photo for the color you want to change.

For this example (Figure 7.18), you can see that the adjustment I made for the grass is actually in the yellow range! It is important for photographers to understand that most of what you see as green in a photograph actually contains a large percentage of yellows. Using the Anchor Point tool allows you to make adjustments on the correct portion of the color graph. I also made an adjustment for the blue sky to increase saturation. Finally, I moved the entire Chroma line vertically by clicking and dragging the triangle on the right side of the graph up.

Figure 7.18

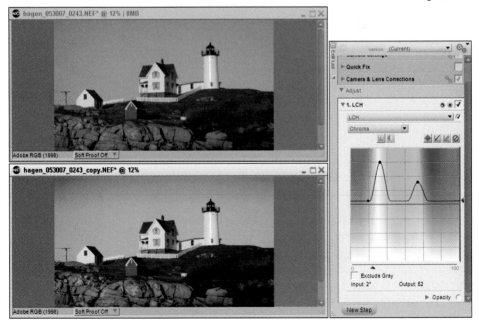

The last menu item in the LCH adjustment is the Hue graph. In general, you won't use this graph for normal image editing. It is used as a color replacement tool and has limited application in your work unless you want to do creative enhancements to your image.

Say, for example, that you want the red on the buildings in Figure 7.19 to be a different hue. You can use the Hue graph to change the red to another color in the spectrum, such as green. Look at the top photo to see where red appears, and then look at the bottom photo to see how the color changed to green for those locations.

Before making changes to the graph, click the menu at the bottom of the graph and set it for 180 degrees. This now allows you to change any color in your photograph to any other color in the

visible spectrum. The default setting is 60 degrees, which allows you to change any color in your image to another color 60 degrees away on the color wheel. Figure 7.20 shows a color wheel. If you start with a color that is red, then the Hue graph lets you replace red with any color on the wheel. If you moved red along the color wheel to 90 degrees, the red is replaced by a green color.

Here are the steps for using the Hue graph.

1 Change the degrees setting at the bottom of the graph to 180 degrees.

2 Click the Anchor Point button to turn your mouse into an eyedropper.

3 Click your mouse on the color you want to modify (red roofs and outbuildings in this example).

Figure 7.19

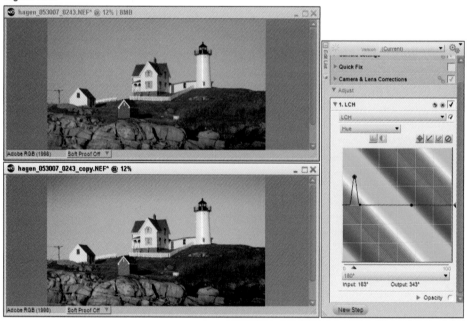

Figure 7.20

4 **Click and drag the anchor point from the Hue graph up or down to change the hue to a different hue on the graph.** Where you stop your mouse on the graph will be the new hue for the anchor point color.

5 **Move the width slider at the bottom of the Hue graph to include a broader range of colors.**

The last thing I want to say about the Hue graph is that you can globally change all the hues in your image by moving the triangle on the right side of the graph up or down. Moving this triangle 30 degrees replaces every color in the image with another color that is 30 degrees away on the color wheel. You'll probably never do this during your image-editing workflow, but it can be useful if you have some strange colorcasts that you are trying to fix in an image.

Color Balance

If you are looking for a color adjustment tool that is a bit easier to use than the LCH editor, then the Color Balance adjustment is probably the best choice. This tool is very familiar to photographers who have worked in Photoshop for a few years because this tool has been around since the dawn of digital image editing.

Color Balance is broken down into two main areas: the tonal adjustments (brightness) and the color adjustments (RGB channels). The primary function is to allow you the ability to change the colorcast in the photograph by moving the Red, Green, and Blue sliders. In the example shown in Figure 7.21, I used the sliders to decrease some of the orange/red colorcast in the photo. I did this by moving the Red slider toward the cyans. I also moved the Blue slider toward the blues (rather than the yellows).

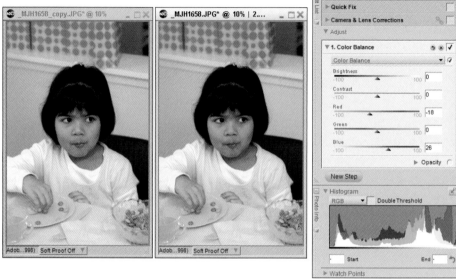

Figure 7.21

There isn't a lot of science that goes into making the adjustments in Color Balance, but I recommend that you do your work on a calibrated computer monitor so that you don't make your colors look too garish. Color Balance should be used to finesse your photo's colors. If you aren't careful, you can quickly ruin the image by moving the sliders too aggressively. Start by looking at your photo and deciding what colorcast you want to remove or add. Then move that slider to make the change. As shown in the example in Figure 7.21, sometimes you need to use two or three sliders to achieve the effect you want.

tip

Use the LCH editor or Levels & Curves for your tonality adjustments.

After you make your color changes, you can also use the Brightness and Contrast sliders to work on the tonality of the image. These two inputs can be a fast way to add brightness and contrast, but as I mentioned in the Contrast/Brightness section earlier in the chapter, I don't recommend doing tonality changes with these tools. If you aren't careful, you can quickly blow out the highlights or block the shadows in your image.

Color Booster

The Color Booster adjustment provides a super-fast way to increase the saturation in an image. There is only one slider control, and if you slide it to the right, you simply boost the colors in the photo. Figure 7.22 shows the effect of the Color Booster. The top image shows what the baby elk looks like before Color Boost, and the bottom image is after a Color Boost of 26.

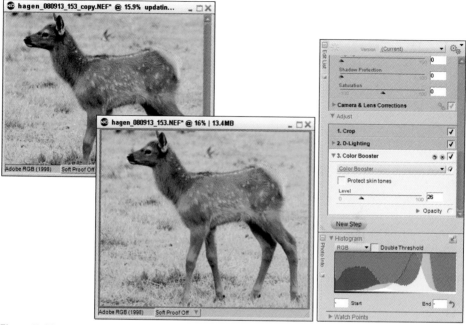

Figure 7.22

I like using Color Boost when I need to edit a photo quickly for posting to the Internet or making a quick print. The tool generally does a pretty good job, but be careful when using it on a photo that has people in it. Moving the Color Boost slider up on a portrait quickly causes a reddish colorcast on people's faces. In this situation, select the Protect Skin Tones option so that you don't oversaturate faces, legs, and arms.

Saturation/Warmth

Another easy-to-use tool for increasing the vibrancy of your image is the Saturation/Warmth adjustment. To access this tool, click the New Step button and choose Select Adjustment→ Color→ Saturation/

Warmth. Figure 7.23 shows how this adjustment can be applied to your image. The top image is the original shot, and the bottom has Saturation/ Warmth applied.

Adjusting the Saturation slider adds vividness to the colors in the photo, while adjusting the Warmth slider adds red or blue depending on which way you move it. Typically, landscapes and nature photography benefit from a little bit of extra warmth. You can also add warmth to your image by selecting a higher Kelvin white balance, like 6,000K or 7,000K. Review Chapter 4 for additional help on making white balance adjustments to your image.

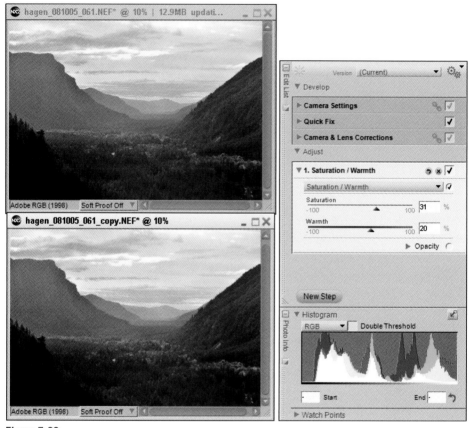

Figure 7.23

Focus

The Focus area of Capture NX 2 is generally used for sharpening your image just before printing. In your workflow, sharpening should be completed at the end of the process after you adjust tonality, color, and Control Points and perform local fixes and cropping.

A Focus adjustment called Gaussian Blur is used to deliberately apply a blurring filter to an image. The other two adjustments, Unsharp Mask and High Pass, are used to sharpen a photograph for

output. There are two ways to activate the Focus adjustments. The first is by clicking New Step and then Focus; the second is by choosing Adjust → Focus and the specific adjustment.

Gaussian Blur

Gaussian Blur is used to deliberately apply a soft filter to your image. I use the blur most often for creating a soft skin effect on a portrait, or I use

it to lightly blur the background in a wildlife/landscape scene. In both cases, I use a selection tool to apply the blur to a local area rather than to the entire image.

The Gaussian Blur step is controlled with a slider at the bottom of the Adjust pane that varies the pixel radius of the blur. To create a blurrier photo, simply increase the diameter of the radius.

Figure 7.24 shows a good example of using Gaussian Blur in a portrait. I first converted the image to black and white and then used the Gaussian Blur to soften the skin, hair, and background. Next, I used the Minus Brush to take the blur away from the eyes, eyebrows, and lips so they remained sharp.

You can use just about any of the selection tools to add or remove the effect of the Gaussian Blur to your image. It is a great creative tool, and I encourage you to try this technique on some of your images. Also, if you are feeling really creative, try clicking on the Opacity area and modifying the blending mode to something else like Screen, Overlay, or Darken.

High Pass

At the most basic level, the High Pass filter is used to highlight edges with dark-to-light contrast. The tool blocks all image details and only shows details that contain strong edge definition. When you first activate the adjustment, the whole image turns gray. As you increase the Radius slider, edge details begin appearing.

Many photographers use the High Pass adjustment step to highlight the edges for sharpening the image. This method is a different approach than using the Unsharp Mask adjustment and sometimes produces a smoother, more pleasing effect.

Figure 7.25 shows a photo of a bird that was sharpened with the High Pass adjustment. The left image is before High Pass sharpening, and the right image is after. You can see more contrast around the black feathers, but the breast feathers have less sharpening. This is a result of the High Pass sharpening method.

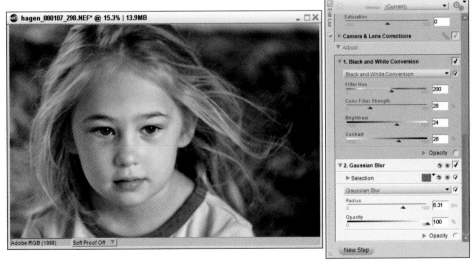

Figure 7.24

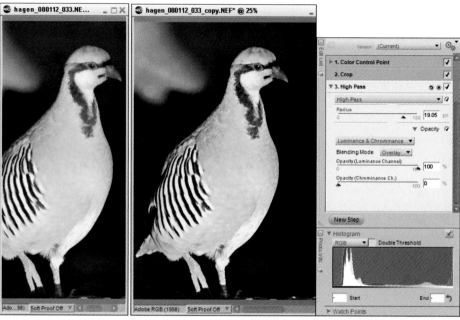

Figure 7.25

There are some specific steps required to do High Pass sharpening, so follow along as I detail the method.

1 After the image is completed (tonality, color, cropped, sized), start a High Pass adjustment by clicking **New Step** and then choosing **Focus → High Pass.**

2 Open the Opacity menu at the base of the High Pass adjustment step.

3 Move the Chrominance opacity to 0%. This prevents sharpening on the color data and allows sharpening on the luminance data.

4 Set the Blending Mode to Overlay.

5 Go back to the top of the adjustment step and move the Radius slider to the point where you are happy with the sharpened photo.

Unsharp Mask

Most people use the Unsharp Mask (USM) for sharpening images before output. If you are familiar with Photoshop USM, then using the Capture NX 2 USM will be an easy transition. In Capture NX 2, sharpening is only done on luminance data rather than on RGB color data. This generally results in a much cleaner, natural-looking image when you are finished.

The USM method is actually an effect that creates halos around details in your photograph. It is the halo that creates the visual impression of sharpness. If your halos are too big, then the photograph takes on a fake look very quickly. The key to good sharpening is to make the photo look just sharp enough but not too much. That said, sharpening can sometimes be more art than science because what I think might look good, you might think looks terrible. Sharpening is very much up to each individual.

There are three main sliders in the Unsharp Mask dialog box: Intensity, Radius, and Threshold (Figure 7.26). Intensity controls the amount of sharpening applied to the image. A higher Intensity makes the photo look sharper up to a point. If you set Intensity too high, then the halos look too big, and the sharpening becomes very aggressive.

The Radius setting controls the diameter of the halos that you create. A larger radius results in larger halos. Most images require a radius of right around 5%, but I've had to use values between 1% and 20% depending on the image.

The third setting is Threshold. Notice that the numerical values for this setting vary between 0 and 255. That should be a clue that you are working with levels (brightness). A low threshold value of 1 creates a halo between pixels that have a brightness difference of 1 level. A high threshold value of 30 creates a halo between pixels that have a brightness difference of 30 levels. Practically speaking, you use low threshold values between 0 and 2 to sharpen all

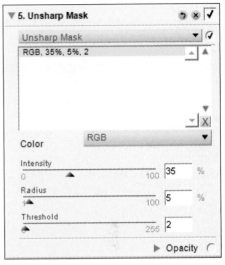

Figure 7.26

the detail in the photograph while using high threshold values between 4 and 30 to sharpen only the edges in a photo.

Figure 7.27 shows an example of a photo that has a lot of detail in the image. This silver sword fern was taken at Haleakala National Park in

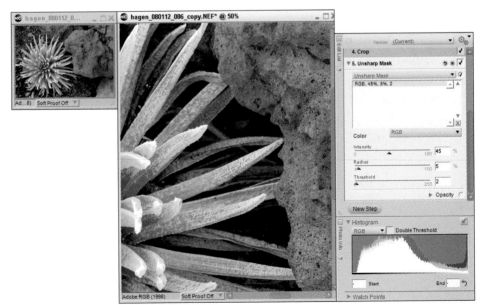

Figure 7.27

Hawaii with a Nikon D300 camera. I enhanced the colors and contrast with a Color Control Point, an LCH curve, and a Color Boost adjustment. After cropping the image to size, I started an Unsharp Mask adjustment and set the values to 45% for Intensity, 5% for Radius, and 2 for Threshold. This results in good detail for a landscape photograph.

Figure 7.28 shows another image of a family portrait where I didn't want to be as aggressive with the Unsharp Mask. In this case, I used an Intensity of 25%, a Radius of 5%, and a Threshold of 4.

Table 7.1 shows some general settings for different types of images. There are as many opinions for sharpening as there are photographers, but these will get you started.

The USM tool also gives you the ability to apply sharpening to an individual color. For example, if you want to sharpen just the petals of a yellow tulip, you can select the color yellow from the RGB drop-down list. The USM approach is the same as if you were sharpening on the RGB channel, but now the effect is only being applied to the single color. In general, you apply sharpening in the RGB channel, but it is good to know you have this option.

Figure 7.28

Table 7.1
USM Suggestions for Image Sharpening

Subject	Intensity %	Radius %	Threshold
Landscape	45%	5%	1–2
Face portrait	20% – 35%	5%	3–5
Family portrait	30% – 50%	5%	2–5
Wildlife/birds	40%	5%	2–3
Flower closeup	30% – 40%	5%	1–4

Correct

The Correct adjustments should only be used when you have a known lens distortion or problem in your image. Some lenses have known issues with barrel or pincushion distortion, while other lenses have problems with color aberration. This section is where you learn how to make the necessary fixes.

Distortion Control

If the lens you are using has a tendency to distort straight lines, you can use the Distortion Control adjustment to eliminate the problem. Moving the slider to the left reduces pincushion distortion (for example, contract the corners). Moving the slider to the right reduces barrel distortion (for example, expand the corners). In the example shown in Figure 7.29, the top photo is the original, the lower-left photo is with the slider moved to the left, and the lower-right photo is with the slider moved to the right.

After you make an adjustment for pincushion distortion (moving the slider to the left), you will sometimes create new blank areas in the image. You can use the Fill Color to pick a color to place in these areas.

Color Aberration Control

The Color Aberration Control tool helps eliminate any color fringing that might occur due to your lens. I recommend always leaving the Adjust pane setting turned on, but if you find that your photograph has additional Color Aberration, then you can solve it by using the Color Aberration Control adjustment.

see also

Chapter 5 reviews the Auto Color Aberration switch in the Adjust pane.

The most common places to find color aberration are in locations where there is a dark line against a bright background, such as a branch against the sky. To see the aberration, you generally need to zoom in very close and look toward the edges of your photo.

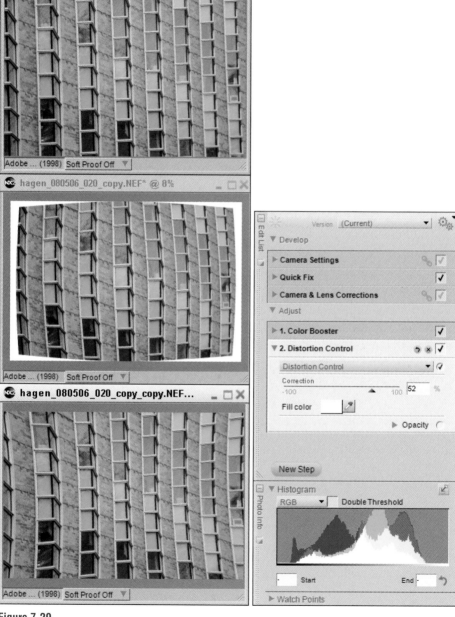

Figure 7.29

Figure 7.30 shows the before and after photos for Color Aberration Control. In order to see the problem, I zoomed in at 200%, so the photo looks very pixilated in the example. The top photo clearly shows color fringing around the tree branches, with cyan along the top of the branches and magenta at the bottom of the branches. For the bottom photo, I used the Color Aberration Control and moved the Red-Cyan slider to help eliminate some of the red fringing. I also moved the Blue-Yellow slider to try to remove some of the blue. You can see that the adjustment didn't do a very good job because the lens I used had a significant amount of fringing to begin with.

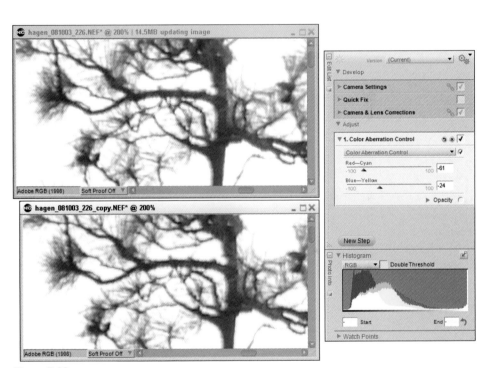

Figure 7.30

Noise Reduction

Any time you photograph at high ISO values with your camera, noise appears in the shadow regions. With older cameras such as the Nikon D200 and D2X, noise tends to start appearing around ISO 400 to 640. With newer cameras like the D300, noise starts to show up around ISO 1000. The newest full-frame sensor cameras like the D3 and D700 don't start exhibiting noise until around ISO 2500 or higher.

For some photographers, noise is bothersome, and they want to remove it entirely from the image. For other photographers, noise isn't a big deal, and they don't worry about it very much. If you want to remove noise from your image, then I recommend doing it as a New Step rather than doing it in the Develop pane. The reason why is that you can paint

the noise reduction into the photograph where it is most needed with the Plus Selection brush or any of the other selection tools.

Noise reduction should be performed early in your editing process. I recommend doing it right after your tonality adjustments and before your color adjustments. Don't wait until the end of your editing process to complete noise reduction because as you'll see, it actually changes your colors a little bit.

To eliminate noise in a photograph, start a Noise Reduction adjustment from the New Step menu, and then choose Better Quality from the drop-down list.

Many times, noise will appear in your photograph as pronounced orange/brown blotches of color in the shadow regions. These orange/brown blotches are called chroma noise (color noise) and can be easily removed with the Noise Reduction adjustment. The key to doing it well is to change the Opacity from All to Luminance and Chrominance. Then, set the Luminance channel for 0 percent so all the noise reduction is being applied only on the color data.

If you apply Noise Reduction to your image without changing the Opacity, then your photo will look very blurry from the Noise Reduction filter. This method allows you to maintain sharpness while eliminating the color noise.

Photo Effects

The Photo Effects adjustments are designed to allow you to make very quick canned enhancements to your image. Figure 7.31 shows all four Photo Effects. The upper left is Enhance Photo, the upper right is Black and White, the lower left is Sepia, and the lower right is Tinted.

The following list describes each effect and what it is used to enhance:

- **Enhance Photo.** Allows for quick and simple color enhancements. You can also click the Auto button to see how Capture NX 2 might enhance your image.

- **Black and White.** Converts your image to black and white. You can adjust the background colors by moving the RGB sliders to the right and left. You can use this tool or the Black and White Conversion adjustment step described later in the chapter.

- **Sepia.** Converts your image to a sepia-toned photo. Your only available control is the Brightness slider.

- **Tinted.** This is used to create a monochrome image, such as a cyanotype. Your controls are the RGB sliders, as well as the Brightness slider.

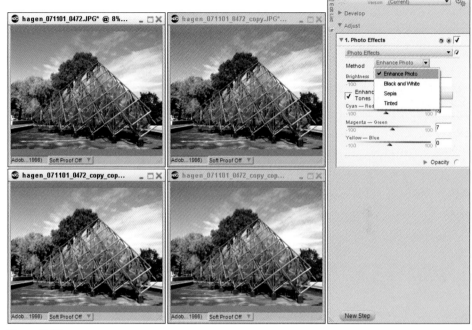

Figure 7.31

Add Grain/Noise

The Add Grain/Noise adjustment is used to do the opposite of the Noise Reduction adjustment. As mentioned earlier, some people like the look of Add Grain/Noise and don't want to remove it from their image. If you want your photograph to take on a film-like look, then use this tool.

For the stairwell shown in Figure 7.32, I converted it to black and white, then added the Grain/Noise adjustment to give it a gritty look. You can make changes to the settings based on your desire for large grain or small grain, and color grain or monochrome grain. Move the Grain Strength slider to change the intensity of the effect.

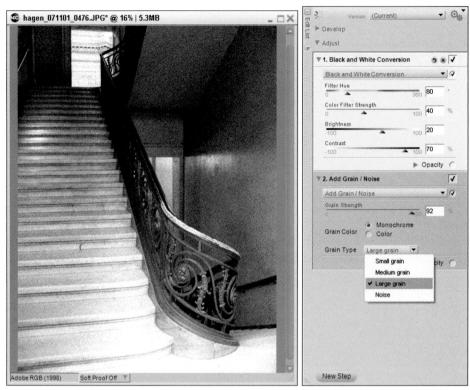

Figure 7.32

Contrast: Color Range

This is a tool you probably won't use very much in your workflow. The Contrast: Color Range tool allows you to control the contrast between selected colors without causing a colorcast across the entire image. To use it, select the color you want to adjust with the Hue slider, and then modify the color with the Contrast and Brightness sliders.

The color selected is brightened while the complementary color is darkened. In the example shown in Figure 7.33, I selected the reds and then increased the contrast so the complementary color, cyan, would be darkened. You can see the effect on the image. The left photo is the original, and the right photo has the Contrast: Color Range adjustment applied.

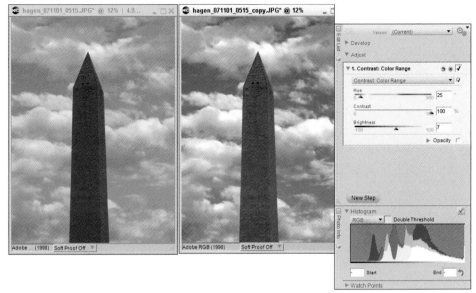

Figure 7.33

Colorize

This is another tool that you probably won't use much in your editing, but the Colorize adjustment allows you to add a color globally across your image. The primary use is to create a monochrome image from a black-and-white image, like a cyanotype or sepia-toned photo. Figure 7.34 shows a typical example. The photo on the upper left is the original, and the photo at the bottom has been colorized with a slight blue cast.

To colorize the image, click on the color swatch to pick a color. Then change the Opacity to decrease the impact on the image. The second way to pick a color is by clicking the eyedropper and then selecting a color directly from the image for the Colorize step.

Figure 7.34

Black and White Conversion

There are a few ways to convert your image to black and white in Capture NX 2, but the Black and White Conversion adjustment gives the most control. The tool utilizes a Filter Hue slider that allows you to choose the color filter for the conversion. This works similarly to the way you'd photograph in the real world with black-and-white film. Objects that are the same hue as the filter are lighter, while colors that are the complementary color become darker.

After you pick the Filter Hue, you can adjust the Color Filter Strength as well as the Brightness and Contrast in the image. Figure 7.35 shows two black-and-white conversions using this tool.

The best images for black-and-white conversions are those that have good contrast in the original file. If you don't have good contrast, then you might have to create it yourself with a Color Control Point or a Curve. In the cannon photo in Figure 7.35, I used a Color Control Point to darken the sky before converting the image to black and white. This helps add drama and interest to an otherwise uninteresting photograph.

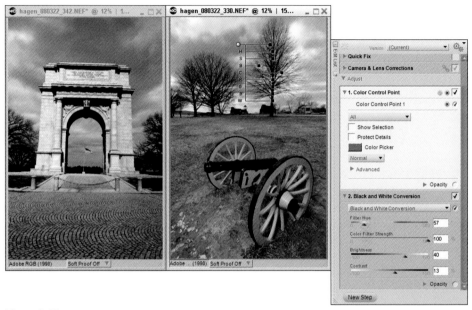

Figure 7.35

Cropping

The Crop adjustment tool allows you to remove areas from the edges of your photograph that you deem to be unnecessary. I frequently crop my photographs to make the composition more compelling or to eliminate elements such as branches, telephone wires, and jet contrails.

To activate the Crop tool, click the black Crop button at the top of the screen (Figure 7.36) or press the keyboard shortcut letter C. Next, click on the photograph and create a crop selection by dragging your mouse to the other edge of the area you want to keep. To change the size of the crop, you can click on any one of the small black boxes along the edges of the crop line. To activate the crop, double-click your mouse inside the crop area.

At this point, you'll notice that a new Crop adjustment has been placed in the Edit List. It is important to understand that in Capture NX 2, a Crop adjustment doesn't actually eliminate pixels from the image if you save the photo as an NEF. Rather, it just creates an instruction step that can be removed in the future if you decide that you don't like the crop or if you want to crop to a different size.

Crop tool

Figure 7.36

At the top of the Capture NX 2 window, a new toolbar appears with different options available for the Crop tool. Free Crop allows you to crop to any aspect ratio that you want. If you choose Fixed Aspect Ratio, then you can select an aspect ratio from the next drop-down list to the right. The choices run the gamut from 4 × 6 to 16 × 20. Capture NX 2 also allows you to create

your own custom crop sizes by clicking on the Custom line item. Finally, if you select the Show Crop Assistance Grid option, you can create crop lines inside your crop area to help you make a decision on the best composition. Selecting this option places grid lines at the 1/3 points in the photo so you can crop to the classic rule of thirds.

Resizing

Generally, you resize your image just prior to sharpening, so this is the second-to-last step of your workflow. To activate the Resizing adjustment, choose Edit → Size/Resolution (Figure 7.37) or press Ctrl+Alt+S (⌘+Alt+S). There are two options available in the Resizing dialog box: Resample Image and Don't Resample Image.

Select Resample Image when you want to change the output dimensions of the photo and the resolution of the photo. For example, you might want to reduce your resolution to 200dpi so you can make a large 20-x-30-inch print. For most printing applications, 200dpi produces a file with more than enough resolution. An

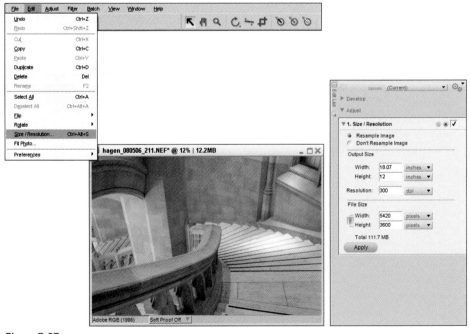

Figure 7.37

uncompressed 20 × 30 image created at 300dpi is 154MB while one created at 200dpi is 69MB. The 200dpi version will print just as well as the 300dpi version.

Resampling the image actually creates new pixels or removes pixels from your image. This is done by a process called interpolation and can make your image look bad if you start with a small file and try to make it larger.

Selecting the Don't Resample Image option doesn't allow you to change the total quantity of pixels in your image. For example, if you start with a 12-megapixel image, you'll end with a 12-megapixel image after this step. This adjustment only allows you to change the ratio

between resolution and image size. If you choose a small image size such 4 × 6 inches, then the resolution will be very high (for example, 700dpi). Alternatively, if you choose a large image size like 24 × 36 inches, then the resolution will be lower (for example, 115dpi). Select the Don't Resample Image option when you don't want Capture NX 2 to create or remove pixel information from your image.

When you click Apply, Capture NX 2 resizes the photo based on your input values and shows you the new image on the screen. If you save this image as an NEF, then you can come back to it in the future and remove the Resizing adjustment or change it to a different value.

8

Implementing Local Fixes
With Control Points

The real power of Nikon Capture NX 2 is hidden in a few small buttons at the top of the screen called Control Points. Nikon Capture NX 2 uses U-Point technology to power Control Points, and their implementation represents a revolutionary new way of working on photographs. Rather than spending your time selecting areas of the photo with marquee tools or layer masks, Capture's Control Points allow you to literally click on the area you want to fix and then fix it.

The Control Point tools include the Black/Neutral/White Control Points, the Color Control Point, and the Red-Eye Control Point. Also in this chapter, I cover using the Auto Retouch Brush.

U-Point Tool Overview

Nikon's U-Point tools operate in a way that is somewhat new to photographers. They allow you to make enhancements for hue, brightness, and saturation by simply placing a Color Control Point on your image and then adjusting the sliders until you are happy with the result. Not only are they fast, but they are effective and produce amazing results.

There are many situations in which you might want to change brightness or saturation in your photographs. Just about every photograph we take could use a little bit of enhancing to bring it back to the way we remember. Here are some situations that illustrate when it makes sense to use Color Control Points:

- Taking a photograph of a flower against a bright background will sometimes leave the flower underexposed. You can use one Color Control Point to brighten up the flower and another Color Control Point to darken the background.

- If you take a photograph of your new car and it was in the shade of a tree, you can increase the brightness and saturation by placing a Color Control Point on the side of the car.

- If you are taking a landscape photograph on an overcast day, you can increase the brightness and contrast of the gray sky by placing a Color Control Point in the clouds.

Figure 8.1 shows an example of an image modified with Control Points. The top image is the original, and the bottom image is the same photo after adding two Color Control Points. In the bottom photo, I placed one Color Control Point on the sky and another one on the sails of the boat. I adjusted the one in the sky to brighten it up and add a touch of blue. For the sails, I increased brightness while also increasing local contrast. It took less than a minute to make the enhancements and the results are impressive.

Integrating Control Points into your workflow means that you don't have to spend hours making delicate selections in your photograph. Rather, you just click on what you want to fix, and then fix it!

If you are used to working in other programs like Photoshop, then you know that making accurate selections for your enhancements is a big part of image editing and can sometimes be extremely time consuming. Making masks and marquees can take hours or more, especially if the area you need to select is complicated. For example, a woman's long hair or all the leaves and branches of a tree are some the most difficult subjects to select. Nikon Capture NX 2's Control Points make these types of selections simple and quick.

U-Point technology is the backbone behind the ease of use and performance of the Color Control Points. This technology uses four main factors to determine the selection:

- Position

- Color

- Brightness

- Texture

Any or all of these criteria may be used to select the elements in the image that you want to change. When you first place a Control Point, all you need to do is move the Size slider to increase or decrease the diameter so that all of the area you want to adjust is included within the circle. The U-Point technology takes care of the rest and doesn't require you to really modify the selection in any way.

There are five Control Points that are used for various color and tonal fixes, and these can be seen in Figure 8.2. Starting on the left is the Black Control Point, Neutral Control Point, White Control Point, Color Control Point, and Red-Eye Control Point.

Figure 8.1

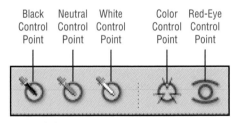

Figure 8.2

The tool that most photographers use in their image editing is the Color Control Point because it offers the most capability for improving an image. However, the Black, Neutral, and White Control Points are just as valid and should also be used regularly in your workflow. The Red-Eye Control Point will only be used when you have a red-eye problem in an image, so you won't be using this tool very much at all.

One of the neat aspects of Control Points is that you can use them along with other selection tools. You aren't limited to using just a Color Control Point or just the Selection Brush, as they can be used in tandem. For example, you can use the Linear Gradient Selection tool to lighten the foreground and then use a Color Control Point to change saturation in the sky.

Figure 8.3 shows a good example of using multiple selections in an image. The left image shows the original photograph, and the right image shows how a Linear Gradient Selection and a Control Point are used to improve the image. I performed a Levels & Curves adjustment for the foreground and then used the Linear Selection Gradient to apply it to the water and hills. Then I placed a Color Control Point on the sky to slightly increase saturation.

The approach for using the Control Points is generally to start with the Black, Neutral, or White Control Points to set the image tonality. Next, apply the Color Control Points to adjust saturation, hue, local contrast, and local brightness. Setting your white point and black point first gives you a much better understanding of how much color you need to add or change in your image. You won't use all the Control Points for every photo, but knowing the proper order to apply them is helpful.

Figure 8.3

Black, Neutral, and White Control Points

The Black, Neutral, and White Control Points allow you to set the tonality in your image. In other words, you use them to set the brightest point, the darkest point, and the neutral point in your image. The brightest point in a photograph is often called the white point, and it obviously follows that the darkest point is called the black point. If your photograph doesn't have anything in it that is white, then using a White Control Point won't make much sense.

For example, if you are editing a photograph of a red rose, then there probably isn't anything in the image that is truly white, and your image doesn't need a white point to look good. On the other hand, if you are editing a photograph of a bride wearing a white dress, then you'll generally want the dress to look bright white, rather than gray.

The White, Neutral, and Black Control Points are found at the top of the Capture NX 2 screen. They are shaped like black, gray, and white eyedroppers.

I recommend using these Control Points early in the editing process, as long as your photograph allows you to use them. I generally place the Black, Neutral, and White Control Points on the photo immediately after finishing in the Develop pane. For example, I might fix the white balance in the Camera Settings, and then go immediately to the Black, Neutral, and White Control Points to set the tonality of the image.

Notice that these tools are shaped like eyedroppers, which is your clue that they are used to sample a spot in the photograph. Also notice that each of the droppers is shaded white, gray, or black. It should go without saying that the White Control Point is used to set white locations, the Black Control Point is used to set black locations, and the Neutral Control Point is used to set neutral locations in the photo.

If you are a seasoned Curves user, then you know that the Levels & Curves adjustment also contains eyedroppers that let you do the same thing on your image. Although the Black, Neutral, and White Control Points are also used for the same purpose as the black, white, and neutral eyedropper tools in the Levels and Curves adjustment, you'll find out later in the chapter they are a bit more sophisticated. It is my opinion that you can actually produce a better result with the Control Point eyedroppers than you can with the Curves adjustment eyedroppers.

see also

For more information on using Curves, see Chapter 6.

Correct application of the Control Points

In order to effectively use the Black, Neutral, and White Control Points, your image needs to have definite areas that are black, gray, and white. Figure 8.4 shows four photos with different tonalities. The top two shots have obvious areas of white, gray, and black, while the bottom two photos don't really have any well-defined areas of white, gray, or black.

In the top-left image of the lifeguard station, the white paint in the sunshine is an ideal spot for setting the white point. For the top-right photo, the bird's white feathers are also a perfect spot for setting your white point. For setting the Neutral Control Points, you can select a gray portion of the scene, such as in the shadow region of the lifeguard station under the number 21 or the gray feathers of the bird. For the Black Control Points, I selected the dark shadow under the steps of the lifeguard station and the black feathers of the bird.

The lower two photographs in Figure 8.4 don't have tonalities in them where it makes sense to place white, neutral, or black points. The hotel with blue sky has some areas that are close to black, but if I used these to set the black point, then the photo would become too dark overall. The flower shot doesn't have anything in it that is white, gray, or black. The colors are all red, yellow, and green. For either of these shots, if you need to increase the brightness or adjust the contrast, it makes more sense to use Levels & Curves or any of the other Light adjustments available from New Steps.

tip

If your photograph doesn't have areas of white or black, then use Levels & Curves to adjust the brightness and contrast of your image.

Figure 8.4

If you choose to use the Black, Neutral, and White Control Points on the images in Figure 8.4, then you'll quickly find that they cause a significant colorcast. The reason is that these Control Points set the colors to equal parts Red, Green, and Blue. Any pixel that is set as equal parts Red, Green, and Blue is defined as a neutral color. For example, an RGB value of 128, 128, 128 is neutral gray. An RGB value of 255, 255, 255 is defined as white, and an RGB of 0, 0, 0 is pure black.

When you click on a photo with the White Control Point, it sets the tonality of that spot at an RGB value of 255, 255, 255—pure white. Correspondingly, a Black Control Point sets it for 0, 0, 0.

Another way to describe tonality is in terms of luminance. A value of 100% luminance is equal to an RGB value of 255, 255, 255. Fifty % luminance would be equal to an RGB value of 128, 128, 128, and 0% luminance is equal to an RGB value of 0, 0, 0. Table 8.1 shows these values in a different way.

Table 8.1
Luminance and RGB Values

Luminance Value	RGB Value
100%	255, 255, 255
50%	128, 128, 128
0%	0, 0, 0

There are many situations in image editing in which it doesn't look good to set the image tonality at the extremes of the tonal range. For instance, if you set your white point at 255, 255, 255 (100 percent luminosity), then that area won't have any detail. In other words, it will be blown out and can look pasty white in the final print. The same thing goes for the shadow regions in your image. If you set those values to 0, 0, 0 (0 percent luminosity), then you lose all detail in the shadows and those regions can look blocked up (solid black).

To address this issue, the Black, Neutral, and White Control Points allow you to dial down the luminance for the white point or dial up the luminance for the black point so that you are able to maintain detail in these areas. Each of the Black, Neutral, and White Control Points has a slider adjustment that you can control to change the default brightness of the Control Point (Figure 8.5). I cover the particulars of the sliders later in the chapter.

The Neutral Control Point works a little bit differently than many people are used to. In other image-editing programs such as Photoshop, clicking the gray eyedropper automatically assigns a Levels value of 128, 128, 128 to that tonal region. In other words, it affects the brightness of the image as well as the color of the image. In these other programs, placing the eyedropper on a dark area brightens that area as well as the rest of the image.

Figure 8.5

In Capture NX 2, the Neutral Control Point is really designed to just affect colorcast. This is a new concept in placing gray points, and I actually like using this tool to help improve the hue (colorcast) of the image. You can almost think of the Neutral Control Point as an alternative way to set your white balance, because it truly only adjusts colors.

The best way to set a Neutral Control Point is to find something in your photo that you know is a neutral color in the real world. Things like white shirts, gray pavement, white cars, gray houses, and clouds work very well for this. Don't be tempted to use people's skin, blue sky, or green leaves to set your Neutral Control Points, because if you do, you'll get an awful colorcast, as shown in Figure 8.6.

One of the best features of the Neutral Control Point is that you can add as many neutral points as you want to the photo. You aren't limited to one Neutral Control Point like you are in other programs (you are, however, limited to one white point and one black point in an image). Figure 8.7 shows a great example of a photograph in which I used multiple Neutral Control Points to set the colorcast. The left photo is the original, and the right photo has been fixed with two Neutral Control Points, one on the top of the gray feathers and the other on the bottom of the gray feathers.

I often place multiple Neutral Control Points to achieve a better color balance. Many times you'll find that using one neutral point produces too much of a color shift, while using multiple points looks more natural. Also, placing multiple Neutral Control Points can be particularly useful if your photograph has more than one light source in it, such as a window light and an incandescent light.

When you first place a Black, Neutral, or White Control Point, a slider (or sliders) immediately appears next to the dot where you clicked on the photo. The slider allows you to control luminance,

Figure 8.6

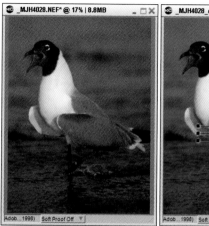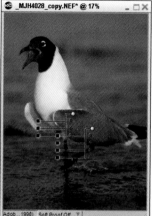

Figure 8.7

or brightness of that point. In fact, there are two options for controlling brightness: RGB or Luminosity. You can change the type of controls by clicking the drop-down list under the B/W/N Control Point adjustment step, as shown in Figure 8.8. I go into the detailed operation of each slider control in the next section.

Here is my recommended method for applying Black, Neutral, and White Control Points to a photograph:

1 Use Double Threshold to find the lightest and darkest areas of the image.

2 Turn off Double Threshold to see the normal view.

3 Click on Black Control Point and place the eyedropper on the darkest area.

4 Move the Black Luminance or RGB sliders up to a brighter level to maintain detail in the shadows.

5 Click on White Control Point and place the eyedropper on the brightest area.

6 Move the White Luminance or RGB sliders up to a brighter level to maintain detail in the highlights.

7 Click on Neutral Control Point and place the eyedropper on a neutral area.

8 Move the RGB sliders to achieve the best color balance.

You don't always have to use all three points in your photograph. In fact, there are many times when you will only use one of the points. For example, only use the Neutral Control Point when you want to neutralize the colors in a scene that only has a gray item to click on. On other images, such as a wedding photograph, you might use a White Control Point on the bride's dress and a Black Control Point on the groom's tuxedo.

In the photograph shown in Figure 8.9, I used only a single White Control Point on the brightest part of the ship to set the white point in the image.

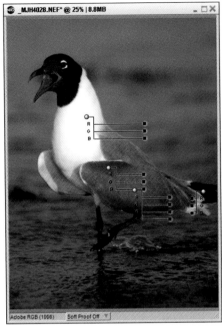

Figure 8.8

Figure 8.9

There are two ways to adjust Black, Neutral, and White Control Points. One method is via the RGB sliders, and the other is with the Luminance slider.

RGB setting

After placing the Neutral Color Point, to activate the RGB sliders, go into the B/W/N Control Point adjustment step in the Edit List and click the drop-down list to choose between Affect Luminance and RGB. Next, click on the Advanced menu to view the numbers for RGB. RGB stands for Red, Green, and Blue, and it represents the levels or brightness values for each color channel in your white point, neutral point, and black point. Figure 8.10 shows a photograph with a neutral point where I modified the default RGB settings.

In this example, I placed the Neutral Control Point on the side of the airplane and then changed the Green value to 131 and the Blue value to 143. My goal was to bias the colors so they looked better on my monitor. The default settings of 128, 128, 128 made the colorcast too warm, so I added blue and green to cool it down a bit.

There are many times when you set a point that and don't necessarily want to use the default values. The example in Figure 8.10 is a perfect scenario for this.

When you set a White Control Point, you can reduce the RGB values in equal amounts to something like 249, 249, 249 to try to maintain detail in the highlights. For the black point, something around 6, 6, 6 helps preserve detail in the shadows. This is a common approach for photographers who print their images and want to keep detail in the extremes. Each photographer has his or her own opinion about setting white and black points. Some like their shadows to be inky black with no detail, while others like to maintain a little bit of detail. The same goes for the highlights. My preference is generally to try to maintain a little detail in both the shadows and the highlights. For my Neutral Control Point, I adjust the RGB values so the photograph looks well balanced on my calibrated computer monitor. This technique of using the Neutral Control Point to change the colors of the photo can also be done with the White Balance area in the Develop pane.

Figure 8.10

Luminosity setting

Of the two methods for adjusting the Black, Neutral, and White Control Points, the Luminosity slider is definitely the easiest. It is a quick way to adjust the brightest element and the darkest element in an image. Although you don't have the ability to control each color channel as with the RGB slider controls, this method still provides an effective way to set the luminosity.

When you choose Luminosity from the drop-down list in the B/W/N Control Point step, it changes the slider control to a value indicating Luminance percentage. One hundred % equals the brightest possible value for the White Control Point, and 0% equals the darkest possible value for the Black Control Point. The Neutral Control Point has a numerical value of 0%, but it is important to note that this value is really equal to the middle tone, or 128.

The proper approach to using the Luminosity method is to first set the black point on the part of the image that you want to define as the darkest spot. Then you adjust the slider to set the black point brightness to the luminance you are happy with. If you set the black point luminance to zero, then this spot of the photo (and everything that is darker than that spot) prints as pure black with no detail. Many photographers like to set the black point luminance at a higher value, such as 2% to 5%, in order to preserve a little bit of detail in the shadows, as shown in Figure 8.11.

The same approach holds true for setting the Luminance value for the white point in your image. If you place the White Control Point on the part of the photograph that you want to define as the brightest white, then its level will be set at 255, or 100% luminance. Setting it to 100% luminance means that that area will have no detail. A lot of photographers find that it makes sense to reduce the Luminance to a value between 95 and 97% in order to maintain a little bit of detail in the highlights. For the photo in Figure 8.12, I reduced the Luminance to a value of approximately 95% to keep detail in the mountain snow.

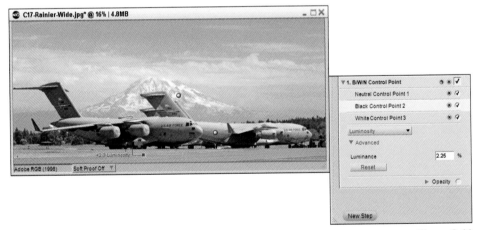

Figure 8.11

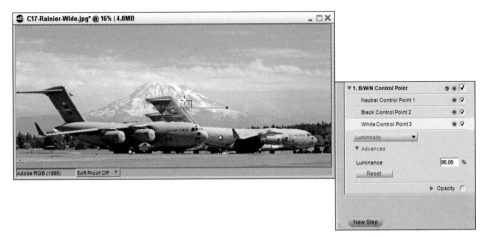

Figure 8.12

The Neutral Control Point has both Luminance and RGB sliders. The RGB sliders work the same as before, and they allow you to bias the neutral color by any ratio of Red, Green, or Blue that you desire. The default numerical values are 128, 128, 128, and if you want to bias the color of the image, then you can choose any other ratio from zero to 255 for any channel. In practice, a change of just a few levels will make a dramatic and pronounced effect on the image.

In addition to the RGB sliders, you have the ability to change the Luminance value of the midtones. The default setting for the Neutral Control Point luminance is 0%, which really means level 128. If you increase the value, it brightens the photo. If you decrease the value, it darkens the photo, as shown in Figure 8.13.

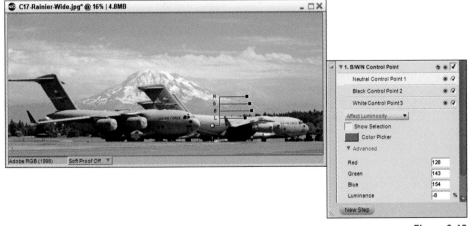

Figure 8.13

Color Control Point

Color Control Points are my favorite tools for editing photos in Nikon Capture NX 2. Their utility, ease of use, amazing capability, and effectiveness never cease to amaze me. I've used other image-editing programs like Photoshop for years and am very proficient at editing images. Even with all my knowledge, I am still enthralled with the ease at which I can improve my images in Capture NX 2 by using the Color Control Points.

Color Control Points can be used for many purposes in a photograph. Here's a short list of things that I use them for in my workflow:

- Changing the hue of the sky

- Increasing the saturation of a flower

- Removing color from a section of an image

- Increasing the brightness in the shadow of a tree

- Adding contrast for a small section of the photo

- Changing the colorcast on a person's face

- Adding warmth to a sunset sky

- Reducing the brightness on a person's cheek

To place a Color Control Point in your picture, click on the Color Control Point button (Figure 8.14) and then click on the location in your picture that you want to fix. Alternatively, you can press Ctrl+Shift+A (⌘+Shift+A), which allows you to click on the photo to place the Color Control Point.

With a little bit of knowledge and skill on your part, you can use Color Control Points in very creative ways to turn your images into masterpieces. As I mentioned earlier in this chapter, Color Control Points use U-Point technology to help define where they affect an image. This technology automatically selects objects in the photograph that have a similar color, brightness, and texture as the spot on which you have placed the Color Control Point.

Figure 8.15 shows a good example of how a Color Control Point can be placed on an image to only affect similar objects while not impacting other parts of the image. In this example, I have clicked on a single red leaf, and the Color Control Point is able to select all the leaves in the image that meet the criteria of the U-Point selection technology. The photo on the right shows what the selection looks like from the Color Control Point; anything that is white is being selected by the Color Control Point, and anything that is black is being excluded.

When you place a Color Control Point on your photograph, nothing initially happens to the image. In order to start applying changes to the image, you have to begin moving the adjustment sliders. The slider closest to the Color Control Point is called the Diameter slider, and it is used to set the overall reach, or area of influence, of the Control Point. The larger the diameter you set, the more objects with similar color, brightness, and texture are affected in the image. Figure 8.16 shows the Diameter Control slider.

Color Control Point

Figure 8.14

Figure 8.15

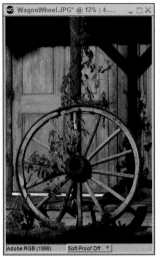
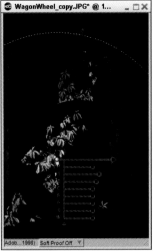

Diameter slider for Color Control Point

Figure 8.16

rather, it is only an approximate estimate of influence. The selection is strongest at the middle of the circle, mildly strong at the outer radius of the circle, and then gradually loses its influence outside the circle. You might think of the selection as being feathered in a radial fashion, starting from the center of the Control Point.

Depending on where you place the Color Control Point, you might see the adjustment sliders pointed to the left, right, up, or down (Figure 8.17). This is confusing for first-time users because sometimes you move the slider to the left to increase the adjustment, and other times you move the slider to the left to decrease the adjustment. It all depends on where you initially click to set the point. No matter where you first set the point, if you always remember that moving the adjustment slider away from the line increases the adjustment, then you'll be just fine.

Most people who begin using Color Control Points incorrectly assume that the outer diameter of the circle is the hard limit of the Control Point. After using the Color Control Points a few times, you quickly realize that the circle is really only limiting the selection to areas in the general vicinity of the circle's radius. In fact, the circle radius doesn't define a hard stop for the influence;

The first time you place a Color Control Point, you will probably notice that the adjustment sliders only show three items, named BCS. If you want to access the other slider controls, click on the small triangle under the Color Control Point that you placed on the photo, or click the BCS drop-down list in the Edit List. Then choose RGB, HSB, BCS,

or All. Figure 8.18 shows the different Color Control Points options with their associated labels.

There are three ways to make changes to the slider values. The first and most obvious is to click on the slider and move it side to side. The second way is to click the Advanced menu in the Adjust step pane to see all the numerical values for the slider settings. Once this is open, you can type a numerical value for the adjustment. The third way to make adjustments is to click in the number box and then use your keyboard up/down arrows to increase or decrease the value.

After you set a Color Control Point and make enhancements to the image, you'll want to eliminate the point from your view so you can evaluate the quality of the adjustment. If you roll up the New Step by clicking on the triangle next to the Color Control Point title, then it will remove the point from view.

Figure 8.17

Figure 8.18

Also, when you print your photograph, the image itself will not show the Color Control Point with the sliders. All you'll see are the changes caused by the Color Control Point. I know this is obvious to most people, but you'd be surprised at how many users ask me if the point itself shows up when you print.

Color Control Point modes

As shown previously, there are four modes for the Color Control Points: BCS, RGB, HSB, and All. Depending on what improvements you need to make to your photograph, you can select any of these modes. However, I generally find that I like working in the All mode because it gives me easy access to all possible adjustments in the tool. Figure 8.19 shows the drop-down menu and the different selections available.

The following list explains what the acronyms mean:

- **BCS.** Brightness, Contrast, Saturation.

- **RGB.** Red, Green, Blue.

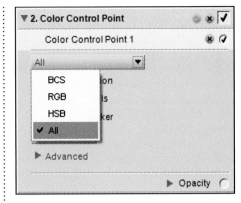

Figure 8.19

- **HSB.** Hue, Saturation, Brightness.

- **All.** Allows you to make adjustments on all the slider controls. It also adds another slider control called W that changes the warmth of the selection. (In Figure 8.20, I decreased the W slider to remove a strong colorcast.)

Table 8.2 summarizes all the slider names and functions.

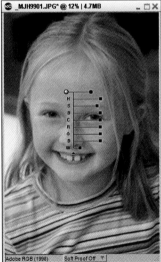

Figure 8.20

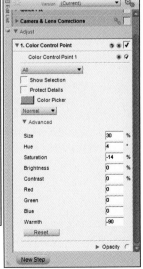

Table 8.2

Names and Functions of Color Control Point Sliders

Abbreviation	Name	Function
H	Hue	Changes the color of the selection to another color in the visible spectrum. The number values are actually degrees that correspond to the 360-degree color wheel.
S	Saturation	Increases or decreases the vibrancy of the color in the selection.
B	Brightness	Increases or decreases the brightness of the pixels in the selection.
C	Contrast	Increases the contrast of the pixels in the selection.
R	Red	Changes the ratio of red in the selection. Positive adds red. Negative adds cyan.
G	Green	Changes the ratio of green in the selection. Positive adds green. Negative adds magenta.
B	Blue	Changes the ratio of blue in the selection. Positive adds blue. Negative adds yellow.
W	Warmth	Biases the color warmer or cooler by adding red or blue to the colors in the selection. This is often used as a local white balance tool.

Most of the time you are working on an image, you'll only be changing the brightness, contrast, or saturation. From that standpoint, just keeping the BCS method visible might make sense. It simplifies your view and keeps the photograph less cluttered.

Applying multiple Control Points in the same step

When you place only one Color Control Point in a photograph, it will impact the selected area and not be influenced by anything else. However, you aren't limited to only placing one Color Control Point in each picture. In fact, you can place as many Color Control Points as you want in the same step to help achieve your final look. When you place multiple Control Points in the same step, their behavior changes slightly because they actually influence each other by pushing back the other Control Point's selection.

To place multiple Color Control Points in an image, make sure that the adjustment step stays open and active. If the step goes inactive (for example, you clicked out of it somewhere else in the program), you can reactivate it by clicking on the words "Color Control Point" in the Edit List. You will always know that the step is active if the entire dialog box is lighter gray than the other adjustment steps.

In the photograph in Figure 8.21, you can see that I have two control points placed in close proximity. The first is on the sky, and the next is on the church building. The sky Color Control Point should only be affecting the blue sky. However, what you typically find with control points is that their influence can sometimes bleed over into adjacent areas.

If you place another Control Point nearby, then the second Control Point will "push back" on the first Control Point so that it doesn't affect the

second point's area. For the example in Figure 8.22, I placed a second Color Control Point on the church steeple to protect it from the Color Control Point in the sky. When I adjust the second point it will be independent from the first point and won't impact anything in the sky. Because both Control Points are in the same step, they influence each other just by their proximity.

Figure 8.21

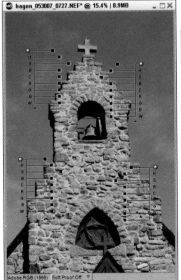

Figure 8.22

Many times it makes sense to use multiple Color Control Points to fix an area rather than one big Color Control Point. For example, in Figure 8.22, I used four smaller Color Control Points in order to keep the Saturation adjustment confined to just the sky. If I used a single large point, then I run the risk of having the Saturation adjustment bleed over to another part on the church steeple, such as the blue in the stained-glass window.

It is also common to use multiple Color Control Points in an image that all perform different functions. For instance, you can place one point for increasing brightness on a person's face and then another point in the sky to increase saturation, as shown in Figure 8.23. The left photo is the original, and the right photo has two Color Control Points. The point in the sky changed the hue to a different shade of blue while also decreasing the brightness and increasing saturation. The point on the photographer's face has only increased brightness to help him stand out from the shadows.

Color Control Points can also be used in separate steps so they won't influence each other. To do this, place your first Color Control Point(s) on the image and make adjustments. Roll up the step by clicking on the small triangle so the step is minimized. Then click outside of the step in the gray area by the New Step button, which completely deselects the Color Control Point. Now click the Color Control Point button at the top of the screen to initiate a brand-new step.

Figure 8.24 shows how I created a new Color Control Point step that is separate from the first step. In this example, the changes I made in the first step with two Color Control Points are still active (Figure 8.23), but their influence is separated from the Color Control Point I made in the second step. In this case, I wanted the new Color Control Point to brighten up everything within its selection without being pushed back by another control point. You can see that I increased the diameter of the circle so that it

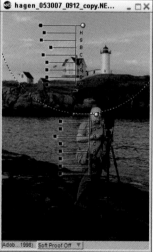

Figure 8.23

Figure 8.24

included the rocks on the other side of the water. The other two Color Control Points in the previous step are hidden below and not influencing the selection from the new Color Control Point.

Show Selection

Many times you want to see how much of the image your Control Point is actually influencing. To see the selected area from the Color Control Point, select the Show Selection check box. As with all selections, anything colored white means it is being affected by the change, and anything colored black means it isn't being affected. Shades of gray indicate differing amounts of selection, so something light gray is mostly selected and something dark gray is mostly not selected.

I frequently use the Show Selection tool to set the diameter of the Control Point so that I don't overlap my adjustment into another region. It is a great tool to help you finesse the size and see what pixels you are truly affecting. Figure 8.25 shows what the selection looks like for the Color Control Point placed on the rocks.

If you have a lot of Control Points in a single step and choose Show Selection, then it can be a little difficult to understand which Control Point is affecting which area. Figure 8.26 shows an example of a photo with many control points (left side) and the associated selection (right side).

In this example, the entire photograph looks selected because everything is white. It is difficult to know which Color Control Point is affecting the rocks and which Color Control Point is affecting the

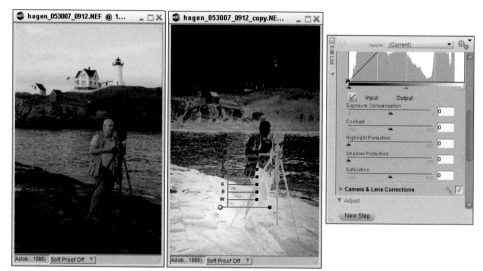

Figure 8.25

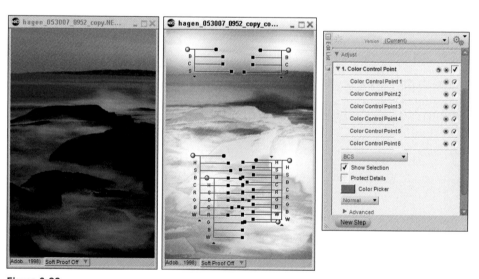

Figure 8.26

water. So, to show the selection from just one of the Color Control Points rather than all the points, just highlight the point you want to see by clicking on it in the Edit List. Then make sure that the Show Selection box has a check mark in it (Figure 8.27).

The Show Selection tool is also very helpful when you want to be accurate with your placement of the Color Control Point. Sometimes when the image is in full color, it can be difficult to tell whether your selection is placed in the right spot.

Figure 8.27

If you want to be absolutely sure of the placement, activate the Show Selection tool and move the Color Control Point around in the photo until you achieve a good selection. Clicking and dragging the point with your mouse and watching the white selection appear or disappear is the most accurate way to position these Color Control Points.

Protect Details

The Protect Details tool transforms your Color Control Point into a point that prevents changes to the area it is selecting. Think of it as a point that says "do not touch my area" to the other Control Points in the same step. When you select the Protect Details check box, it uses the selection it created to block the effects from other Control Points and return that portion of the photograph to the previous condition.

For example, let's say you were working on an image and noticed that the background changed from one of your Color Control Points. To return the background to its previous condition, you could drop a Color Control Point on the area and use the Protect Details option to return that section to the original color. Figure 8.28 shows an example in which I placed Color Control Point 3 on the yellow background to return it to the original hue. The other two Color Control Points on the saxophone player's face and shirt had slightly modified the yellow background.

When you select the Protect Details check box, all the adjustment sliders disappear from the Control Point except for the Diameter slider. This slider allows you to determine the size of the protected zone.

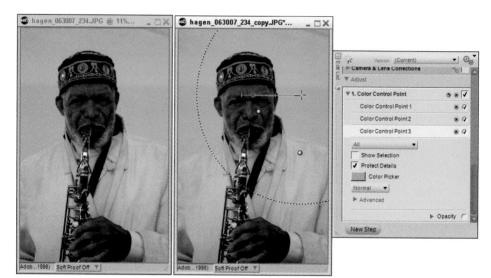

Figure 8.28

Color Picker

A very neat subset of the Color Control Point is the Color Picker utility. To activate the Color Picker, first place a Color Control Point in the photograph and then click the Color Picker box, as shown in Figure 8.29.

The Color Picker is a powerful tool that allows you to change the color of your selection to any other color in the visible spectrum. It can be useful for changing the color of the sky or a flower or even a person's face. When you first activate the tool, you see a color wheel with a triangle inside. The top of the triangle represents the main color hue you are

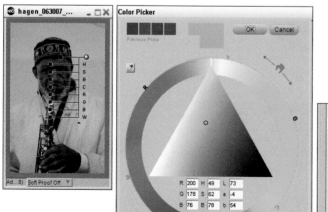

Figure 8.29

working with. In Figure 8.29, the triangle is pointed to the yellow spectrum, because that is the color where I first placed the Color Control Point.

If you want to change the color in your photograph to something else, it's as simple as clicking a different color on the color wheel (such as red). When you do this, the new color moves to the top of the triangle. At this point, you can click a color inside the triangle to fine-tune your choice. Figure 8.30 shows how I used this technique to change the background of the photo to the color red.

Inside the circle, the color choices are listed in three tables in terms of RGB, HSB, or Lab numbers. Most of the time, you won't need to manually type a specific color. The true application for this is if you want to match the colors from two different images. For example, if you photograph a yellow tulip from different angles and want to make sure that each image is exactly the same color, then you would type the numerical RGB value for yellow into the Color Picker utility so the images are consistent. There are lots of other applications for the tool as well, such as changing the color of the sky, the grass, or anything else in your image.

Each of the three color models allows you to choose which definition you want to use to enter the data. RGB represents values for Red, Green, and Blue. HSB lets you enter specific values of Hue, Saturation, and Brightness, while Lab lets you enter values for Luminance, a-channel (Green-Red), and b-channel (Blue-Yellow). Setting the values for one color type (for example, RGB) also changes the values for the other color types.

The next area of the Color Picker is the Swatches pane. Click on the triangle next to the word Swatches to open a section with various colors and tones. These are extremely useful for adjusting the colors of skin tones, foliage, skies, and black-and-white images. I use this area extensively to properly set the correct color for people's faces or to add color back to a washed-out blue sky. Figure 8.31 shows the Swatches pane.

Figure 8.32 shows how I used the Skin Tones swatch to adjust the tonality of the saxophone player's face. I first placed a Color Control Point on his face and then clicked on the Color Picker. Next, I opened the Swatches pane and clicked in the Skin Tones area to select different skin values for his face. You can clearly see the

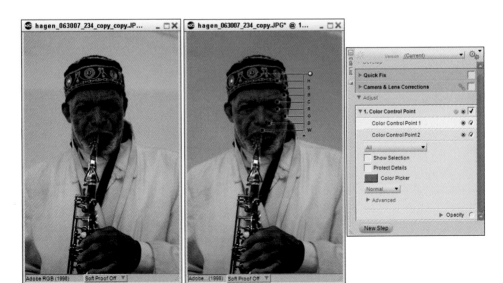

Figure 8.30

different effects in each image. The top-left image is the original, and I chose different skin tones for the remaining three images.

The last tool in the Color Picker utility is the Eyedropper button located in the upper left of the Color Picker window. The Eyedropper is

Figure 8.31

Figure 8.32

used to select a color or tone in your image that you want to duplicate for the Color Control Point. For example, Figure 8.33 shows a photo (top) that has two different color flowers. If you want the flowers to match in color, then you can use the Color Picker to sample one flower and copy that color to the second flower.

The bottom photo shows that I changed the color of the background flower to be a closer match to the front flower. To do this, follow these steps:

1 Activate a Color Control Point and click on the back flower.

2 Open the Color Picker utility.

3 Click the Eyedropper button.

4 Click on the front flower (that is, the color you want to copy).

5 Change the opacity until you are happy with the look.

Method drop-down list

All of your Color Control Points can be applied in different quality settings as determined by the Method drop-down list. Access the different methods from the Normal drop-down list in the Color Control Point adjustment step (Figure 8.34). The menu is called the Method menu, and it is located below the Color Picker button.

I recommend using the Advanced setting for almost everything, because it uses a much more powerful algorithm to apply the adjustment to the photo. You'll sometimes find that the Basic setting creates some posterization or noise when you try to do big brightness or saturation adjustments. The benefit of the Basic setting is that the adjustment is fast and doesn't take very much computing power. If you have a fast computer, though, you're always better off using the Advanced setting. Table 8.3 details each method and its intended use.

Figure 8.33

Table 8.3
Method Settings

Method	Use
Basic	Fastest to render adjustments but provides the lowest quality. Use for Web graphics or when you have a slow computer.
Normal	Good balance between speed and quality. This setting is sufficient for most images and Color Control Point adjustments.
Advanced	Best quality but takes the longest to render the adjustment, especially if you have selected a large area. This is best for brightening dark shadows or when your image has a high level of digital noise.

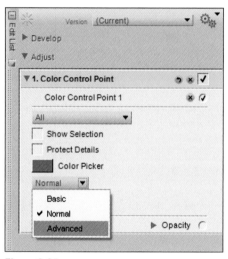

Figure 8.34

Duplicating and synchronizing Control Points

Many times when you place Color Control Points in an image, you can save time by just duplicating a point rather than creating it again from scratch. For example, if you are working on the sky in a photograph (Figure 8.35) and make a few changes to brightness, contrast, and saturation, then you can simply duplicate that information and move the new duplicate point to a different area of the sky for even coverage.

Duplicating points is very easy to do. Follow these steps:

1 Activate a new Color Control Point.

2 Make adjustments as necessary.

3 Right-click on the point (Figure 8.36) and choose Duplicate Control Point.

4 Move the new point to a different area of photo.

Figure 8.35

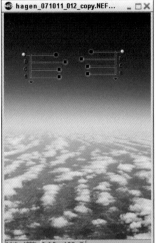

Figure 8.36

There are two other methods for duplicating Color Control Points. The first is by choosing Edit→ Duplicate. The second is by pressing Ctrl+D (⌘+D).

caution

If you don't have a Color Control Point selected with your mouse, then choosing Edit→ Duplicate duplicates the entire image and creates a copy in the Capture NX 2 window.

Red-Eye Control Point

After working with the other Control Points in Nikon Capture NX 2, using the Red-Eye Control Point will be easy. If your image has red-eye, fixing it is as simple as activating a Red-Eye Control Point and placing it on the eyes of your subject (Figure 8.37). The only adjustment you need to do is to change the diameter of the Control Point so that it fully covers the retina of the subject. After you set the diameter, you're done. Simple!

You can place as many Red-Eye Control Points on your photo as you need. Also, you need one Red-Eye Control Point for each eye you want to fix. In other words, you need two points for each person.

In Chapter 5, I reviewed a feature in the Develop pane called Auto Red-Eye that automatically eliminates red-eye from a photo. This works very well most of the time, but there are situations in which the Auto Red-Eye control won't completely remove red-eye. In these situations, go ahead and place a Red-Eye Control Point on the subject's eyes to complete the job.

One final note: There are some kinds of red-eye that the Red-Eye Control Point tool doesn't do very well with. For example, it won't remove green-eye or yellow-eye from pets. Also, I have found some cases in which my human subject had a different shade of red and the Red-Eye Control Point wasn't able to eliminate the problem. In those situations, you might just have to send the image to Photoshop to complete the fix.

see also

See Chapter 3 to learn how to easily send your image to Photoshop for further editing. See Chapter 5 to review information about the Auto Red-Eye function in the Develop pane.

Figure 8.37

Auto Retouch Brush

In previous versions of Nikon Capture, if a photograph had areas that needed to be retouched, repaired, or fixed, you had to send the image to another program like Photoshop. For example, if the image had dust in the sky and the Dust Off Reference tool in your Nikon camera wasn't used, there was no way to fix the problem in Nikon Capture NX or Nikon Capture 4.4.

Nikon Capture NX 2 has a new tool called the Auto Retouch Brush. It is a pretty slick tool that solves your simple retouching needs with the click of a mouse. The Auto Retouch Brush works well, but keep in mind that if you have significant retouching to do, then you still need to send your image to Photoshop or a similar editing program.

Figure 8.38 shows an example of a before-and-after shot of the Statue of Liberty in which the Auto Retouch Brush was used to remove two dust spots in the blue sky. You can see that the tool worked well for this scenario.

How to use the brush

Click the Auto Retouch Brush button in the toolbar. It's the button that looks like a band aid (Figure 8.39). When you do this, your mouse pointer changes into a circular brush. To change the diameter of the brush, click and drag the Size slider in the tool options bar at the top of the window. Make the brush slightly larger than the diameter of the dust or area you are trying to fix. Click and paint on the photograph where the dust appears and let go of the mouse button. Capture NX 2 automatically attempts to repair the area that you selected.

In addition to fixing small spots like dust, you can fix regions or lines by clicking and dragging across a larger area. This is especially useful for repairing things like power lines, jet contrails, or wrinkles underneath a person's eyes.

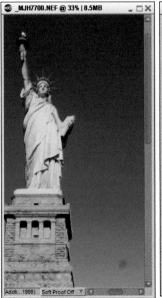
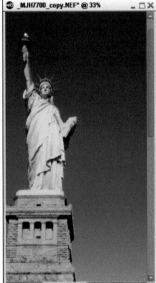

Figure 8.38

Auto Retouch Brush Brush diameter control

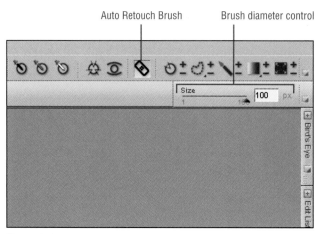

Figure 8.39

If you don't like how well the brush repaired the area, you can undo the mistake by choosing Edit → Undo and trying again. Alternatively, you can undo the entire retouch step by clicking the Reset button in the Edit List.

If you click on the photo a bunch of times, Capture NX 2 eventually creates a new Retouch step. If your image requires a lot of retouching, then you might have three or four Retouch steps in the Edit List.

Situations in which the brush works best

The Auto Retouch Brush works best in areas that have a fairly simple background. For example, a speck of dust against a solid blue sky or a spot on someone's cheek is easy to fix. Figure 8.40 shows an example where the Auto Retouch Brush worked very well to get rid of a flag and an errant shoelace. The photo on the left is the original, and the photo on the right was repaired with the Auto Retouch Brush.

The Auto Retouch Brush did an excellent job of removing the flag because it is surrounded by areas without texture. Also, it did a good job on most of the shoelace, but if you look carefully, you can see a little bit of blooming right at the interface between the black shoe and the grass. This blooming exists because the Auto Retouch Brush is trying to blend the foot into the background where the shoelace was removed. It is always at these interfaces where the brush has a difficult time.

Figure 8.41 shows a different example in which the brush didn't do a very good job fixing the image. The example here involves a mouth that has a little bread crumb at the edge of the lip. I tried to eliminate the crumb, but Capture NX 2 made the edges of the lip look a little funny.

In general, if the area is easy to fix, then I use the Auto Retouch Brush in Capture NX 2. If the area is complicated and busy, I send the photograph to Photoshop after I finish making the photo look good in Capture NX 2.

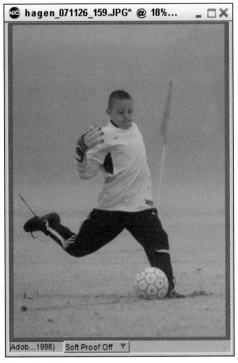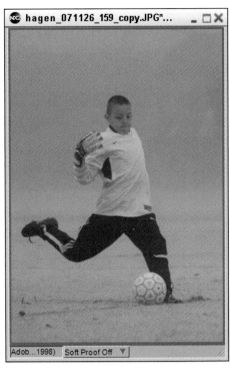

Figure 8.40

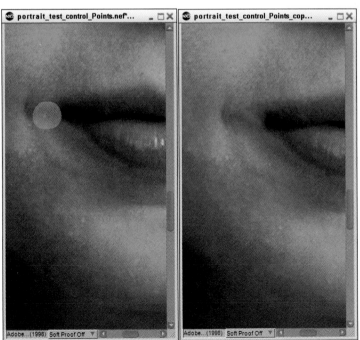

Figure 8.41

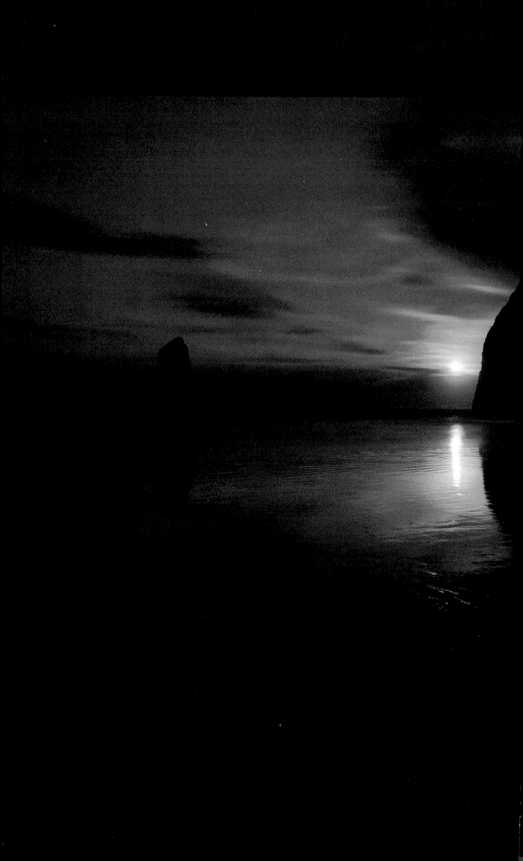

9

Preparing for Output

Printing from Capture NX 2 can produce excellent results as long as you have a bit of patience with the printing utility. The first time you use Capture to print an image, it can be difficult to understand which items to activate or how colors and profiles are managed. However, with a little knowledge and patience, you can create fantastic prints from your inkjet printer or from your local photo lab.

In this chapter, I cover color management issues, such as soft proofing and changing color profiles. I also explain using the print layout dialog, working with photo labs, and sending your images to other programs for further editing.

Printing

There are generally two types of printing methods photographers use in their workflow: printing on inkjet printers and printing at the photo lab. Both methods have pros and cons, and neither choice is always the best for all purposes. The advantage to printing at home on an inkjet printer is that you have full control over the entire printing process from start to finish. This level of control can often result in better-quality prints than a lab can produce. However, printing at home requires a sizeable investment in color management tools and knowledge.

Printing at a lab places most of the responsibility for color management on the shoulders of the lab. The lab is responsible for making sure its printers produce accurate colors. Your responsibility is to provide the best file possible in terms of color, sharpness, and brightness. Generally speaking, a professional laboratory's process is tightly color controlled and efficient. If you are printing a large quantity of photographs, it is often much more cost effective to print at the lab.

Table 9.1 summarizes the advantages and disadvantages to printing at the lab or on your inkjet printer.

Neither method of printing is "best," and both have their place in photography. I use the lab whenever I need to make a large quantity of prints for a client, such as prints from a portrait session or wedding. I use my own inkjet printer whenever I need to create a single enlargement or a print for wall art.

Table 9.1
Comparison Between Printing at the Lab and on an Inkjet

Printing on an Inkjet	Printing at a Lab
Takes a long time to print large projects like weddings.	Hands off. The lab is responsible for everything.
You have full control over the entire process.	The lab sometimes makes color decisions for you.
You have to stock and manage ink and paper supplies.	You can send big batches for one-hour or one-day turnaround.
You need intimate knowledge of the communication process between your computer, software, and printer.	The lab handles all communication between the computer, software, and printer.
Requires a color-managed workflow.	Requires a color-managed workflow.
The cost can sometimes be higher.	You can get volume pricing on prints.

Monitor calibration

The most important thing you can do to ensure great color in your prints is to calibrate your monitor. This step alone takes you most of the way to perfect color matching. Monitor calibration is absolutely critical, because the only way to truly judge whether your photos have the right color is view them on a calibrated monitor.

The first time you calibrate your screen, you will be amazed at the difference in colorcast and brightness. Because the first calibration is most dramatic, most people assume that they did it incorrectly. The truth is that the calibration has set your monitor to match with the rest of the calibrated world. Calibration just means that the colors and brightness your screen displays are the same as a global standard. What you see on your monitor will be the same thing that you print at the lab or on your inkjet printer.

I recommend the calibration tools from Datacolor and X-Rite. There are many monitor calibration tools on the market, and using just about any

product will be an improvement over simply guessing about your calibration. As you might imagine, you get what you pay for in the calibration world, so buy something from a reputable vendor and don't skimp on this purchase. You should recalibrate your LCD monitor about once every two months and your CRT monitor about once every two weeks for the best results.

The monitor you use also plays an important role your workflow, so you should use the highest quality monitor you can afford. Laptop screens are not appropriate for editing your photos because they have a wide variation in brightness, contrast, and color depending on your viewing angle. If you want to have prints that look like your screen, then I recommend using a high-end LCD screen such as an Eizo, LaCie, or Apple Cinema display. Figure 9.1 shows an Eizo 21" display. Low-end desktop LCD monitors that cost $300 aren't much better than laptop screens and shouldn't be used for color work. You need to spend anywhere from $800 to $1,500 for a quality LCD monitor.

Figure 9.1

Color space

Getting great prints from Nikon Capture NX 2 starts with setting your color space preferences properly and ends with setting up the printer dialog. In Chapter 3, I showed you how to set up your Preferences based on the type of work you'd be doing. To quickly review those settings, open your Color Management Preferences from the Capture NX 2 menu by choosing Edit → Preferences → Color Management (Figure 9.2).

Start with the Default RGB Color Space menu shown in Figure 9.3. There are quite a few color spaces, but the three we are most interested in are Adobe RGB, sRGB, and Pro Photo RGB.

Most photographers use either Adobe RGB or sRGB color spaces. Some knowledgeable photographers have also recently started using Pro Photo RGB. Pro Photo RGB contains a

Figure 9.2

Figure 9.3

bigger color gamut than Adobe RGB, and Adobe RGB contains a larger color gamut than sRGB. In fact, Pro Photo RGB contains about 100 percent of the colors that are visible to humans, whereas the Adobe RGB color space contains about 50 percent of the visible colors and sRGB contains about 35 percent of the visible colors.

Because Pro Photo RGB contains more colors to work with, you might assume that you should always work in Pro Photo RGB color space. The decision on which color space to work in always comes down to where you will be outputting your images. There isn't a printer or computer monitor on earth that will output or display all the colors in Pro Photo RGB. If you are printing on a new inkjet printer, then it will be able to print many of the colors in the Adobe RGB space. If you are printing at the lab, then its machines typically will print in the sRGB space.

A problem arises when you send an Adobe RGB file to a printer that will print it in sRGB. The lab will redefine the colors and map them to the smaller space. This causes some of the colors to shift in your image because sRGB can't produce the same colors as Adobe RGB.

To prevent any surprises in the printing process, the general approach you should follow is to edit your photos in a large color space and then map the colors down to the smaller color space when you print. You need to be able to see the color shift in real time on your monitor, and that is where the method of *soft-proofing* comes into play.

As I mentioned earlier, many photographers are starting to use the Pro Photo RGB space. This is a large color space that encompasses most of the colors in the visual system. In fact, about 13 percent of the colors in Pro Photo RGB are imaginary colors that don't exist! Working in Pro Photo RGB ensures that you never clip (lose) any colors in software. However, it is imperative that you understand what happens when you map your colors down from Pro Photo RGB to your printer's profile and color gamut.

Printers have color gamuts that are unique to the inks they use and the paper type being used. A glossy paper gives you an image with more contrast and intense color, whereas a fine art paper is more muted in tone and color. When you work on your image in Capture NX 2, you see a version based on what your computer monitor can show. The trick is getting a good match from the monitor to the printed image. Your software uses a printer driver to convert the image to the paper and ink that you use. If you don't tell the printer driver what type of paper you're using, then you run the risk of getting a bad print. You need to tell the printer if you are using a glossy, matte, or fine art paper.

Table 9.2 shows common paper types and their characteristics.

Table 9.2
Inkjet Paper Characteristics

Paper Type	Characteristics
Satin matte	Bright, saturated colors. High contrast. Has a smooth, satin surface.
Glossy	Bright, vibrant colors. Excellent contrast.
Fine art	More muted colors. Better suited to a "water color" look or artistic black-and-white prints.
Canvas	Punchy colors. The canvas material adds texture to the print. Used mostly for very artistic purposes.

Soft-proofing

The Soft Proof tool in Capture NX 2 is the best way to make your printed photo look like the original photo on your screen. Soft-proofing enables you to look at your image on the computer screen to get a preview of what it might look like during the printing process. It requires you to tell the software the type of printer and paper you will be using.

Activate the Soft Proof function in Capture NX 2 by clicking the Soft Proof button at the bottom of the window. Figure 9.4 shows what the Soft Proof dialog box looks like. If you click Soft Proof Off, you see the image based on what your calibrated (or uncalibrated) computer monitor can show. Clicking Soft Proof On shows the image based on what the software calculates the final image looks like based on the printer paper you have chosen.

The options in the Soft Proof window include the following:

- **Soft Proof On.** This activates soft-proofing for only the selected photograph. No other photographs in the editing screen are affected when you select this option. You need to click the Soft Proof On button in order to have access to the Target Profile and the Intent functions.

- **Soft Proof Off.** Selecting this option turns off the Soft Proof feature. In this mode, the image is displayed in whatever default color space you have set in the Preferences. For example, if you are editing in Adobe RGB, then the photograph is shown in Adobe RGB.

Figure 9.4

- **Target Profile.** This is where you set the output profile. This might mean paper/printer or photo laboratory or another profile. Most of the time, you set the paper and printer type that you want to print to. If you have multiple printers, make sure to choose the correct combination. For example, an Epson Glossy paper is different than an HP Glossy paper.

- **Intent.** There are four different intents: Perceptual, Saturation, Relative Colorimetric, and Absolute Colorimetric. These define how colors are remapped from one color space to another. You can choose to remap the data using a numerically accurate calculation (Relative Colorimetric), or you can remap the data using one that is more pleasing to the eye (Perceptual). The rendering intent you use depends on what you want to accomplish in your photography. Sometimes, one intent causes your colors to shift in a way that you don't like. In this case, picking another intent might solve the problem. Table 9.3 shows the different rendering intents and their explanations.

tip

The general rule of thumb for photographers is to use either Perceptual or Relative Colorimetric. If one causes a color shift that isn't pleasing, choose the other rendering intent to see if it is better. The great thing about the Soft Proof function is that you can quickly select any of the rendering intents to see their effects on the photograph.

- **Use Black Point Compensation.** This maps the black point of your photograph to the black point of your printer/paper combination. The goal is to give you nice, saturated blacks. Most of the time, you should leave this option turned on. However, if you find that your prints are lacking details in the shadows, then try another print with the option turned off (unchecked) to try to bring out more detail in the shadows.

Table 9.3
Rendering Intents

Intent	Explanation
Perceptual	Maintains colors to printed images; it appears natural to the human eye. I use this rendering intent most of the time.
Saturation	Produces highly saturated colors. Typically used for business graphics. Not appropriate for photography.
Relative Colorimetric	Maps all the colors that fall outside of the gamut (for example, sRGB) and then re-maps them to the closest reproducible colors. This is also a good choice to use for photography.
Absolute Colorimetric	Similar to Relative Colorimetric, except it matches the white points of the starting profile to the target profile. This rendering intent can cause color shifts that are undesirable, so I don't recommend using it for photography.

My approach for soft-proofing is to make my photo look good to my eye with Soft Proof turned off, then create a duplicate file next to it and turn soft-proofing on. Figure 9.5 shows what this looks like. The photo on the left is the original photo, and the photo on the right is what it looks like when printing on the HP B9180 inkjet with Hannemuhle Smooth Fine Art paper.

The following are instructions for soft-proofing in Capture NX 2 and comparing the images side by side:

1 Open an image in Capture NX 2.

2 Edit the image until you are pleased with the look.

3 Duplicate the image by choosing Edit → Duplicate. You can also press Ctrl+D (⌘+D).

4 On the duplicate image, turn soft-proofing on and select the paper and printer you are using.

5 Edit the duplicate image so that it looks like the original image and print it.

Another tool that photographers sometimes use is the Color Profile tool. You access this tool by choosing Adjust → Color Profile. This enables you to work on your images on an individual basis and change the profile of one without changing the profile of others. Figure 9.6 shows how the Color Profile tool adds a New Step to the Adjust pane.

The first option in the Color Profile adjustment is Apply Profile. This is used to assign an input profile to your image if it doesn't already have one. For example, if you take an image with a lower-end digital point-and-shoot camera, it won't insert a color profile into the image. Also,

Figure 9.5

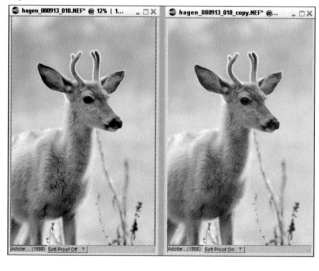

many times when you scan a film image, the scanning software doesn't insert a color profile into the digital file. The Apply Profile feature takes your image from not color managed to being color managed.

Figure 9.6

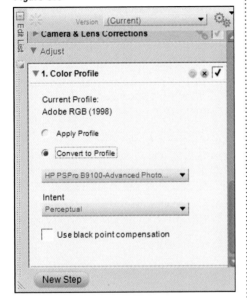

If you are a portrait photographer who typically sends your images to the laboratory for printing, apply the sRGB profile before sending the images to the lab, because that is the color space they use for output. If you are a landscape photographer who prints with large-format inkjet printers, you might choose the Adobe RGB 1998 profile, as that more closely matches the printer's output capability.

The second option is Convert to Profile. This is used to assign an output or destination profile to your image. This should generally be the profile of your output device. You can think of it almost as a soft-proofing tool. The concept with this Convert to Profile option is that you send your image to another company that is going to do the printing for you and has provided you with the output device's profile. For example, if you are printing at a lab like Costco or Sam's Club, you can sometimes download the printer profile from the company's Web site and use the Convert to Profile option to prepare the image for their printers.

The neat thing about the Color Profile tool is that you can batch process this function. For example, if you have 100 images from a project you were working on and you want to convert them from sRGB to Adobe RGB, you can automate this function and not have to do it one by one. Chapter 10 shows you how to copy a step and then apply it to other images in your browser.

see also

Chapter 10 shows you how to batch process functions like the Color Profile tool.

The Print layout dialog box

Assuming that you have done a good job calibrating your monitor and setting the correct color profiles for your images, using the Print dialog in Capture NX 2 should produce excellent results. If you haven't been paying attention to color spaces and soft-proofing, this step in the printing process is likely to produce terrible results.

The printing process in Capture NX 2 involves two steps. The first is the process of telling Nikon Capture NX 2 how you want the photograph to be sent to the printer. For example, do you want a 4-x-6-inch print, a 13-x-19-inch print, or a contact sheet with 16 small thumbnails on it? These instructions are set up in the Print layout dialog box.

After you make those decisions and click OK, Capture NX 2 hands the print information off to the inkjet printer's driver software. This driver software is different for every brand and model of printer on the market. The examples that follow are based on a Hewlett Packard Photosmart Pro B9180 model, but the approach is similar to using an Epson or Canon or any other brand of inkjet printer.

Before I get into describing the sections of the Print layout dialog box, I want to give you a workflow for printing a single image to an inkjet printer. The list that follows shows the process:

1 Open the image and edit until you are happy with the result.

2 Open the Print layout dialog box by choosing File → Print.

3 Click Page Setup to define the paper size, source, orientation, and margins. Click OK.

4 Click the Page Layout tab.

5 Select Layout: 1 Photo on Page and select the Rotate to Fit option.

6 Click the Color Management tab and choose Use Source Profile.

7 Click Print. The printer driver window opens.

8 Click Properties (or Options). Confirm paper source, size, and type.

9 If the image is black and white, choose to use only gray inks (not composite).

10 Choose print quality (usually select "Best" or "Optimum").

11 Select Color Management so it reads "Printer Managed Colors".

Click OK and then click Print. The three ways to activate the Print layout dialog box are by choosing File → Print, by pressing Ctrl+P (⌘+P) or by clicking the Printer button at the top of the Capture NX 2 screen. The Print layout dialog box is shown in Figure 9.7.

Figure 9.7

At the top of the dialog box is the summary data for your print job. In this example, it shows that the printer is an HP Photosmart B9100 series and it is set to use letter-sized paper. The next section down shows that it is set to print one photo total. The window displays "1/1 Page," which really means that there is one photograph prepared for printing. You can select multiple images from the browser to print, and sometimes you can have multiple pages in the print job. This can be confusing because to the right of this box is another section called Copies. This enables you to make multiple copies of the same photograph.

When you click Page Setup, the Page Setup dialog box appears (Figure 9.8). In this dialog box, you can designate the size of the paper you want to use and the source. There are a number of paper sizes available from the menu, and if you don't see the paper choice you want, it is probably because you haven't installed the appropriate printer driver. The source defines from where the paper is pulled—the main tray or a manual feed tray. You can select the Automatically Select option, but I find that the driver software frequently chooses the incorrect paper source, so I choose either Main tray or Specialty Media Tray (manual feed).

At the bottom of the Page Setup dialog box are the Orientation and Margins options. If you want your photo printed vertically on the paper, select the Portrait option. Select the Landscape option if you want the photo printed horizontally. The Margin settings allow you to modify how much white space (unprinted area) exists around the photograph. When you finish entering this information, click OK.

The next button in the Print layout dialog window is the Metadata button. Clicking it displays the Metadata dialog box, as shown in Figure 9.9. The purpose of the Metadata dialog box is to enable you to print text on your final print. You can select the type of text based on the options in the dialog box.

Figure 9.8

Figure 9.9

The metadata is printed in the margin of the photo unless you choose to imprint the date shot over the image. There are three metadata options you can choose to include in the print: Basic, Additional Information, and Detail Information. Click Change in the Font section to set the font. If you want to imprint a Date/Time Stamp over the image, select the Date Only option and/or the Date and Time option. After you make your choices, click OK and the Print layout dialog box shows you a preview of the image. Figure 9.10 shows an image with the maximum amount of metadata printed on it. For this example, I selected all the options in the dialog box.

Most of the time you won't be including metadata on your prints. However, if you are making contact sheets or proofs for clients, then the metadata can be a great way to help your clients determine which images they want to select and keep. I know of other photographers who print the image name in the margins of the print so they always have an easy way to remember which digital file was used to create the print.

The next option in the Print layout dialog box is Use Output Resolution. This option causes Capture NX 2 to print your file at the native resolution of the image. For example, say that your image is 6 megapixels and is sized at 2,000 × 3,000 pixels. Most likely, its native resolution is at 300 pixels per inch (ppi). If you print this image at the Output Resolution, the actual size of the print would be 6.67 inches by 10 inches. If you print this on a 13-×-19-inch piece of paper, then it would only print ink on a 6.67-×-10-inch area of that paper. In general, I don't recommend using this function because I would rather make the picture match the size of the paper.

Figure 9.10

2008/08/31 10:29:34

hagen_0809914_002.NEF 2008/08/31 10:29:34
Nikon D300; 1/1250Sec - F/4 (4288x2848)
Exposure Mode: Aperture Priority, White Balance: Cloudy, A2, 0
Metering Mode: Matrix, Exposure Compensation: -0.7 EV
Focal Length: 195 mm, AF Mode: AF-C, Sensitivity: ISO 800

There are two radio buttons called Select Layout and Select Picture Size. Selecting Select Layout allows you to determine how many photos you want to fit on a page. Most of the time, you'll just select 1 Photo on Page. However, as Figure 9.11 shows, there are many options available.

Figure 9.11

If you select two images to print from your browser and you select 2 Photos on Page from the Select Layout option, then Capture NX 2 places two images on the final print.

The Select Picture Size option lets you predefine how big your final prints will output. The smallest setting available is 1 inch × 1.5 inches

(25mm × 38mm). You can use this tool to make wallet-sized prints, contact sheets, or CD case covers of your images.

The Rotate to Fit option is one of the most important options in the Print layout dialog box because it automatically rotates your image for the best fit on your paper. This means that you don't have to worry about whether your image is in landscape or portrait orientation, because Capture NX 2 automatically fits it to the paper. I make sure to select this option every time!

The Print a Picture Multiple Times option is used to fill up all the cell boxes you created if you chose any option that placed multiple images on a page. For example, if you select 8 Photos on a Page and don't select this option, then Capture NX 2 prints only one photo out of eight, as shown in Figure 9.12. However, if you select the option, Capture NX 2 populates the boxes with your photo (Figure 9.13). In this example, you need to either select 8 or Full Page to get an image that looks like Figure 9.13. You do have to tell Capture NX 2 how many boxes to fill and you'll actually print eight images on one page.

Next is the Crop Photos to Fit option. Selecting this option takes the images and pushes out the smallest dimension so that you can print to the edges of the paper. When you make this selection, the top and the bottom of the image are cropped so that the image prints to the edge of the paper.

Select the Use Thumbnail Data (Draft Use Only) option when you want to get a quick and fast idea of what your image will look like on paper. Capture NX 2 won't use the full-resolution image, but uses the file's built-in thumbnail to generate the photo.

Figure 9.12

Figure 9.13

The last option on the Page Layout tab is Print to File. Selecting this option creates an actual JPEG based on all the information you have input in the previous options. Here are some reasons why you might want to select Print to File:

- You want to make several wallet-sized prints but want to print at the lab. Selecting Print to File creates a JPEG that you can e-mail to the lab.

- You want to create a photo with the metadata printed on it that you can post to the World Wide Web.

- You want to create a photo with the date stamp that you can e-mail to your family.

- You want to test a few different rendering intents or printer profiles at the lab.

Now that the Page Layout is set up, it is time to work through the Color Management tab (Figure 9.14). There are two methods for color management: printer-managed colors or application-managed colors. Unfortunately, Capture NX 2 does not make this choice very clear in the way the program is written.

Select the Use Source Profile option (Figure 9.14) when you assume that you have the correct color profile in the original image. The term "source" means the image itself. A better term for Use Source Profile is Printer-Managed Colors. As discussed earlier, you are typically going to use sRGB or Adobe RGB as your color space. If you have the source profile correct, you should be able to hand off the file to the printer so the printer can do the color translation from

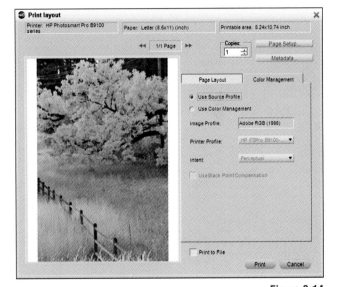

Figure 9.14

Adobe RGB to the printer's color space. If you select this option, make sure that your printer driver is set up so that it has the profile and rendering intent correct.

Select the Use Color Management option when you want Capture NX 2 to manage the color translation between the source (the photo's color space) and the printer. A better term for Use Color Management is Application-Managed Colors. When you select this option (Figure 9.15), you must specify the Printer Profile (paper type), Intent, and Black Point Compensation. After you click Print, the printer driver starts, and you need to make sure that the printer knows Capture NX 2 is managing the colors. Usually, this selection involves clicking a button in your driver that is titled Application Managed Colors.

Making these selections is critical to getting good prints. If you tell Capture NX 2 that it is going to manage the colors and then tell the printer that it will also be managing the colors, you are bound to get bad prints because both compete to manage the colors. Trust me, I've done it too many times! Make sure you fully understand which selection you are making before you click Print.

Table 9.4 explains both methods of color management.

Before clicking Print, decide whether to Use Black Point Compensation. This maps the black point of your photograph to the black point of your printer and paper combination. The goal is to give you nice, saturated blacks. Most of the time you should leave this option turned on. If you find that your prints are lacking details in the shadows, try a print with the option turned off (unchecked).

Figure 9.15

Use Source Profile

When you select the Use Source Profile option, will the printer manage the colors? That depends. If the image has been converted to the output profile (printer profile), color management has already taken place. In this situation, the image would be sent to the printer without any color management. The printer driver has to print the image without altering the data.

If the image is still in the working space (Adobe RGB, sRGB) and Use Source Profile is selected, then the printer driver or the operating system has to apply the profile and convert the image to the destination space (printer profile).

When you select the Use Color Management option, it means that Capture NX 2 will manage the colors.

Table 9.4
Color Management Choices

	Use Source Profile	*Use Color Management*
Who manages colors?	Printer	Capture NX 2
How to set up Capture NX 2	In Capture NX 2 Color Management tab, select Use Source Profile.	In Capture NX 2 Color Management tab, select Use Color Management. Specify Printer Profile, paper, Intent, and so on.
How to set up the Printer Driver	Set up printer driver by specifying printer, paper, rendering intent, quality, and so on.	Set up printer driver to read "Application Managed Colors."

You are ready to click Print. When you do, it opens the Print dialog box (Figure 9.16). Don't be hasty and click OK, because your work is only half over. You need to tell the printer a few things about the print job—the most important being who is going to manage the colors.

Because each printer is different, you need to set it up. Click Properties, or some printers may have a Set Up button instead. The Properties (or Set Up) dialog box (Figure 9.17) is where you choose the paper source, paper size, paper type,

and print quality. Also, if you are printing a black-and-white photo, I recommend setting the Print in Grayscale selection to On, which will have the printer only use gray inks.

The last selection to make before clicking OK is to set up the Color Management menu. Figure 9.17 shows the Color Management choices you have if you are using an HP B9180 printer. Your choices are ColorSmart/sRGB, Adobe RGB (1998), or Application Managed Colors. ColorSmart/sRGB means that you are allowing

Figure 9.16

Figure 9.17

the printer to manage the colors in sRGB space. Adobe RGB (1998) also means that you are allowing the printer to manage the colors, but in Adobe RGB space. Application Managed Colors means that you are allowing Capture NX 2 to manage all the colors. If you want the printer to manage the colors, I recommend choosing Adobe RGB (1998). If you want Capture NX 2 to manage the colors, you should choose Application Managed Colors.

Whew! You are now finally ready to click OK and send your photograph to your inkjet printer. Good luck!

Working with photo labs

The main difference between printing at a lab and printing on an inkjet printer is that the lab is responsible for the printer driver settings. Printing on an inkjet printer means you have to manage the driver. Basically, your responsibility is to prepare your image based on an sRGB workflow and then give the lab a JPEG or a TIFF at the appropriate resolution.

Your main job is to make sure your photo has the correct profile embedded before you send it to the lab. Most labs utilize the sRGB color space, so it makes sense to send your photos to them as sRGB images. My recommendation is to edit your photograph in sRGB color space and send it to the lab in sRGB color space.

To set up a simple workflow for printing at the lab, follow these steps:

1 **Set up Capture NX 2 Preferences for an sRGB workspace.**

2 **Open the image and edit it to taste.**

3 **Save the image as a JPEG with a quality level of 100 (best quality).**

4 **Give the image to the lab for printing.**

Printing at the lab is much easier than printing at home. If you have a well-calibrated computer monitor and you send the lab the print in sRGB space, you should expect great results. If you don't get great results, then most likely the lab is performing its own adjustments on the print after you send it. I recommend asking the lab to not apply any additional adjustments on your images.

Sending Photos to Other Programs for Further Editing

Nikon Capture NX 2 is a great tool for working on your images, but it can't serve all your digital workflow needs. As I've said many times in this book, I use Capture NX 2 to create a beautiful image, then I send it to another program to finish it with retouching or other tasks. Most photographers use many types of programs in their workflow, such as Photoshop, Corel Painter, and Photomatix Pro.

I also use lots of other editing programs, but the most frequently used program is Photoshop. Photoshop is a great tool to do all kinds of things that are impossible to do in Capture NX 2, such as:

- Extensive retouching on people's faces

- Creating panoramas

- Making a composite from elements in different photographs

- High dynamic-range photographs

- Web graphics

- Video graphics

The programmers of Capture NX 2 knew that photographers would want an easy way to send photographs from the Capture work environment to Photoshop, so they created Open With command. You access this command by choosing File ➤ Open With, as shown in Figure 9.18.

Before using this function, you must configure your preferences as explained in Chapter 3 so that the Open With command sends the image to Photoshop. When you choose this function, Capture NX 2 creates a 16-bit TIFF of the image and opens it in Photoshop for further manipulation. Depending on how your preferences are configured, you can tell Capture NX 2 to place the new TIFF in the original file location or a different location of your choosing. To keep things simple, I generally have Capture NX 2 place the new TIFF in the original file so that it is easy to find if I need it again.

Figure 9.18

see also

Chapter 3 shows how to configure your Preferences for the Open With command.

You can configure the Open With command to send your photograph to any other program that you regularly use in your workflow. Just go back to the Preferences menu and point Capture NX 2 to the program of your choice.

10

Batch Processing

U sing Nikon Capture NX 2's batch processing tools is the best way to process many images at one time. Fortunately, Nikon has made it fairly easy to automate your work in Capture NX 2, and after you understand the basic approach, it is easy to process hundreds of images at a time. Wedding and portrait photographers are most likely to heavily use the batch processing utilities. However, landscape and travel photographers can also save time by incorporating batch processing into their workflows.

In this chapter, I'll cover the approach to batch processing, copying, pasting and saving adjustments, creating adjustment files and managing all your adjustments for quick access in the future.

Batch Processing Approach

The concept of batch processing is that you apply the same setting or group of settings to several images. In the typical wedding example, you might have 30 or 40 images that you took inside the reception hall that all need to have the white balance tweaked. Rather than opening each image one by one, it is a lot easier to apply the new white balance setting to all images as a group.

Many photographers (myself included) work with a batch mentality that greatly decreases the amount of time spent in front of the computer. I encourage you to try to automate as much of your workflow as possible. Doing so will save you a great deal of time in Capture NX 2.

To do batch processing in Capture NX 2, follow these steps:

1 **Make changes to an image that is similar to the others in your group.**

2 **Copy the settings from the image.**

3 **Paste the settings to the others in the group.**

As you know, when you copy and paste in most software programs, you are working with text, pixels, or objects. For example, in a word processor, you copy a section of text and then paste that section of text somewhere else. Another example: With a pixel-editing program such as Photoshop, you copy one part of a photograph from picture A and then paste it to picture B.

Capture NX 2 is different. With this program, you copy the adjustments from one photograph and then paste those adjustments to another photograph. This is the essence of batch processing. You make changes on one image that is a representative image of a group. Then, when you are happy with those settings, copy the settings (adjustments). Select the other photographs that you want to change, and then paste the settings onto the group.

As demonstrated in Chapters 4 through 8, all the improvements you make to your image are saved as steps in the Edit List. The neat thing about Capture NX 2 is that all these steps (adjustments) in the Edit List can be copied, saved, pasted, and managed for your future use. If you find yourself always making a common change to an image like a saturation boost, then it makes sense to save that adjustment so you don't have to re-create it every time you want to add saturation. I will show you how to save and manage your adjustments later in this chapter.

The easiest way to access the batch controls in Capture NX 2 is by clicking on a gear icon located in two locations in the window. The first is located on the upper-right side of the Edit List (Figure 10.1). The second is located on the lower-left side of the Browser pane.

There are a few other ways to activate the batch commands in Capture NX 2. One is by choosing them from the Batch menu at the top of the screen (Figure 10.2). Another is by right-clicking on an image in the Browser and selecting one of the batch commands from there.

Figure 10.1

Let's go through each of the batch tools, starting with the Edit List gear icon. The gear (batch processing) icon at the top of the Edit List allows you to automate adjustments to your images. This is different than the other batch processing tools in Capture NX 2, because they also allow you to automate your keywording and XMP/IPTC (Extensible Metadata Platform/International Press Telecommunications Council) data. Figure 10.3 shows the five choices you can make from the gear icon.

The Browser pane gear icon allows you to batch process your adjustments as well as your keywords, labels, ratings, and IPTC entries (Figure 10.4). As discussed in the following sections, the Browser pane is a great way to automate adjustments to your images, as well as keywording and copyrighting. Figure 10.4 shows the choices available under the Browser pane gear icon.

Figure 10.2

Figure 10.3

Figure 10.4

one additional line item in this list named Run Batch Process that allows you to define and execute a series of batch process events across a number of folders and images. This is covered later in the chapter.

Finally, you can activate batch functions in the Browser by right-clicking on any image, as shown in Figure 10.5. This contextual menu allows you to batch process adjustments as well as XMP/IPTC data.

Figure 10.5

Just like the Browser gear icon, activating the batch utility from the Batch menu at the top of the window allows full access to automate your adjustments and your IPTC data. Also, there is

Copying and Pasting Adjustments

The first step to automating your workflow is to learn how to copy your adjustments. You can follow along by opening a photograph from your Browser that is a part of a group of similar photographs in the Browser. In the example I show here, I will edit some palm tree images taken in Maui. I want to make some subtle improvements to the whole group, so I start by opening one photograph. I make the appropriate adjustments, copy the settings, and then paste the settings to the remaining photographs.

Now that the photograph is open, I'll make some changes to White Balance, Lens Vignetting, Curves, and Saturation (with the LCH editor) (Figure 10.6). All these adjustments appear as individual items in the Edit List.

 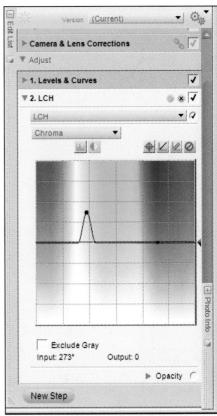

Figure 10.6

Now, I copy the settings I just made by clicking the gear icon in the Edit List and selecting Copy Adjustments (Figure 10.7). Selecting Copy Adjustments temporarily saves those settings to a Clipboard so you can apply them to another image or group of images. The data stays in your Clipboard until you copy another setting or you shut down Capture NX 2. Note that when you select Copy Adjustments from the gear icon, all the settings in the file are copied.

The next step is to apply these adjustments to the remaining images in the Browser. Open the Browser and select the other similar images by Ctrl+clicking or Shift+clicking on them. Click the gear icon in the lower-left corner of the Browser pane and choose Paste Adjustments. When you do this, a window displays telling you that Capture NX 2 is performing an analysis of the files (Figure 10.8). Capture NX 2 is trying to figure out if you are changing any of the file's

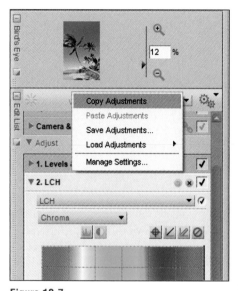

Figure 10.7

settings that have already been altered. If you have any settings that you've previously changed, another window displays similar to the one shown in Figure 10.9.

Here are the three options in the Alert window and what they mean:

- **Append New Settings.** Adds the changes to the bottom of the Edit List stack. In other words, it appends the new adjustments to the image file.

- **Replace Current Settings.** Overwrites any existing settings with the new adjustments.

- **Show Differences.** Opens a window, as shown in Figure 10.10, to display the differences between the new adjustments and the existing image. If you don't want to make one of the changes, click the drop-down list and select Don't Change or Delete.

Figure 10.8

Figure 10.9

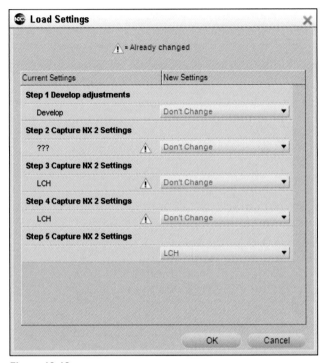

Figure 10.10

caution

The Replace Current Settings option overwrites your existing file settings. Be sure to choose this option only if you are sure you want to replace your current settings.

Click OK, and the Processing Queue displays to give you more options (Figure 10.11). The Processing Queue is covered in more detail later in this chapter. However, assuming that you are happy with the changes you are about to make, click Start and watch the batch process work through the images. Remember that if you are working on RAW images, then you are adding only new instructions to the NEFs. If you are working on JPEG or TIFF images, then you should be careful that you don't overwrite your original files by saving the changes in a new destination.

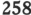

Figure 10.11

This process also works if you have two images open in your Browser and want to copy adjustments from one to the other (Figure 10.12). The method for copying the settings is the same as described earlier—just click the gear icon and choose Copy Adjustments. To paste the settings on the second photo, simply click on the frame, click the gear icon, and select Paste Settings. When you do, a window displays like the one shown in Figure 10.13. This window asks whether you want to overwrite the Develop settings or skip the Develop settings. If you don't want to change any of your Develop section settings, then click the "Skip Develop Section" button. If you want to overwrite the Develop section settings, then click the "Overwrite Develop Section" button. Make your selection and click OK to complete the copy/paste action.

Figure 10.12

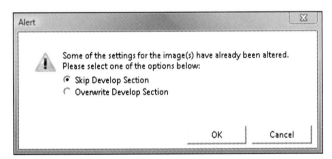

Figure 10.13

Let's review the process for applying settings to an entire group of photos. Follow these steps:

1 **Open one representative image.** Make adjustments as necessary.

2 **Copy adjustments by clicking the gear icon.**

3 **Close the representative image.**

4 **Open the Browser with similar images.**

5 **Select the images to which you want to paste settings by Ctrl+clicking or Shift+clicking.**

6 **Click the gear icon and choose Paste Adjustments.**

7 **Select the check boxes next to the adjustments you want to apply to the images.**

8 **Click OK to start the batch process.**

Another important aspect to Capture NX 2 is that you don't have to copy and paste all the settings from one photo to another. If you want, you can copy or paste individual items from the Edit List. For example, say that you want to do a black-and-white conversion, and then copy just that step to another photograph. Follow these steps:

1 Open a photograph.

2 Click New Step and choose a step type, such as Black and White conversion.

3 Make the adjustments.

4 Right-click the title bar of the New Step, as shown in Figure 10.14.

5 Choose Copy Adjustments. Note that this copies the one step you selected.

6 Paste the setting on another image by clicking the gear icon and choosing Paste Adjustments.

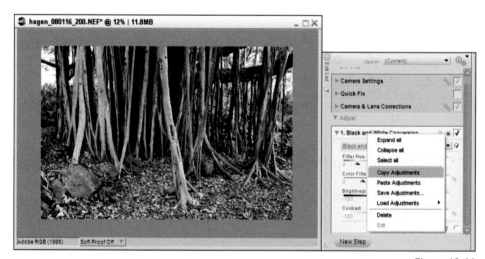

Figure 10.14

Copying and Pasting XMP/IPTC Data

Copying and pasting things in Capture NX 2 isn't limited only to adjustments and image enhancements. It is also possible to copy and paste XMP/IPTC data from one image to another. Let's walk through an example of how this works.

Open the Browser pane and select one photograph from a group that is the same subject as the group. Use the metadata pane to apply keywords,

copyright, and other information pertinent to the group of photos, as I demonstrated in Chapter 2. Click the gear icon underneath the Browser pane and choose Copy IPTC Info (Figure 10.15).

Pasting the IPTC data to other images is simple. You can do it one at a time, or you can select as many photographs as you want by Ctrl+clicking

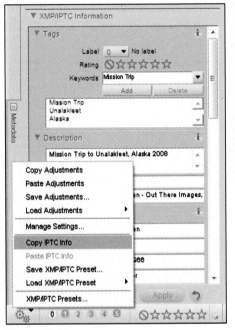

Figure 10.15

As with copying and pasting image adjustments, you can right-click to access a contextual menu (Figure 10.16) that has the same info as the gear icon. Alternatively, you can access the IPTC batch commands from the Batch menu at the top of the Capture NX 2 screen.

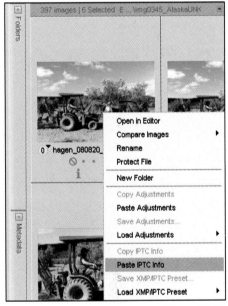

Figure 10.16

or Shift+clicking the thumbnails. After you select all the images to which to paste the data, click the gear icon and choose Paste IPTC Info to apply the same set of IPTC data to the images.

Saving Adjustments

Copying and pasting adjustments is a fine way to quickly apply settings to groups of images in a single working session. But what happens when you want to save your settings for future editing sessions? If you close down Capture NX 2, it purges the copy/paste data from the Clipboard. The solution is to save your most often used settings in Capture NX 2's permanent memory.

If you look at the image enhancements you do in Nikon Capture NX 2, I bet you'll find that you do the same things over and over again to most images. In my case, I almost always add a little bit of contrast with a curve, add a little saturation with the LCH editor, and then perform some sharpening for output. Because I do these three things for many of my photographs, it makes sense to save the adjustment steps so I don't have to re-create them in the future.

Capture NX 2 gives you the ability to save an individual adjustment or to save a group of adjustments. For example, if you make a Curves Adjustment and you want to apply that same step to a future photograph, then all you need to do is save the adjustment. Here's the process for saving an adjustment (or adjustments) to permanent memory:

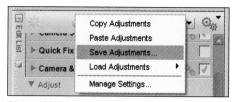

Figure 10.17

 Open an image.

2 Click New Step and add a new step, such as a Curve.

3 Click the gear icon and choose Save Adjustments (Figure 10.17).

4 Select the check boxes for the adjustments you want to save (Figure 10.18).

5 Type a descriptive name, such as "extra contrast curve," for the adjustment.

6 Click the Browse button to choose the destination. Alternatively, you can keep the Adjustments in the default folder from Capture NX 2.

7 Click OK.

Now you can check to make sure that you've saved your adjustment by clicking the gear icon and choosing Load Adjustments. Figure 10.19 shows that the "extra contrast curve" setting is in your saved Adjustments list. At any time in the

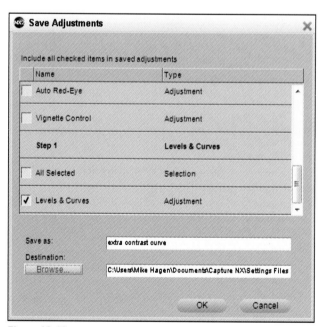

Figure 10.18

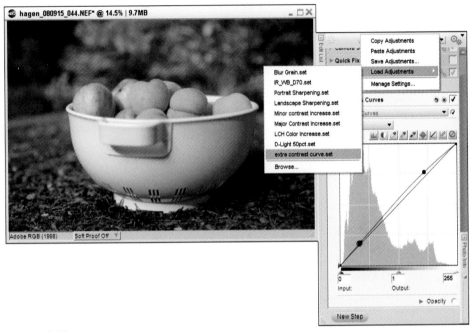

Figure 10.19

future, you can go back to the batch processing menus in Capture NX 2 and choose this curve for any photo without having to go back through all these steps.

Just as you saved this Curves setting, you can save all kinds of other adjustments. The following are some types of adjustments I recommend saving in Capture NX 2:

- Minor contrast increase for photos that need a little more contrast, such as portraits. You could do this with a slight s-curve adjustment.

- Major contrast increase for photos that need significant contrast enhancement, such as a landscape. You could do this with a stronger s-curve adjustment.

- Saturation increase for blues to enhance blue skies. Use the LCH editor in the Chroma channel for this adjustment.

- Saturation increase for yellow/green to enhance the colors in foliage. Use the LCH editor in the Chroma channel for this adjustment.

- Sharpening for output. Use the USM setting for this adjustment.

- Sharpening for Web/Internet. Use the USM setting for this adjustment.

- Black and White conversion high contrast. Add a black and white conversion adjustment and then move the contrast slider farther to the right. Use this for landscapes or scenics.

- Black and White conversion low contrast. Add a black and white conversion adjustment and then move the contrast slider to the left. Use this for portraits.

Applying Adjustments

There are a few ways to apply adjustments to images. The first is by choosing Load Adjustments from any of the batch processing menus. The second is to activate the Run Batch Process command window.

The first method is simple. The process involves opening an image (or multiple images) and then clicking the gear icon. Choose Load Adjustments, and another menu opens that shows all the settings you've saved in Capture NX 2 as shown in Figure 10.20. After you choose the adjustment, Capture NX 2 immediately applies the setting to the image or images you have selected. It is simple and fast.

The Run Batch Process utility can be activated only from the main menu in Capture NX 2 (Figure 10.21). To activate it, choose Batch → Run Batch Process. A new window opens, as shown in Figure 10.22.

Figure 10.21

The purpose of the Run Batch Process command is to enable you to make a number of changes to a large group of photographs with one quick command. For example, say that you just

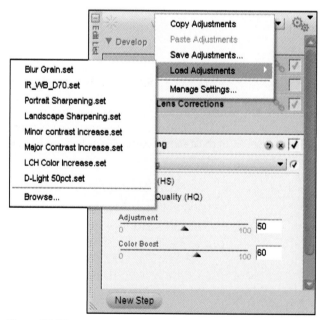

Figure 10.20

Figure 10.22

returned from a portrait session for Mrs. Davis that you photographed in RAW format. Your client wants to view the photos on her computer, but she doesn't have any way to look at Nikon NEF images. You can use the Batch Process tool to convert all the images in the folder to JPEGs with a few simple mouse clicks. The following sections discuss each of the tool's settings and their uses.

Source

This section represents the photos that you are going to change. In the example here, they represent the original NEFs of Mrs. Davis. If you

select Include Subfolders, then all images in subfolders are affected. If you select Delete files after they are processed, then Capture NX 2 deletes the images from your hard drive. I don't recommend selecting this option for obvious reasons.

Apply Settings

Selecting this option enables you to apply any of your saved adjustments during the batch process. You can click Browse to navigate to the folder where your adjustments are saved.

The Conflict Management drop-down list lets you determine how the settings are applied if Capture NX 2 discovers that you are overwriting any preexisting settings (Figure 10.23). The choices in the drop-down list include the following:

- **Append New Settings.** Adds the changes to the bottom of the Edit List stack. In other words, it appends the new adjustments to the image file.

- **Replace Current Settings.** Overwrites any existing settings with the new adjustments.

- **Show Differences.** Opens a window to display the differences between the new adjustments and the existing image. If you

don't want to make one of the changes, then you can click the drop-down list and select Don't Change or Delete.

Rename

Selecting this option enables you to rename the images while you convert them. Click Edit to change the name sequence.

Select File Format

If you want to convert your images from one format (such as NEF) to another (such as JPEG), then this is the area to make those selections.

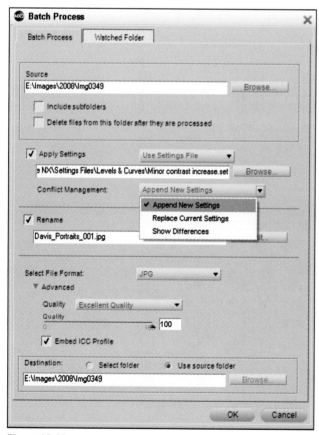

Figure 10.23

Click the triangle next to the word Advanced to access all the conversion options. If you are converting to JPEGs that will be printed, use the Excellent Quality setting of 100. If the JPEGs are going to be used on the Web, then use a quality setting between 30 and 60 as a good balance between size and quality. If you use really low quality settings like 0 through 20, then you'll see a substantial decrease in image quality.

Also, you should choose to embed the ICC profile by placing a check in the box next to the "Embed ICC Profile" selection. This will keep the color profile (such as sRGB or Adobe RGB) in the new file.

Destination

Use this section to determine where you'll place the converted files. If you use the Source folder, then the images are placed in the same folder as the original images. If you choose Select folder, then you can place the converted images in any location on your hard drive.

There is one more tab on the Batch Process window called Watched Folder (Figure 10.24). Click this tab to watch a folder and convert images in real time. For example, if you are shooting tethered to your computer with your

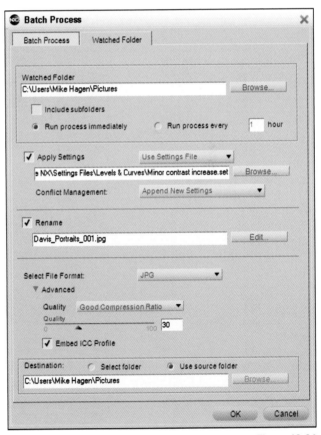

Figure 10.24

camera, you can send your images into a specific folder. Then you can program the Watched Folder to immediately apply settings to those images the instant they appear in the folder. This can be useful for sports shooters who might need to quickly format images for a newspaper or an Internet news site. Also, wedding photographers have used this feature to create small JPEGs to be used in a slide show at the end of a wedding they are shooting.

Creating Adjustments Files

Capture NX 2 enables you to save adjustments as separate files so that you can share your settings with other photographers or use your settings on different computers. For example, in my office, I have a laptop and a desktop computer both loaded with Nikon Capture NX 2. I want to have all the same adjustment files available on both computers so I can work with my images on the road or in the office.

If I choose Batch → Save Adjustments and save them all to the same folder location, then it is easy to copy those adjustments to another computer. Here's the process:

1 Open a photograph and make the adjustments.

2 Click the gear icon and choose Save Adjustments.

3 Select which specific adjustments you want to save by selecting the check box next to the line (Figure 10.25).

4 Type a representative name for the adjustments.

5 Click Browse to save the adjustments to a folder on your hard drive.

Figure 10.25

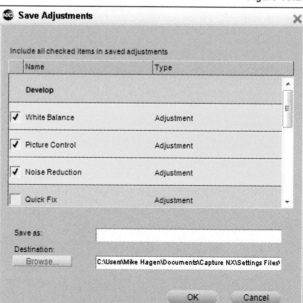

6 Click OK.

7 Open Windows Explorer or Mac Finder to navigate to the folder with your adjustments (Figure 10.26).

8 Copy the folders of adjustments to another storage device, such as a CD-ROM or thumb drive.

9 Insert the CD or thumb drive in your second computer, and copy the folders of adjustments to your second computer.

10 Click the gear icon and choose Manage Settings (Figure 10.27).

Figure 10.27

11 Click Add.

12 Choose the folder and settings where the adjustments are stored on your computer.

Figure 10.26

You have successfully copied settings from one computer to another computer. You can also use a similar method to the one just described to e-mail the settings to your colleagues and friends or post the settings to a Web site for other Capture NX 2 users to download.

Manage Settings

To access the Preferences dialog box, choose Edit → Preferences → Manage Settings. On a Mac, the path is Capture NX 2 → Preferences. This displays a window with the names of your settings and the type of settings they are (Figure 10.28).

see also

In Chapter 3, I reviewed the Settings Preferences and talked about how you can manage the settings from the Preferences window.

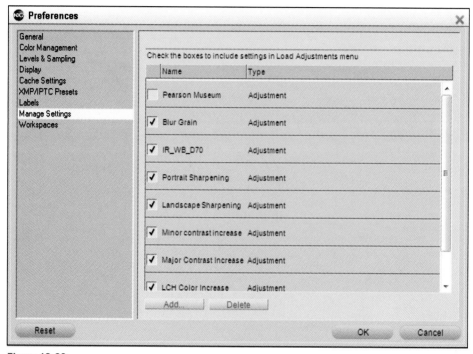

Figure 10.28

The options on this screen enable you to manage all your Capture NX 2 presets, settings, and adjustments. If you have a check box next to the name of the adjustment, then that setting is available to use from your Batch processing menus. Figure 10.28 shows the settings available from the Batch (gear) menu. Notice that the information in Figure 10.28 matches selections available in Figure 10.29.

If you plan on frequently using an adjustment, then it makes sense to select the check box next to it in the Preferences so it is always available. If there are other settings that you use only for certain subjects, then remove the check box so the setting doesn't appear in the Batch (gear) menus. This keeps your working environment cleaner and less distracting.

The Manage Settings window is also used for deleting adjustments you no longer use. To do this, simply click on an adjustment to turn it yellow and then click Delete. The Delete Multiple Items dialog box appears (Figure 10.30). Click Yes to delete the adjustment.

As discussed earlier in this chapter, you can also batch process your XMP/IPTC data entries. One of the best areas to do this is to go into the Preferences dialog box to manage your XMP/IPTC presets. Figure 10.31 shows the XMP/IPTC presets area. In this image, you can see a number of preset XMP/IPTC entries that I can quickly apply to photographs in my Browser. The top preset is my Copyright & Contact Info. Here, I simply set up an IPTC field for all of my business contact information including name,

Figure 10.29

Figure 10.30

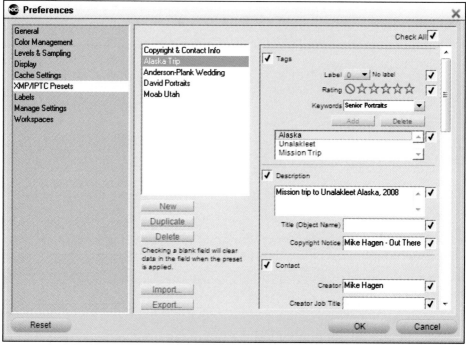

Figure 10.31

e-mail, address, phone number, copyright, and so on. This preset is applied to all the images in my entire archive so that they are all identified immediately.

The other fields represent different projects that I might be working on such as an Alaska trip, a wedding, or a portrait session. I can use these keyword sets to quickly apply the same IPTC data to the photos in that group. Follow these steps to create new XMP/IPTC presets:

1 **Open the Preferences window.** You can choose Edit → Preferences → XMP/IPTC Presets.

2 **Click New and type a name for your new preset.**

3 **Type any information you think is necessary into the fields, such as keywords, description, copyright, and contact information.**

4 **Put a check in the box next to the items you want to remain active.**

5 **Click OK.** The new XMP/IPTC preset is active and saved for use in your batch processing work.

The best place to apply any of the new XMP/IPTC presets to your images is from the Browser. To add the keyword and metadata information, follow these steps:

1 **Select images in Browser by Ctrl+clicking or Shift+clicking.**

2 Click the gear icon in lower left of Browser pane.

3 Choose Load XMP/IPTC Preset (Figure 10.32) and the preset you want to apply (for example, Alaska Trip). That's it. Now each of the photos is keyworded and tagged with the appropriate information.

caution

If you include a checkbox next to one of the IPTC fields, it overwrites the existing IPTC field when you apply it to a new photograph. If a blank field is checked, it clears the data in the new photo when the preset is applied. If you overwrite the existing data, then you can lose some important keywords, copyright or contact information in your photograph.

The other buttons in the XMP/IPTC Presets pane are used to manage your data for batch processing. Here's a quick summary of the buttons and how they are used:

- **New.** Creates a new XMP/IPTC preset as described in the previous steps.

- **Duplicate.** Click this button to copy one set of XMP/IPTC data and easily modify a few items to create a new preset.

- **Delete.** Removes a preset from your Presets list.

- **Import.** Enables you to copy another XMP/IPTC preset from your hard drive to the list of presets. For example, if you saved (exported) a preset from another computer, you can then import that preset to the computer you're working on.

- **Export.** Enables you to save an XMP/IPTC preset to your computer's hard drive so you can then copy that preset file to another computer.

That wraps up batch processing. Save yourself some time and set up some adjustment presets and XMP/IPTC presets.

Figure 10.32

Appendix A: Keyboard Shortcuts

Table AA-1
The Browser

Tool	Windows	Mac
Open Browser	Ctrl+Alt+B	⌘+Option+B
Label image(s) with label 1	1	1
Label image(s) with label 2	2	2
Label image(s) with label 3	3	3
Label image(s) with label 4	4	4
Label image(s) with label 5	5	5
Label image(s) with label 6	6	6
Label image(s) with label 7	7	7
Label image(s) with label 8	8	8
Label image(s) with label 9	9	9
Remove label from image(s)	0	0
Rate image(s) with 1 star	Ctrl+1	⌘+1
Rate image(s) with 2 star	Ctrl+2	⌘+2
Rate image(s) with 3 star	Ctrl+3	⌘+3
Rate image(s) with 4 star	Ctrl+4	⌘+4
Rate image(s) with 5 star	Ctrl+5	⌘+5
Clear image(s) rating	Ctrl+6	⌘+6
Filter by Label 1	Shift+1	Shift+1
Filter by Label 2	Shift+2	Shift+2
Filter by Label 3	Shift+3	Shift+3
Filter by Label 4	Shift+4	Shift+4
Filter by Label 5	Shift+5	Shift+5
Filter by Label 6	Shift+6	Shift+6
Filter by Label 7	Shift+7	Shift+7
Filter by Label 8	Shift+8	Shift+8
Filter by Label 9	Shift+9	Shift+9
Filter by Label 0 (Unlabeled)	Shift+0	Shift+0
Filter by Rating: 1 Star	Ctrl+Shift+1	Ctrl+Shift+1
Filter by Rating: 2 Stars	Ctrl+Shift+2	Ctrl+Shift+2
Filter by Rating: 3 Stars	Ctrl+Shift+3	Ctrl+Shift+3
Filter by Rating: 4 Stars	Ctrl+Shift+4	Ctrl+Shift+4
Filter by Rating: 5 Stars	Ctrl+Shift+5	Ctrl+Shift+5

Table AA-2
The Toolbar

Tool	Windows	Mac
Direct Select Tool	A	A
Hand Tool	H	H
Zoom Tool	Z	Z
Temporary Zoom Tool (in)	Ctrl+Space	⌘+Space
Temporary Zoom Tool (out)	Ctrl+Alt+Space	⌘+Option+Space
Crop Tool	C	C
Color Control Point	Shift+Ctrl+A	Shift+⌘+A
Auto Retouch Brush	R	R
Selection Control Point	Shift+Ctrl+C	Shift+⌘+C
Lasso Tool	L	L
Marquee Tool	M	M
Selection Brush	B	B
Decrease brush size	[[
Increase brush size]]
Decrease brush hardness	Shift+[Shift+[
Increase brush hardness	Shift+]	Shift+]
Gradient Tool	G	G
Fill	Alt+BackSpace	Option+delete

Table AA-3
Photo Info

Tool	Windows	Mac
Double Threshold	Shift+T (toggle on/off)	Shift+T (toggle on/off)

Table AA-4
File Menu

Tool	Windows	Mac
Open Image	Ctrl+O	⌘+O
Open Folder in Browser	Ctrl+Alt+O	⌘+Option+O
Launch Transfer	Ctrl+Alt+T	⌘+Option+T

Tool	Windows	Mac
Save	Ctrl+S	⌘+S
Save As	Shift+Ctrl+S	Shift+⌘+S
Close	Ctrl+W	⌘+W
Page Setup	Shift+Ctrl+P	Shift+⌘+P
Print	Ctrl+P	⌘+P
Exit	Ctrl+Q	⌘+Q

Table AA-5
Edit Menu

Tool	Windows	Mac
Undo	Ctrl+Z	⌘+Z
Redo	Shift+Ctrl+Z	Shift+⌘+Z
Cut	Ctrl+X	⌘+X
Copy	Ctrl+C	⌘+C
Paste	Ctrl+V	⌘+V
Duplicate	Ctrl+D	⌘+D
Delete	Delete	del
Rename	F2	F2
Select All	Ctrl+A	⌘+A
Deselect All	Ctrl+Alt+A	⌘+Option+A
Rotate Clockwise 90	Ctrl+R	⌘+R
Rotate Counterclockwise 90	Ctrl+Shift+R	⌘+Shift+R
Size/Resolution	Ctrl+Alt+S	⌘+Option+S
Preferences /Options in Capture NX 2	Ctrl+K	⌘+K

Table AA-6
Adjust Menu

Tool	Windows	Mac
Levels & Curves	Ctrl+L / Ctrl+M	⌘+L / ⌘+M
Contrast/ Brightness	Ctrl+Alt+Shift+C	⌘+Option+Shift+C
LCH	Shift+Ctrl+L	Shift+⌘+L
Color Balance	Ctrl+B	⌘+B
Saturation	Ctrl+U	⌘+U

Table AA-7
Filter Menu

Tool	Windows	Mac
Black and White Conversion	Ctrl+Shift+B	⌘+Shift+B

Table AA-8
Batch Menu

Tool	Windows	Mac
Run Batch Process	Ctrl+Shift+Alt+B	⌘+Shift+Option+B

Table AA-9
View

Tool	Windows	Mac
Show Selection Overlay On/Off (Toggle)	Shift+O	Shift+O
Show Selection Mask On/Off (Toggle)	Shift+M	Shift+M
Show Active Selection On/Off (Toggle)	Ctrl+H	⌘+H
Show Lost Highlights	Shift+H	Shift+H
Show Lost Shadows	Shift+S	Shift+S
Show Focus Area	Ctrl+Shift+F	⌘+Shift+F
Zoom to 100%	Ctrl+Alt+0	⌘+Option+0
Fit to Screen	Ctrl+0	⌘+0
Zoom In	Ctrl++	⌘++
Zoom Out	Ctrl+-	⌘+-
Full Screen	F	F
Presentation	P	P
Hide Palettes	Tab	Tab

Table AA-10
Window Menu

Tool	Windows	Mac
Browser Workspace	Alt+1	Option+1
Metadata Workspace	Alt+2	Option+2
Mutipurpose Workspace	Alt+3	Option+3
Edit Workspace	Alt+4	Option+4
Cycle between open images	Ctrl+Tab	Ctrl+Tab

Table AA-11
Help

Tool	Windows	Mac
Contents	F1	⌘+?

Table AA-12
Apple Specific Shortcuts

Tool	Windows	Mac
Hide application	—	Ctrl+⌘+H

Appendix B: Resources

www.outthereimages.com

This is Mike's Web site. It's full of up-to-date information on digital photography, including regular articles on photography. It also has free downloads and camera setup guides for Nikon shooters.

www.nikoncapturenx.com

This is Nikon's product site for Capture NX 2. It contains tutorials, links for software download, and other links.

www.niksoftware.com

This site has great software plugins for Capture NX 2 and Photoshop.

www.nikon.com

This is Nikon's official global portal for all Nikon Corporation Web sites.

www.nikonians.org

This site has great forums, podcasts, workshops, and support for Nikon photographers.

www.wiley.com

Check out this site for Digital Field Guides for your camera gear and software.

www.luminous-landscape.com

This is Michael Reichmann's popular Web site covering digital topics from printing, workflow, and travel photography.

www.hdrsoft.com

HDRSoft: Photomatix. This is a great tool for creating high dynamic range photographs.

www.xritephoto.com

This site has color management tools for calibrating your monitor, printer, and projector.

www.datacolor.com

Display calibration tools for photographers.

www.iptc.org

International Press Telecommunications Council. This site contains quite a bit of information on IPTC metadata.

www.flickr.com

This is a photo-sharing and critiquing Web site.

www.smugmug.com

This is a photo-sharing and commerce site for professional and amateur photographers.

www.photo.net

This is a large site dedicated to everything photographic.

http://dptnt.com/2008/09/the-ultimate-nikoncapture-nx-and-nx2-resource-guide/

Digital photography tips and techniques for Nikon Capture NX 2.

Glossary

Adobe RGB (1998) This color space has a wider (larger) gamut than the sRGB and CMYK gamuts. Use this color space if you are printing on an inkjet printer.

bracketing Photographic technique where you vary the exposure of your subject to ensure proper exposure in difficult lighting conditions. Sometimes used for high dynamic range (HDR) photography.

boolean logic A system for logical operations that allows you to sort based on different criteria. In Capture NX 2, you can filter images in the browser using these logical operations to find your image. For example, you can filter to include NEF files with one star rating but not include red labels.

cache Capture NX 2 uses temporary storage called cache in order to speed up the program. The cache settings can be configured from the Preferences window.

CF card CompactFlash memory card used to store images.

color gamut The range of colors that can be represented or reproduced by a device (for example, a camera, printer, or monitor). Each device has a different gamut depending on factors such as paper, ink sets, CCD chips, internal software, and so on.

color space A mathematical model that represents a range of colors. A color space is device independent. Some color spaces are large enough so that the gamuts of other devices (printers, cameras, monitors, etc.) generally fall within them. Because of their size they are often used as editing spaces in image editing programs. The two most common color spaces for photographers are sRGB and Adobe RGB. See also *sRGB* and *Adobe RGB*.

color temperature The colorcast given off by different light sources. High temperature light sources give of a blue colorcast and low temperature light sources give off a yellow or orange colorcast. The color temperature of a light source is measured in degrees Kelvin.

compression Reducing the size of a file by digital encoding. JPEG compression reduces file size by discarding information, also called lossy compression, while RAW (NEF) and TIFF compression can be lossless and do not discard information.

contrast The difference in brightness between two parts of an image. There are many tools in Capture NX 2 that allow you to increase or decrease contrast such as Levels & Curves, Brightness/Contrast, and the LCH editor.

curves A powerful tool that enables you to adjust contrast, tonal levels, and color balance. See also *Levels*.

DAM Digital Asset Management. The process of archiving, keywording, storing, and sorting all your digital images.

exposure The combination of shutter speed, aperture, and ISO that is used when you capture an image in your camera.

exposure compensation An exposure modification control that allows the photographer to overexpose or underexpose images by a specified amount. This is usually done by changing shutter speed, aperture, or ISO. Nikon Capture NX 2 has an exposure compensation tool that allows you to brighten or darken the photo by moving a slider control in the Quick Fix area of the Develop pane.

global fixes Repairs or changes to an image that affect the whole image. White Balance and Exposure Compensation are examples of global fixes because they impact all areas of the image equally.

histogram A graph representing the total number of pixels that appear at different level values. The horizontal axis represents the brightness level and the vertical axis represents the number of pixels at each brightness level. The left side of the histogram represents dark tones and the right side represents the light tones.

IPTC International Press Telecommunications Council. The XMP/IPTC area in Capture NX 2 contains text fields that can be used to indicate copyright, usage requirements, keywords, and other information for your images.

ISO sensitivity The measure of a photographic sensor's sensitivity to light. Lower ISO values like ISO 100 require longer exposures but have very low noise (grain). Higher ISO values such as ISO 6400 allow faster exposures but suffer from high noise (grain). See also *noise*.

jaggies A digital artifact that is often caused by overincreasing a photo's dimensions. Jaggies are stairlike lines that appear where there should be straight lines or curves.

JPEG Joint Photographic Experts Group. A file format that compresses your image for portability and storage. The degree of compression can be adjusted as a trade off between storage size and image quality.

keyword A word that describes important aspects of your image. Keywords are stored in the XMP/IPTC fields and are permanently saved to your image for use in sorting and cataloging.

Kelvin The color temperature of light. Low Kelvin values such as 2500K produce a warm yellow/orange light, while high Kelvin values such as 8000K produce a strong blue light.

labels A color assigned to a photo for the purpose of identification. Frequently the color red is used to signify a "select" file while the color green is used to signify a "customer approved" image. Capture NX 2 labels can be configured in the Preferences dialog.

levels The brightness or tonality of pixels in your image. Level 0 represents black, level 128 represents middle tone (gray), and level 255 represents white. The Levels & Curves tool in Capture NX 2 is used to adjust contrast, tonality (brightness), and color balance. See also *Curves*.

megabyte A unit of computer storage equal to 1 million (1,000,000) bytes. Abbreviated MB.

megapixel A count of the number of pixels on your camera's sensor. Abbreviated MP. A 12 MP sensor contains 12 million pixels.

metadata Data about the data. In photographic terms, metadata is all the information pertaining to the photograph such as camera type, lens used, exposure information, copyright notice, keywords, and so on.

NEF Nikon Electronic File. Nikon's RAW format.

Nikon View NX An image browsing program that is available free from Nikon.

noise Random variation in brightness and color information in your photo. Digital noise often appears as brown or yellow splotchy areas in your image. Noise is generally worst in shadow areas and when using high ISO sensitivity settings.

noise reduction A utility in Capture NX 2 that helps reduce the amount of noise in an image. Noise reduction can cause your image to look soft, so it is generally applied locally (rather than globally) with a selection tool.

picture controls Nikon's Picture Controls make it possible to share image processing settings among different cameras so that your images have the same look. The Picture Controls adjustments are available under the Develop section in Capture NX 2.

pixel fixes Repairs made to small, pixel-level problems in an image. Typically used for getting rid of dust in an image, pixel fixes sample the color and texture of the pixels surrounding the problem area in order to repair the problem. The Auto Retouch Brush is typically used for pixel fixes.

Pro Photo RGB An RGB color space developed by Kodak that offers a very large color gamut, almost as large as the human visual spectrum. Use Pro Photo RGB if you are knowledgeable about converting your files from Pro Photo RGB to the destination's color space.

RAW An image file format that contains image data directly from the camera's sensor. A RAW file hasn't been processed and contains just the original image data such as white balance, Picture Controls, and exposure data.

regional fixes Repairs or changes that are applied only to selected areas of an image. Color Control Points and Selection Tools are examples of regional fixes because they impact only the portions of the image that you choose to alter.

soft proofing A tool that enables you to preview the effect of an output profile on your image. Use this feature to approximate the results you would expect from your printer.

sRGB The RGB profile used in the majority of computer monitors, TV broadcasting, and commercial laboratory printers. The common setting for this color space is sRGB IEC61966-2.1. Use sRGB if you are printing at the lab or if you are displaying your images on the Web.

star ratings The quality ratings applied to your images. Zero stars means that your photo is unrated. One star means that your image is better. Five stars means that the image has the highest rating. Capture NX 2 allows you to apply star ratings in the Browser pane.

tags Another term for keywords, ratings, and labels.

TIFF Tagged Image File Format. A type of digital file that is lossless and retains all pixel data when you save and close it. TIFFs can be very large.

upsample To increase the bit depth of an image. For example, upsampling an 8-bit image to a 16-bit image.

white balance A setting in the camera to adjust for the color of the light illuminating a scene. The goal is to render something white in the scene as the same color of white in the captured image. When this is successful, color reproduction is accurate and less adjustment is required to make the recorded image faithful to the original scene. White balance typically involves adding red (amber) or blue to bias the colors of your photograph.

XMP Extensible Metadata Platform. XMP protocol was designed by Adobe to be the standard for processing and storing metadata. Nikon Capture NX 2 saves keywords, ratings, and labels in a way that follows the XMP standard.

Index

continued

continued